MARVEL
SPIDER-MAN
SCRIPT TO PAGE

MARVEL'S SPIDER-MAN: SCRIPT TO PAGE

Spider-Man created by Stan Lee and Steve Ditko

Interviews by Andrew Sumner

MARVEL PUBLISHING

Jeff Youngquist, VP Production & Special Projects

Brian Overton, Manager, Special Projects

Sarah Singer, Associate Editor, Special Projects

Sven Larsen, Vice President, Licensed Publishing

Jeremy West, Manager, Licensed Publishing

David Gabriel, SVP Print, Sales & Marketing

C.B. Cebulski, Editor in Chief

ISBN (print): 9781789098853

ISBN (ebook): 9781803360850

Published by

Titan Books
A division of Titan Publishing Group Ltd
144 Southwark St
London
SE1 0UP

www.titanbooks.com

First edition: November 2022

10 9 8 7 6 5 4 3 2 1

© 2022 MARVEL

To receive advance information, news, competitions, and exclusive offers online, please sign up for the Titan newsletter on our website: www.titanbooks.com

Did you enjoy this book? We love to hear from our readers. Please e-mail us at: readerfeedback@titanemail.com or write to Reader Feedback at the above address.

A CIP catalogue record for this title is available from the British Library.

Printed and bound in the UK.

MARVEL
SPIDER-MAN
SCRIPT TO PAGE

SCRIPTS BY

Dan Slott

Saladin Ahmed

Nnedi Okorafor

Chip Zdarsky

Zeb Wells

TITAN BOOKS

CONTENTS

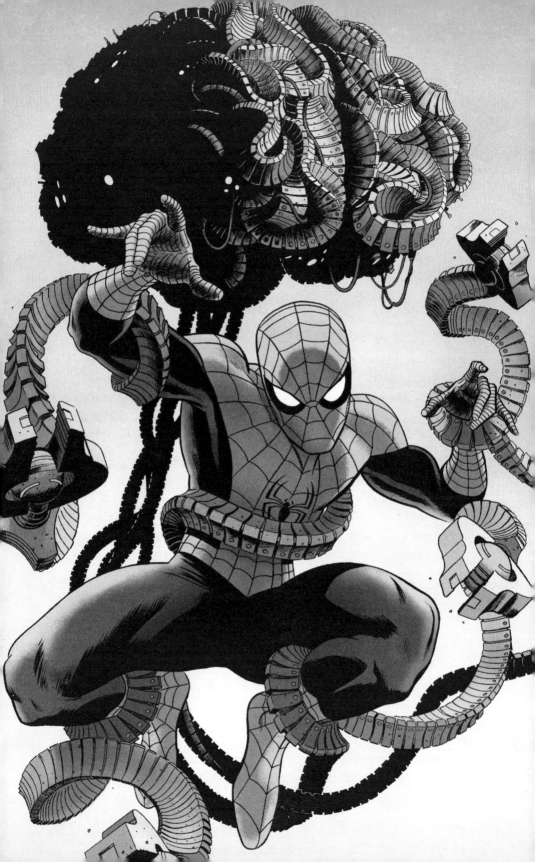

AMAZING SPIDER-MAN (2012) AND SUPERIOR SPIDER-MAN (2014) BY DAN SLOTT

AN INTRODUCTION BY **DAN SLOTT**
IN CONVERSATION WITH **ANDREW SUMNER**

Superior Spider-Man is everything Spider-Man shouldn't be.

The way the whole Superior Spider-Man era started was that I had everything mapped out for a long time. I knew that issue 700 was coming, and you always want to do something big for the anniversary issues, some story where Spider-Man has to face odds he's never faced before. At that time within Marvel Comics there were certain characters that were locked off that I couldn't use on Spider-Man, like Norman Osborn. In my mind, I wanted to do a big Green Goblin story for #700, but Norman Osborn was busy; sometimes in Warren Ellis and Mike Deodato's *Thunderbolts*, sometimes in Brian Michael Bendis and Mike Deodato's *Dark Avengers*, later in Kelly Sue DeConnick's *Osborn* miniseries; but he was always kind of locked up. And, also, because of different scheduling problems, I couldn't use Venom or Carnage. So suddenly, Spidey's three biggest villains were off the map and completely unusable, which is part of the magic of working in a shared universe. I knew that, with those guys being unavailable, it had to be a Doctor Octopus story.

Now, I work Marvel style—not Stan Lee Marvel style [where the artist illustrates the issue to a brief outline or germ of an idea and the writer adds the dialogue and captions over finished art], but I write without a script: I supply a description of what's on every single panel. And then, when I get the art in, I add the script once I can see and admire all the gifts the artists have given me. So, in a weird way, I get to write every story twice. A hundred issues earlier, when I was writing *Amazing Spider-Man* #600, the great John Romita Jr. was doing all the art. When his art came in, the climactic scene of that storyline is that Doc Ock is dying, his body is withering away, and, as a final gift, Otto has put his mind

into all the machines in New York—but they've all gone haywire because, subconsciously, he hates Spider-Man. So all of New York City wants to kill Spider-Man—and the way Spidey wins is that he puts on the helmet Doc Ock used to put his brain into all the machines and, as Peter has a stronger brain, he's able to get all the machines to shut down, even to the point where he's able to control Doc Ock's own mechanical arms. When I was looking at the story second time around, with fresh eyes, I went, "Oh my god—Spider-Man, that's the dumbest thing you can possibly do. You know the super villain's dying. You know he's a mad scientist. You know he has a helmet that can transfer brainwaves… and you've just put it on? If I'm Doc Ock and I'm caught, right before I die I'm going to swap brains with you, Spidey. That has got to be a story!" And I started thinking, "Well, that lands perfectly around issue 700. That's my issue 700: Spider-Man and Doc Ock, you're gonna swap brains!"

So *Superior Spider-Man*'s plan was a really long time coming—the thing I liked about it is that we knew from the get-go that we were canceling *Amazing Spider-Man*, a beloved long-running Marvel book, with issue 700. And we were telling everybody, for two weeks, that Peter Parker was dead. Now, once you opened up *Superior Spider-Man* #1 two weeks later, you saw the ghost of Peter Parker saying, "I'm going to figure out a way to get my body back," and we knew the more irate fans would calm down. But we were still leaving people with a two-week window where they thought Peter Parker was dead and Doc Ock had taken his place. I remember Tom Brevoort saying to me, "You know how you'll know you won? When you come out with the story where you put them back the right way and readers say, 'But we wanted it to go on longer!'"

It really was fun to do—working on that book with artists Ryan Stegman, Humberto Ramos, and Giuseppe Camuncoli, it was such a great time, because it was fun to take every convention of Spider-Man and break them one by one. I got to have Spider-Man do all the things you wanted him to do, but you really didn't want him to do—and all the things that Spider-Man should never do. I always wanted to see Spider-Man just blow up at Jonah, to threaten him and get in his face—but conversely, when Spider-Man starts doing stuff like taking the law into his own hands and shooting people and doing horrible things that Doc Ock would have no problem with, Jonah starts liking him!

Ock's Superior Spider-Man behaves in a whole different way. For example: a building is on fire, but Doc Ock just calls the fire department and says, "It's over there. I'm not missing my dinner with Aunt May. I'm not going to leave this sweet old lady eating alone when I promised I'd be there. That's what the trained firemen are for." So ruining Spider-Man was the fun of it!

Every person who's read a comic has read the adventures of a particular world-famous super hero who has a psychopathic arch-nemesis. And that super hero catches that psychopathic villain and regularly puts them away in some form of asylum. And inevitably, that psychopathic villain breaks out and kills more people. And people go, "What kind of super hero is that? Why doesn't he just kill the psychopathic villain? He'll save lives in the long run." We all know the reason why is because heroes don't do that. And part of the fun of *Superior Spider-Man* was we had a sequence where Doc Ock faces that problem in the form of the villain Massacre, whose *modus operandi* is taking out as many people as he needs to distract you so he can pull off his crime. He just unloads his weapons into civilians. He's horrible. Superior Spider-Man is looking at Massacre, who he's just captured, webbed up and helpless. And Ock is thinking, "What shall I do? I can't just leave a Friendly Neighborhood Spider-Man note on his chest." And he's looking at Massacre's gun. There are people in the background who are still being tended to, wounded and in pain, and Doc does the math. And meanwhile, the ghost of Peter Parker is like, "What are you doing? No, no, no!" And Spider-Man shoots Massacre. Because he's the Superior Spider-Man.

I remember we heard from our letterer, Chris Eliopoulos, that he had that page up on his computer at home, and his very young child walked into the room and looked up and saw the art and freaked out—he started yelling, "Spider-Man doesn't do that!" Chris had to calm down his child. Then, two months later, the book comes out, and grown men on the internet are shouting, "Spider-Man doesn't do that!" That was the fun of it all: Spidey fans were suddenly in over their head. Fifty years of reading Spider-Man comics over and over again—to the point where they are comfort food, where you know how and why Spider-Man should do everything—and suddenly, the whole world is flipped upside down and there's no safe ground to be standing on. That was the real fun of *Superior Spider-Man*.

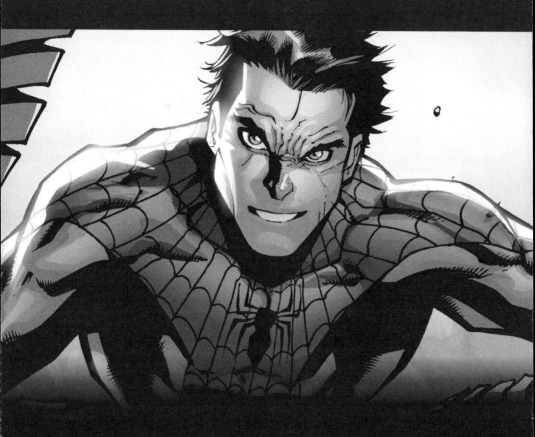

SPIDER-MAN

THE AMAZING SPIDER-MAN
ISSUE #699
2012

"Dying Wish: Outside the Box"

By Dan Slott

Art by Humberto Ramos, Victor Olazaba,
and Edgar Delgado

Humberto,

This is REALLY IMPORTANT. With this issue, YOU are the CENTER of
the Spider-Man Universe--NO JOKE. There are TWO things that YOU are
going to design and set up in THIS issue that will go on to be used
OVER and OVER again throughout #700 and ALL OF 2013. And I couldn't
be happier--because YOU are THE MAN!

So please read over this thoroughly and when drawing these 2
elements--OWN THEM!

Again, this is SUPER IMPORTANT, so if I've screwed up and have in
ANY way been unclear on any of this, please email, call, or Direct
Message me, and we can jam on this together.

(The only changes are on PAGES 16-20. During the breakout there
are now LESS super villains--and we can see more signs that Doctor
Octopus' body is failing and that he doesn't have much longer to
live.

And, we need to establish that MORBIUS' cell is damaged during Doc
Ock's breakout. Steve needs this for a Morbius spinoff book that
will come out the following month.

Also, now the issue ends on a close up of PETER/DOC OCK--instead of
a group shot of the villains.)

SPIDEY/OCK P.O.V. SHOTS

Once the mind-swap takes place, OCK can access SPIDEY'S
memories--and SPIDEY can access OCK'S memories. But whenever we see
these flashback panels--even when they're existing shots of classic
images we've seen before--we NEVER see them as standard panels.

Each character experiences those flashbacks as if they were the
OTHER character--from THEIR P.O.V.

That means that those panels should be in FIRST PERSON
PERSPECTIVE--with the character's hands breaking into the
shot--like a first person shooter/video game. For example, if DOC
OCK was accessing PETER'S memories of the first time he saw MJ,
the panel would still be that classic "You've hit the jackpot"
moment--but PETER would be removed from the shot COMPLETELY--and
we'd see one of PETER'S hands (with the same color shirt and jacket
sleeve from that issue) breaking into frame--as if we were REALLY
witnessing this moment THROUGH Peter's eyes.

When showing SPIDEY accessing OCK'S memories, we can cheat a
little and have one of his tentacles breaking into shot instead of
one of his physical hands.

MARVEL'S SPIDER-MAN—SCRIPT TO PAGE

When space allows, we should cheat in these panels and hide REFLECTIONS of the P.O.V. character in the shot--in mirrors, glass, metal, etc. This is just a nice way to get more OCK and SPIDEY visuals into the issues--and it reinforces that we're seeing a P.O.V. shot--and not just a shot that's cropped weird so that a hand's popping into frame.

GHOSTED BRAINS

Every now and then, we'll see a shot of the PHYSICAL BRAIN in Spider-Man's body (that Doc Ock has taken over), and the PHYSICAL BRAIN in Ock's body (that Spider-Man is controlling). In each case, the brain looks normal (GREY).

But in each case we'll see ANOTHER brain ghosted over it and slightly off register. There'll be a GREEN BRAIN (Doc Ock's brain pattern) overlapping Spider-Man's physical brain--and a RED BRAIN (Spidey's brain pattern) overlapping Ock's physical brain.

We're going to establish this effect here--and it will be PIVOTAL for down the road in SUPERIOR SPIDER-MAN, when both Spidey and Ock are fighting for final control of Spider-Man's ACTUAL brain. And THEN we'll see BOTH of the RED & GREEN GHOSTED BRAINS overlapping SPIDEY'S PHYSICAL BRAIN--and it'll look like watching a classic 3D movie without 3D glasses.

Does that make sense?

THERE IS NO REF. FOR #697 & #698

There are some images/panels that will be call outs to ASM #697 and #698. Don't worry about them. They're going to be drawn AFTER you've drawn this issue--so YOU get to decide how they're going to look and the other artists will have to match you. Just letting you know about that ahead of time so there's no confusion.

Phew!

Ready, sir? This is IT! The lead in to #700! You pumped? I know I am! All right, my friend, let's make some Spider-Man history! :-)

PAGES 1 AND 2

For everything in this issue that takes place in the REAL WORLD, please stick to a standard grid--squares, rectangles, and/or images that bleed off the page.

Feel free to go crazier with your layouts and go off-the-grid for images that take place in Peter/Ock's memories, Peter's imagination, or the mindscape.

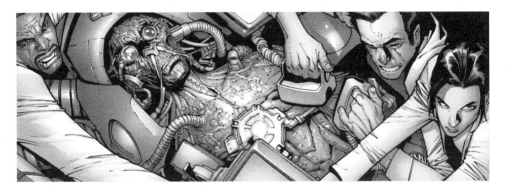

TIER 1

Panel One

Long panel, going across the entire top of both pages. This image will act as our "splash." The title will go here.

INSIDE DOC OCK'S CELL IN THE RAFT, DOC OCK'S body is failing. A team of four doctors are going to work, trying to save him.

We're ABOVE, looking down on OCK'S body. He is withered, scarred, disgusting, and filled with all kinds of tubes and life-support machines. There are tubes going into both nostrils and his mouth. This should look like NEO'S REAL BODY from THE MATRIX when they removed him from the Matrix. All Geoff Darrow-ish, with tubes EVERYWHERE.

NORMALLY, DOC OCK is in a giant, high tech Iron Lung-type device, but it has been opened up--like a coffin--to allow the doctors to work. (It will be closed back up in Panel Six).

The doctor's are hunched over--with hypodermic needles, scalpels, and paddles to restart Ock's heart. Don't worry about showing us the tops of the doctors' heads. They're not important in the shot. OCK'S face is the only one that matters in the panel.

If we can see the walls, there should be medical monitors--all of which are either flat-lining or blinking red. Things are BAD. Doc Ock is dying.

TIER 2

Panel Two (SILENT PANEL)

We see a set of hands shocking OCK'S body with the paddles.

Panel Three (SILENT PANEL)

Another set of hands injecting him with a hypodermic needle.

Panel Four (SILENT PANEL)

Another set of hands starting to cut into him with a scalpel.

Panel Five

DOCTOR #1 (a middle aged woman) is correcting DOCTOR #2 (a young African American) on the medical procedure he's performing.

DOCTOR #2 wants to know why they're working so hard. After all, this is Doctor Octopus: the guy who nearly fried Planet Earth!

DOCTOR #1 tells him that they've all taken an oath--to save EVERY life, no matter who.

TIER 3

Panel Six

DOCTOR #1 says that OCK is stable. She orders the other doctors to close the Iron Lung again. And they start lowering the "coffin door" of the Iron Lung...

Panel Seven

The Iron Lung is shut.

Panel Eight

CLOSE UP on DOCTOR #1 (the woman who was standing up for OCK) as she looks at him with a slight sneer on her face.

Panel Nine

MATCH SHOT as she spits in DOC OCK'S face.

Panel Ten

CLOSE UP of DOC OCK'S withered, tube-filled face--and the wad of spit rolls along his cheek. In a caption box, we hear Peter's narration: "My name's Peter Parker. And I have no idea how I'm getting out of this."

PAGE 3

Panel One

Pull back to a shot of DOC OCK'S body in the Iron Lung--in the high tech jail cell. PETER thinks about how he's trapped inside DOC OCK'S dying body--inside a cell in the RAFT...

Panel Two

As the doctors walk out of Doc Ock's jail cell--we see that there are armed S.H.I.E.L.D. AGENTS guarding the cell.

PETER'S thoughts continue--he's not just IN a dying body, IN an iron lung, IN a cell...it's also a heavily guarded cell...

Panel Three: (LONG PANEL across the page)

As the doctors continue to walk down the long row of cells, we get a good establishing shot of this wing of the prison and the other 3 cells on this block:

Each cell has secure, metal walls--with one strip of VERY THICK, unbreakable plexiglass, to let us see who's inside. Over each cell is a slotted placard telling us who's inside. In order they are:

ALISTAIR SMYTHE, THE SPIDER-SLAYER (in heavy restraints), he is snide and petulant.

DR. MICHAEL MORBIUS, THE LIVING VAMPIRE (in heavy restraints), he is depressed and downtrodden.

DR. CURT CONNORS, THE LIZARD (in heavy restraints, including a Hannibal Lecter mouth clamp over his snout), he is subdued and NOT feral or angry at all. HUMBERTO, please ask Ellie for reference on THE LIZARD'S new visual.

(IMPORTANT NOTE: OCK'S is the last cell on the block--NEXT to THE LIZARD'S).

DOCTOR #1 says that in the end it doesn't matter that they saved OCK right now. With the way his body his failing, he probably only has half a day left to live. He'll be dead by tomorrow.

In PETER'S captions, he tells us that he's not just dying with hours left to live, in an iron lung, in a heavily guarded prison--he's also surrounded by some of his worst enemies!

Panel Four

CLOSE UP on THE LIZARD. He heard about how DOC OCK has hours left to live--and this has caught his attention. Even though he's in restraints, he turns his head towards DOC OCK'S cell.

Panel Five

CUT back to DOC OCK'S cell as Peter thinks he's impossibly screwed--in at least five different ways.

PAGE 4

Panel One

PETER thinks back to how he got into this mess...

Panel Two

In a P.O.V. shot we see an UNMASKED SPIDER-MAN leaning over "us." OCK IN PETER'S BODY tells us:

"From now on, I am Peter Parker. I have all of your memories. I know everything you knew. I have YOUR LIFE--and everything that comes with it. And YOU are now Otto Octavius...with whatever life YOU have left."

(Humberto, since OCK is in an Iron Lung, don't worry about getting his hand in the shot. Because it wouldn't be there in this instance.)

Panel Three

Still in a P.O.V. shot, UNMASKED SPIDER-MAN leans in even closer and tells us, "And like a good magician, I will NOT reveal my secret. And you will die, NEVER knowing how I pulled this off."

Panel Four

Cut back to a normal shot (we're no longer in P.O.V. mode) as a very helpless PETER IN DOC OCK'S BODY starts freaking out. His face is contorted in fear and anguish as he thinks not only about his own imminent death--but the fact that DOC OCK is out there--running around in HIS body...

Who KNOWS what crazy ████████ he could be up to?!!

PAGE 5

Panel One

ASPECT SHOT of PETER in DOC OCK'S DYING BODY--focusing on his eyes--as PETER imagines what Doc Ock is out there doing in HIS/ SPIDER-MAN'S body...

In Peter's overworked imagination we see a montage of...

Panel Two

SPIDER-MAN robbing a bank!

Panel Three

SPIDER-MAN sidling up to an unsuspecting Avengers teammate, like CAPTAIN AMERICA, and snapping their neck!

Panel Four

Then he starts thinking of the damage Ock could do AS PETER PARKER...

We see a very evil looking PETER PARKER forcing himself on MJ...

Panel Five

...or admiring JAY and MAY'S Park Avenue apartment, smiling at the elderly couple, and thinking to himself how he's one of their sole beneficiaries...

Panel Six

ASPECT SHOT of PETER in DOC OCK'S DYING BODY. He's thinking to himself that he has to focus! This isn't doing him any good! There HAS to be something he can do!

When Doc was there in Peter's body, he said he had access to all of Peter's memories. Maybe it's a two-way street? Now that PETER is in DOC'S mind, maybe he can access all of Doc's memories! If he can figure out HOW Doc did this mind-swap, maybe there's a way to undo it!

PAGE 6

Panel One

CLOSE UP on PETER/OCK'S eyes as PETER squints and focuses! He's going into Ock's memories--desperately looking for a clue...

Panel Two

In a P.O.V. shot, PETER gets a glimpse of YOUNG OTTO OCTAVIUS' life--as OTTO'S father hits him and tells him to shut up! From this P.O.V. OTTO'S father is like a giant.

OTTO'S FATHER was a blue-collar working man--who thought his kid was too damn smart for his own good!

Panel Three

In a P.O.V. shot PETER feels what it was like to be caught in the accident that fused Doctor Octopus' arms to his body!

Panel Four

In a P.O.V. shot PETER feels what it was like to be Doc Ock getting punched in the face by SPIDER-MAN!

Panel Five

In a P.O.V. shot, PETER feels what is was like to be Doc Ock at his wedding to Aunt May, AUNT MAY is in her wedding gown, puckering up for a kiss!

Panel Six

Out of P.O.V. and back in the real world. We cut to outside Doc Ock' cell at the raft as he screams, "AHHHH!"

PAGES 7 AND 8 (DOUBLE PAGE SPREAD)

TIER 1

Panel One

Close up on a freaked out PETER in DOC OCK'S DYING BODY. He is thinking to himself that he has to shake this off and FOCUS! He has to find the RIGHT memories! The pertinent ones that will help him get out of this!

Panel Two

We see a P.O.V. shot of the opening sequence from ASM #600 when OCK'S doctor told him he only had a year left to live.

Panel Three

We see a NEW (and previously unseen moment during #600) when DOC OCK put on his CYBERNETIC HELMET. (We can see reflections of him in his monitors--so that we know that he's wearing it).

Along his workstation are little octobots--and ghosted inside EACH of them is GREEN brain--representing DOC OCK'S BRAIN PATTERNS.

It was his brilliant plan to duplicate the same process that allowed his brain to talk with his arms--to make his brain patterns in control of EVERY piece of machinery in NYC!

Panel Four

Peter remembers that adventure from his OWN memories! We switch things and see a scene from ASM #600 from SPIDER-MAN'S P.O.V. as he was fighting DOC OCK one-on-one.

Just like before, we can see SPIDER-MAN'S reflection in the shot--and we can see that HE is wearing the cybernetic helmet!

DOC OCK is struggling as his own arms start fighting against him (as SPIDER-MAN took control of them).

Ghosted over Doc Ock's metal vest and arms we can see a RED brain--representing SPIDER-MAN'S BRAIN PATTERNS taking over Doc's arms.

TIER 2

Panel Five

In another SPIDER-MAN P.O.V. shot, we see SPIDER-MAN'S hands holding up the cybernetic helmet up on top of the Empire State Building--with MJ in the shot.

SPIDER-MAN remembers how he hooked up with the helmet again, strengthening his bond to the process of downloading his brain patterns...

Panel Six

In SPIDER-MAN'S P.O.V. we see how Spidey had built that same technology into his Ends of the Earth armor--and when he was fighting Doc Ock on the beach, he tried to take control of Doc Ock's arms again!

In this P.O.V. shot, we see that fight from SPIDEY'S perspective--and see a GHOSTED RED BRAIN over DOC OCK'S ENDS OF THE EARTH BATTLE SUIT--as SPIDEY tried to get his brain patterns inside the arms...

Panel Seven

Now in DOC OCK'S P.O.V., Peter experiences the same sequence, moments later, from DOC OCK'S perspective. And how DOC OCK triumphed by overriding SPIDER-MAN'S ARMOR with his OWN brain patterns!

As SPIDER-MAN falls to his knees--we see a GHOSTED GREEN BRAIN over his chest/Ends of the Earth Armor!

Panel Eight

In a NORMAL (NON-P.O.V.) shot, we're back in Doc Ock's cell in Rykers, focusing on PETER in DOC OCK'S dying body. He's starting to understand that he set himself up for all of this--constantly using that cybernetic technology to download HIS brain patterns--and that DOC was using to download his brain patterns as well!

HUMBERTO, I know this probably sounds REALLY confusing. I think we should chat a bit on Skype before you hit these pages just to be safe. This is all REALLY weird, but I'm sure we can sell it on the page.

PAGE 9

Panel One

Tight close up on the eyes of PETER in DOC OCK'S DYING BODY as he accesses Doc's memories again...

Panel Two

From DOC'S P.O.V., we cut to an untold scene from ENDS OF THE EARTH, when DOC was building his GOLD OCTOBOT as the ultimate back-up plan.

Using the cybernetic helmet again--he made the perfect copy of his brain patterns INTO this gold octobot. In the past, his octobots would let him use people (and super heroes) as puppets. But THIS one was his masterpiece--one that could download and swap his essence and soul.

On this OCTOBOT, the GHOSTED GREEN BRAIN PATTERN of Doctor Octopus is glowing brighter than before...

Panel Three

We see a P.O.V. from the GOLD OCTOBOT'S P.O.V. as it crawled up on shore in NYC. Instead of hands breaking into frame, we can see the spindly arms of the gold octobot.

A broken beer bottle is nearby in the litter by the shore, so we can see the gold octobot reflected in it.

Panel Four

From the GOLD OCTOBOT'S P.O.V. we see how it located SPIDER-MAN in a battle with the HOBGOBLIN (old or new, your choice).

In captions, SPIDEY thinks back to how his Spider-Sense was going crazy at that time, and he had to teach himself to ignore it!

Panel Five

Later, when SPIDEY had gotten away from the Hobgoblins--and was by himself on a rooftop...In an OCTOBOT P.O.V. shot, we see it leaping towards the back of SPIDER-MAN'S head--its shadow is falling across SPIDEY'S back...

Panel Six

Still in that P.O.V. shot (from the OCTOBOT'S P.O.V.), SPIDEY arched in pain--his hands reaching back to rip the octobot off as one of its tentacles drilled into the back of his head!

PAGE 10

Panel One

Back in DOC OCK'S CELL, PETER IN DOC OCK'S BODY finally realizes what's happened--and how DOC pulled this off!

But how does that help?!

Panel Two

PETER realizes that the Iron Lung that Max Modell built for Doc Ock--shields Doc's thoughts so that he can't contact his arms or his army of octobots...

...but this ONE, LONE GOLD OCTOBOT must be acting on a special frequency. And if DOC could reach out and control it--than so can PETE! He just has to concentrate!

Panel Three

PETER strains!

Panel Four

Cut to that same rooftop in NYC...as that lone, gold octobot gets back up...

Panel Five

...and starts to walk around! In an electronic word balloon, the octobot proudly proclaims in Pete's voice: "I did it! And--and I can talk! I just have to get over to the Avengers and tell them what--"

Panel Six

In a voice over caption, in the LIZARD'S font, we hear the LIZARD say "Octaviussss?"

Suddenly, the little gold Octobot falls over and says, "What?"

PAGE 11

Panel One

Back in the cell block, the LIZARD (in the cell next to DOC OCK'S) is whispering to him.

The LIZARD tells (who he thinks is) OCTAVIUS that he heard what the doctors said before...how he probably won't live through the night...

Panel Two

Cut to the sad, sad LIZARD as he starts unburdening his soul. He tells Otto that he has a strange secret--one he's kept all to himself--but now, that he knows Doc won't live to talk about it, the LIZARD can finally tell someone.

Panel Three

The LIZARD reveals that Spider-Man's final cure worked. He IS Curt Connors--forever trapped in the LIZARD'S body.

Panel Four

Cut to a reaction shot of PETER IN DOC OCK'S DYING BODY. He's stunned! He had NO IDEA!

Panel Five

The LIZARD says that this hideous creature is his TRUE cell--his REAL prison--and that he deserves this hell for what happened to his loving Martha and Billy. And THAT is his secret.

Panel Six

Reaction shot of PETER IN DOC OCK'S DYING BODY. He thinks he believes the Lizard--why WOULD he lie to a "dying man"?

But it all sounds so...stupid and unbelievable...

PAGE 12

Panels One, Two, and Three

Cut to the rooftop and the gold octobot as it begins to pace back and forth.

Through its electronic voice, PETER gets more and more frustrated. No one is going to believe this mind-swap crap! It's ludicrous! And since Ock (in Spidey's body) can access all of his memories--he can "prove" to them that he's the "real" Spider-Man!

So what can the REAL Peter do?!!

Panel Four

Back in the cell...We cut to the face of PETER IN DOC OCK'S DYING BODY'S. He realizes that if he's going to think his way out of this--he's going to have to think like Doc Ock--like a super villain! They always get out of jams like this--they have a MILLION back up plans!

Panel Five

Without going into P.O.V. mode, we stay on PETER IN DOC OCK'S DYING BODY'S face as he accesses DOC OCK'S memories. He's accessing a zillion back up plans--plans that include trap doors, robot doubles, holograms, teleportation platforms...

Panel Six

Staying on his face--PETER IN DOC OCK'S DYING BODY has a "Eureka Moment!" He knows how to get out of this!

PAGE 13 (9 PANEL GRID)

Panel One

The gold octobot crawls down a building...

Panel Two

...into an office, where people look at it strangely (as it says "excuse me.")

Panel Three

...and plugs itself into a computer. The screen says, "MASTER PLANNER: CONTINGENCY SIGMA 6.0"

Panels Four, Five, Six, Seven, and Eight.

On computers, laptops, and TVs in bad guy's lairs around the Marvel U--a computer generated image of CLASSIC DOC OCK (not the withered and dying Doc Ock) appears and tells various off screen bad guys that they have been lucky enough to have been recruited to be part of a NEW SINISTER SIX for a special two-part mission. If they accept, 6 million dollars will be deposited into their accounts--3 now, 3 upon completion...

Panel Nine

Its mission completed, the little GOLD OCTOBOT keels over and goes off line for good...

PAGE 14

Panels One through Six

PETER IN DOC OCK'S DYING BODY stays motionless in his cell. There's nothing more he can do.

Panel after panel the time of day changes, eating away at what remaining time he has.

In Panel Four he suddenly coughs up a bit of blood as another major organ fails.

In Panel Five, the blood is hardened and crusted on his face.

In Panel Six, he tries not to cry.

PAGE 15

Panel One

In the prison infirmary, the warning sounds are going off that
Doc Ock is crashing again. The DOCTORS from Pages 1 through 3 start
prepping for surgery. They think that this time it's probably "it"
for Ock.

One of the DOCTORS is gathering up medical supplies, the other
two go over to an industrial sink and get ready to wash up and
scrub for surgery. But when they turn the faucet on...

Panel Two

...the water goes down, and does a u-turn straight up...

Panel Three

...and forms into HYDRO-MAN! The doctors all recoil in fear!

Panel Four

Like a high-powered hose--HYDRO-MAN BLASTS all of the doctors
back--SLAMMING them into walls and knocking them out!

PAGE 16

Panel One

HYDRO-MAN reaches inside himself and pulls out long piece of
wire/tubing with high-tech Kirby-like beads and mini-boxes threaded
along it. (But, logically, this should be something that could have
snaked its way through the faucet on PAGE 16, Panels One and Two.).

Panel Two

HYDRO-MAN places the high-tech wire along the wall, making a
large loop.

Panel Three

Once the loop is complete--it "turns on"--and we see that this
device is actually an energy portal!

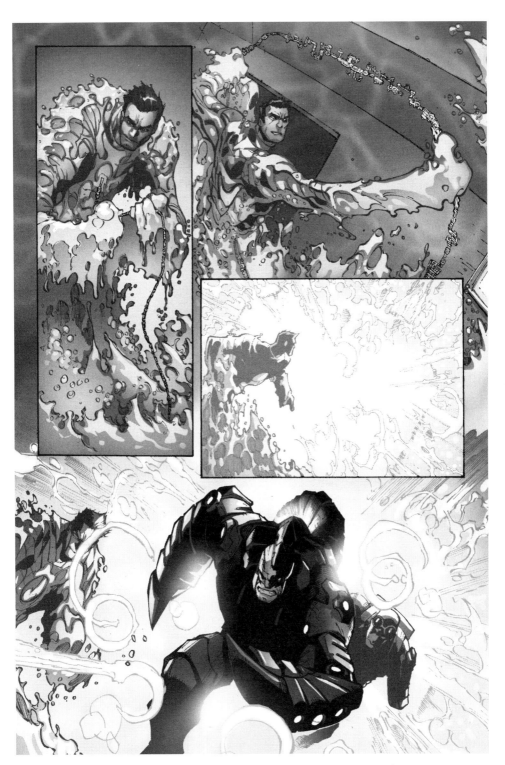

Panel Four

And out of this portal come two more super villains: THE TRAPSTER and the redesigned SCORPION (from ASM #651)!

(Please include HYDRO-MAN in this shot as well in the background behind them. He can still be standing by the portal as the other two villains pop out.)

PAGE 17

Panel One

Cut to DOC OCK'S cell, where PETER (in OCK'S BODY) hears a flurry of sound effects and screams as Scorpion, Hydro-Man, and Trapster wreak havoc getting to him. PETER can't tell what's going on, but he's scared--

--he's scared that in a moment of weakness he's made a terrible choice. He knows that this is his "breakout." And now he's worried about the guards and prison staff. He did NOT think this through!

Panel Two

There's an explosion as the wall of DOC OCK'S CELL is blown open...

Panel Three

...and the TRAPSTER steps through. He tells "DOC OCK" not to worry. They'll have him out of there in a jiffy.

Panel Four

The TRAPSTER opens up the Iron Lung...

Panel Five

...and starts attaching high-tech devices to OCK'S body. The TRAPSTER tells him that these will act as a temporary fix and keep Doc alive till they can get him back to their base.

With the devices in place PETER/OCK can talk again. He demands to know what's going on outside the cell!

Even though these devices are keeping him alive, OCK'S BODY should still be in HORRIBLE shape. To show that, let's see him cough up more blood here as well.

PAGE 18

Panel One

With the temporary/mobile life-support in place, and one of his arms around the TRAPSTER for support, PETE/OCK hobbles outside his cell, where he's surprised to see...

...SCORPION and HYDRO-MAN standing over injured and unconscious S.H.I.E.L.D. AGENTS/PRISON GUARDS.

PETER/OCK demands to know if they're alive or not!

SCORPION tells him that they're alive--but not for much longer! He raises his tail and gets ready to kill a guard...

Panel Two

DOC OCK tells him to STOP! Because...they don't have time for this now! They have to get out of there!

Panel Three

Standing by SMYTHE'S and MORBIUS' CELLS, HYDRO-MAN asks if they should free SMYTHE and MORBIUS as well. This would complete the team and make them the all-new SINISTER SIX!

SMYTHE thinks it's a great idea. He'd love to join up!

Humberto--important for a Morbius spin-off book that Steve needs to launch the following month--in this shot you ALSO need to show that MORBIUS'S cell door is damaged and sparking from the attack. This is so he can escape next month.

Panel Four

CLOSE UP on PETER/OCK. His mind is reeling! He can't let MORE psychos out on the loose--even if they COULD help him get his body back. It's too risky!

He lies and says that MORBIUS is a wild card--and that they should leave SMYTHE--because there's only room for ONE genius on this team!

PAGE 19

Panel One

PETER/OCK turns towards the LIZARD and says that HE should join them. (PETER believes that Curt IS in there. And it wouldn't hurt to have someone like Curt Connors with him--when he's surrounded by the rest of these villains!)

Panel Two

The LIZARD squints his eyes at OCK...

Panel Three

...and then turns, pretending to be a dumb, mindless beast.

Panel Four

The TRAPSTER thinks that OCK is nuts. OCK won't take MORBIUS because he's a "wild card," yet he'll go with a full-on monster like the Lizard? What does OCK know that the others don't?

Panel Five

PETER/OCK takes one last look at the LIZARD, who is now curled up and ignoring him. In thought captions, PETE thinks he could tell them--but they wouldn't believe him. A different mind inside another body? That's crazy, right? No one would fall for that.

PETER/OCK tells them they should all go before more guards show up.

PAGE 20

Panel One

As SCORPION and HYDRO-MAN blast their way back to the infirmary--and the active portal that is still on the wall--PETER/ OCK is still weak and holding onto the TRAPSTER for support.

PETER is horrified at all the infirmary staff and doctors that are knocked out--but he CANNOT show it in his face. He HAS to let the other villains think that he IS Doctor Octopus.

But inside, PETER is freaking out. He can't work with super-villains--not like this--even if his life is on the line. But what can he do?

Panel Two

They all step through the portal...

Panel Three

...and wind up inside one of DOC OCK'S OLD BASES--complete with high-tech gadgets and half-built giant octobots.

HYDRO-MAN wants to know--now that they've freed Doc Ock--what's the NEXT part of the plan.

PETER/OCK tells them it's simple, they're out for revenge! They're going to GET THE AMAZING SPIDER-MAN!

Panel Four

All the villains around PETER/OCK ready their weapons and look menacing in a BIG GROUP SHOT. The SCORPION raises his giant claws and boasts that he can't wait to get the bug--dead or alive!

Panel Five

Close up on PETER/DOC OCK as he says "NO!"

For what he plans to do to him, PETER/DOC OCK needs Spider-Man to be alive! Very much alive!

And in captions, PETER/OCK has NO idea how they can right all this...before he croaks!

TO BE CONCLUDED in ASM #700

SPIDER-MAN

THE AMAZING SPIDER-MAN
ISSUE #700
2012

"Dying Wish: Suicide Run"

By Dan Slott

Art by Humberto Ramos, Victor Olazaba,
and Edgar Delgado

PAGE 1

TEXT: While attending a demonstration in radiology, high school student Peter Parker was bitten by a spider which had accidentally been exposed to radioactive rays. Through a miracle of science, Peter soon found that he had gained the spider's powers...and had, in effect, become a human spider! From that day on he was...

LOGO: The Amazing Spider-Man

TEXT: ...until today. In a final act of vengeance, Spider-Man's greatest enemy, Otto Octavius, has traded places with him, trapping Peter's mind in his dying body. Now, with what little time he has left, Peter Parker is...

LOGO: Doctor Octopus

TITLE: DYING WISH: SUICIDE RUN

PAGE 2

Panel One

LOCATOR CAPTION: Tribeca.

LOCATOR CAPTION: Peter Parker's Apartment.

MJ: Hmm...

TV (electric w/ musical notes): Don't be scared,

You got the mood prepared,

Go on and kiss the girl...

Panel Two

PETER: What?

MJ: My favorite movie, food, and wine?

OTTO/PARKER: What can I say, MJ. I know what you like.

OTTO/PARKER CAP: Because Peter Parker knew. And I have access to all of his memories.

OTTO/PARKER CAP: Along with everything else that used to be his:

OTTO/PARKER CAP: His amazing powers. This young, virile body. And soon...

Panel Three

OTTO/PARKER CAP: ...I will have something he hasn't had in a long time.

MJ: So tell me. Is THIS a date?

MJ: Are we REALLY doing this again?

MJ: You? Me? Us?

Panel Four

OTTO/PARKER: Yes.

PAGE 3

Panel One

OTTO/PARKER CAP: Excellent.

OTTO/PARKER CAP: Another victory for the Master Planner.

OTTO/PARKER: Say it.

MJ: Say what?

OTTO/PARKER: That THING you say. For old times.

Panel Two

MJ: Face it, Tiger...

Panel Three

MJ: ...you hit the--

MJ (small): Oh.

OTTO/PARKER: Why are you stopping? What is it?

MJ: You're Spider-Man.

SFX (buttons popping off): Pop pok pok

Panel Four

OTTO/PARKER: Of COURSE he--I'M Spider-Man!

Panel Five

OTTO/PARKER: You've known that for YEARS!

OTTO/PARKER: HOW is this getting in the way? EXPLAIN!

MJ: "Explain?" Peter? What's come over you?

SFX: (stacked on top of each other along the right side of the panel): ZEE ZEE ZEE

PAGE 4

Panel One

SFX (stacked on top of each other along the left side of the panel): ZEE ZEE ZEE ZEE ZEE ZEE

MJ: Hey! Where are you going? Aren't we going to talk about--

OTTO/PARKER: Not NOW, woman! This is IMPORTANT!

OTTO/PARKER: I set that alert to sound the SECOND there was any news about OTTO OCTAVIUS.

Panel Two

MJ: Doctor Octopus?

OTTO/PARKER: Yes. I wanted to know the moment he--

OTTO/PARKER: NO!

Panel Three

MJ: You're scaring me. What is it?

OTTO/PARKER: Impossible!

OTTO/PARKER: He's crippled. Dying. How on earth did he manage it?

Panel Four

HEADLINE: DOCTOR OCTOPUS ESCAPES FROM SUPER PRISON

Panel Five

MJ: Peter, this is bad. He's out. Desperate. Hours left to live. Who knows what he might do?

MJ: Don't worry. I understand. You HAVE to go.

OTTO/PETER: You're right.

PAGE 5

Panel One

PETER (inside): One ticket to Belgium.

Panel Two

CHECK IN LADY: Belgium, sir.

PETER: Round trip.

CHECK IN LADY: When will you be returning?

PETER: Tomorrow.

Panel Three

CHECK IN LADY: Tomorrow? Sir, you'll spend most of your time in the air.

Panel Four

PETER: Yes. About fifteen hours.

Panel Five

PETER: For some people, that's a lifetime.

PAGE 6

Panel One

PETER/OCK (weak): Koff

PETER/OCK (weak): W-what's going on? What is this?

TRAPSTER: We're in one of your hidden bases.

TRAPSTER: Easy, Octavius. You faded on me for second.

Panel Two

LOCATOR CAP: Doctor Octopus' Secret Lair: Sigma Six.

PETER/OCK CAP: Oh boy...It's NOT a dream. This is really happening.

PETER/OCK CAP: Doctor Octopus mind-swapped me into his dying body--and the only reason I'm not rotting away in prison...

PETER/OCK CAP: ...is 'cause I used one his escape plans, and hired SCORPION, HYDRO-MAN, and THE TRAPSTER to break me out.

PETER/OCK (weak): What're you doing?

TRAPSTER: What you asked, Doc. Hooking up your life support to these old arms of yours.

TRAPSTER: Getting you mobile.

SCORPION: So? When're we goin' after Spider-Man?

HYDRO-MAN: Shhh.

Panel Three

PETER/OCK (weak): W-wait...

PETER OCK/CAP: I should be doing this, not The Trapster. He's only good for building glue guns and jet packs.

PETER OCK/CAP: This is my LIFE on the line!

Panel Four

PETER/OCK CAP: Can't move my REAL arms. Just these METAL ones.

PETER/OCK (weak): Your calculations are off.

TRAPSTER: Ah. Good catch.

PETER/OCK (weak): Imbecile!

PETER/OCK CAP: Weird. I even sound like Doc Ock.

PAGE 7

Panel One

DOC OCK (weak): Th-that should do it.

Panel Two

DOC OCK (weak/connected to balloon from previous panel): Ready to go mobile. Sw-switch it on.

TRAPSTER: All right. Here we go!

DOC (weak): No, you fool! Not th-that one.

DOC (weak): Here. M-must I do everything my-

Panel Three

DOC OCK (weak): Gryahhh!

SFX: SHRAKKZZ

Panel Four

SCORPION: It suppose to do that?

TRAPSTER: Yeah. I think so...

HYDRO-MAN: He don't look too good.

TRAPSTER: ...orrr maybe not.

Panel Five

SCORPION: Great. Now we're not gettin' paid.

TRAPSTER: Shut up, Gargan.

TRAPSTER: Doc? I can fix this.

TRAPSTER: DOC?!

Panel Six

TRAPSTER (fading): DOC?!

PAGES 8 AND 9

Panel One

PETER/CAP: Huh?

PETER/CAP: Where am--?

PETER: Oh.

PETER: Home.

Panel Two

PETER: I'm home.

PETER/CAP: It's Forest Hills. Ingram Street. But I've never seen it like this before.

PETER/CAP: Porch swings. Blue skies. Trees bursting with leaves. Far as the eye can see.

PAGE 10

Panel One

TIM: Hey, Pete. Wonderin' when you'd show up.

TIM: You're gonna love it here. It's the best.

PETER: Wait. You're Tim.

PETER: Tim Hammond. But you're--

Panel Two

ALEKSEI: The boy is right.

ALEKSEI: There is no pain here, comrade.

OKSANA: Only love.

PETER: Aleksei? Oksana!

Panel Three

PETER: They're dead. All of them. Is--?

PETER: Is this Heaven? Does that mean I'm--

SILVER (o/p): This was not SUPPOSED to be your time.

Panel Four

PETER: Sable?

SABLE: I sacrificed myself so you could save EVERYONE. And you FAILED.

PETER: No. We won. I swear.

SABLE: But you didn't KILL Octavius when you had the chance. You didn't even LET him die.

SABLE: If you did, you wouldn't be in this mess.

Panel Five

CAPTAIN STACY (o/p): Don't listen to her, son.

CAPTAIN STACY (o/p): If you let a man die, even a sworn enemy, you wouldn't BE Spider-Man.

PAGE 11

Panel One

PETER: Captain Stacy! Gwen! Oh--

PETER: I'm sorry, sir. I let you down. Both of you. Can you ever...?

CAPTAIN STACY: Nonsense, my boy. Everyone falls short from time to time.

CAPTAIN STACY: But you never faltered from the right path. That's ALL that matters.

Panel Two

GWEN: And everything worked out in the end, Petey.

GWEN: See? We all get to be together.

PETER: Gwendy, I...

Panel Three

MARLA: Peter.

PETER: Marla. I failed you too, didn't I?

MARLA: Just the opposite. I opened one door for you...

MARLA: ...and you SUCCEEDED. All on your own. I know it...

Panel Four

MARLA: ...and so do they.

PETER: "They"?

PETER: MOM! DAD!

Panel Five

MOM: We've been watching you, son.

DAD: All your accomplishments. And look at you.

DAD: A scientist. Like you always dreamed. We couldn't be prouder of you--

UNCLE BEN o/p: Richie, for Pete's sake...

Panel Six

UNCLE BEN: ...give it a rest. You're gonna spoil the boy.

PETER (o/p): UNCLE BEN!

PAGE 12

Panel One

UNCLE BEN: Oh, Peter. I hate to say this, but you have to GO.

UNCLE BEN: You can't stay here.

PETER: What? I don't get to--After all I've--

PETER (small): No. It's that one mistake ISN'T it. When I let you down.

PETER (small): But I've tried, Uncle Ben. I've tried so hard...

Panel Two

UNCLE BEN: That's not it at all, boy. You've MORE than earned your rest.

UNCLE BEN: And any OTHER time, I'd give you my blessing.

UNCLE BEN: ...but not this time.

Panel Three

UNCLE BEN: But you CAN'T leave a man like Otto Octavius running around AS Spider-Man.

UNCLE BEN: OR Peter Parker.

UNCLE BEN: You've built an amazing life. Don't you dare let him destroy it.

Panel Four

PETER: I won't, Uncle Ben.

UNCLE BEN: Good. Now listen. There are NO scales you have to balance. Not in my eyes.

UNCLE BEN: You've done so much. When this is over, THEN you can rest. Someone ELSE can be Spider-Man. It's okay.

UNCLE BEN: Until then? You have one LAST thing to do.

Panel Five

UNCLE BEN (no tail): You need to get up and fight ONE MORE TIME!

UNCLE BEN (no tail): C'mon, Peter! GET UP!

PAGE 13

Panel One

TRAPSTER (fading in): DOC?!

SCORPION: See? Nothing to worry about. He's still breathing.

TRAPSTER: Technically he WAS dead for three minutes.

HYDRO-MAN: Say there, boss. Maybe you should lay down for a bit.

Panel Two

PETER/OCK (weak/big): NO!

PETER/OCK (weak): There's not a moment to waste!

PETER/OCK (weak): We have WORK TO DO!

Panel Three

SCORPION: That's more like it! All right, Ock, what's our next move?

Panel Four

PETER/OCK/CAP: Okay. Let's look at our assets.

PETER/OCK: Simple, gentlemen.

Panel Five

PETER/OCK/CAP: I've got bad guys, Doc Ock's arsenal, and MY super-brain in HIS rapidly failing body.

PETER/OCK CAP: Oh. And a plan. I've got a crazy plan.

PETER/OCK (weak): We're going straight to the authorities.

PAGE 14

Panel One

LOCATOR CAP: The Raft.

LOCATOR CAP: Maximum security prison for superhuman inmates.

JONAH (burst/inside): Answer me you incompetent idiot! HOW MANY?!

GUARD (inside): How many what, Mr. Mayor?

JONAH (burst/inside): How many prisoners escaped your INESCAPABLE PRISON?!

Panel Two

GUARD: Um. Two Mayor Jameson.

JONAH: Octavius and who else?

GUARD: Morbius, sir.*

JONAH: NOT Smythe?

GUARD: No.

JONAH: Good. Show me Smythe!

GUARD on the far right of the page: Here, sir.

EDITOR'S CAP (small/lower left corner): *Morbius the Living Vampire broke out in ASM #699.1. Read what happens next in Morbius #1.--Steve.

Panel Three

SMYTHE: Don't worry, Jameson. It's only a matter of time before I--

JONAH: Shut up! Ms. Grant? We're leaving!

Panel Four

JONAH: Uh. The press. Parasites, the lot of 'em.

GRANT: Jonah, YOU used to be part of the press.

JONAH: Back when it was a bastion of integrity, Ms. Grant.

PRESS #1 (balloon no tail): Mayor Jameson!

PRESS #2 (balloon no tail): Jonah, over here!

PRESS #3 (balloon no tail): Can we get a statement?

PRESS #4 (balloon no tail): Given that Doctor Octopus is expected to die soon...

PRESS #5 (balloon no tail): ...are the police putting forth a SERIOUS effort to recapture him?

Panel Five

JONAH: Of all the--I don't care if he's got six seconds to live!

JONAH: When it comes to a crazy crackpot like Ock?!

PAGE 15

Panel One

JONAH (electric): I'll throw everything I've got at 'im!

JONAH (electric): Mark my words, that madman will breathe his last breath behind bars!

REPORTER (electric, no tail): But Mr. Mayor, what chance will the police have against a criminal mastermind like--

JONAH (electric): Like what?! Otto Octavius?! The man's a blubbery, bespectacled BUFFOON!

JONAH (electric): Name ONE thing he's ACTUALLY accomplished?!

JONAH (electric): One "master plan" that impotent imbecile's ever pulled off!

JONAH (electric): I know it! You know it! EVERYONE knows it! His ENTIRE time on Earth, Otto's only been ONE thing--

Panel Two

JONAH (electric, no tail): A LOSER!

Panel Three

FLIGHT ATTENDANT: Air Belgium Flight 168 to Brussels. Final boarding.

FLIGHT ATTENDANT: Sir?

OTTO/PETER: I'm thinking.

PAGE 16

Panel One

LOCATOR CAP: The 18th Precinct.

SCORPION: THIS is what you meant by "goin' to the authorities?"

SCORPION: You're CRAZY, Ock! What does this get us?

PETER/DOC OCK (weak): Quiet, Gargan. All you have to know...

PETER/DOC OCK (weak): ...is that there's something here...I need.

HYDRO-MAN: No problem. Do what ya gotta. We'll keep these cops busy.

Panel Two

PETER/DOC OCK (weak): Don't harm ANY of them? Understood?

PETER/DOC OCK (weak): Right now, we only have to worry about Spider-Man or Daredevil interfering...

Panel Three

PETER/DOC OCK (weak): ...but kill an officer, our threat level increases...

PETER/DOC OCK (weak): ...and that could bring the AVENGERS down on us!

COP: Huh? It doesn't work like that!

PETER/DOC OCK (weak/whisper): Dude? You for real? I'm trying to--never mind.

Panel Four

PETER/DOC OCK CAP: Scorpion's right. This IS crazy.

PETER/DOC OCK CAP: Just lucky that no one's been hurt yet.

PETER/DOC OCK CAP: Here we go. The storage locker. They had me working down here during SPIDER-ISLAND.

Panel Five

PETER/DOC OCK CAP: It's where they bring super villain tech to be cataloged.

PETER/DOC OCK CAP: If my luck holds out, this is where they would have brought...

PETER/DOC OCK (weak): Yes!

PAGE 17

Panel One

PETER/DOC OCK CAP: Doc Ock's GOLD OCTOBOT!

PETER/DOC OCK CAP: It's what he used to pull off this mind-swap. If I could study it, I might find a way to--

VOICE o/p (burst): FREEZE!

Panel Two

PETER/DOC OCK CAP (BIG): CARLIE!

CARLIE: Hold it right there, Octavius!

Panels Three and Four

PETER DOC OCK (weak): Carlie, wait! I can explain.

PETER DOC OCK (weak): I'm NOT Doc Ock. I'm SPIDER-MAN!

PETER DOC OCK (weak): I--he used a device to swap our brains and--

CARLIE: BULL!

PETER DOC OCK (weak): No. It's true! I swear!

Panel Five

CARLIE: Fine! PROVE it!

CARLIE: Tell me something only Spidey AND I would know.

PETER DOC OCK (weak): Okay...

Panel Six

PETER DOC OCK (weak): You and MJ, you're the only ones who know. I'm Spider-Man--

PETER DOC OCK (weak): --AND I'm Peter Parker.

Panel Seven

Silent

PAGE 18

Panel One

CARLIE: You're NUTS! AND you know his secret!

CARLIE: I--I can't let you leave here!

SFX: PKOW POW POW

Panel Two

PETER DOC OCK (weak): Carlie! Stop! I'm not--

PETER DOC OCK CAP: The arms! Moving on REFLEX--

SFX: KTING

SFX: PING

Panel Three

CARLIE (BURST): ARGHH!

SFX: SPUTCHH

Panel Four

PETER DOC OCK (BURST): CARLIE!

Panel Five

PETER DOC OCK CAP: Thank God! It's just her arm.

PETER DOC OCK CAP: Clean through. If I tie it down, she should live--

PETER DOC OCK CAP: "Should"? What's happening to me? This is a disaster...

Panel Six

PETER DOC OCK CAP: ...innocent people are getting hurt. I should STOP!

PETER DOC OCK (weak): I got what we were after. Let's go.

TRAPSTER: What was THAT back there?

PETER DOC OCK (weak): Nothing. A cop. I took care of her.

PAGES 19 & 20

TOP TIER

Panel One

TV (electric): --just in. Local police attacked by escaped criminal, Doctor Octopus.

TV (electric): Though no fatalities, one officer suffered a gunshot wound after she--

Panel Two

LOCATOR CAP: Central Park West.

LOCATOR CAP: The apartment of Jay and May Jameson.

JAY: That's Carlie!

MAY: Quick dear, we have to find out which hospital she's being sent to...

SPIDER-MAN (o/p): There's no time for that!

Panel Three

JAY: Spider-Man?

SPIDER-MAN: You're all in grave danger.

SPIDER-MAN: The Scorpion has targeted the entire Jameson family.

SPIDER-MAN: And Octavius is trying to get to me through my connection with Peter Parker.

MAY: Peter!

Panel Four

SPIDER-MAN: Not to worry. Peter took my advice.

Panel Five

SPIDER-MAN (o/p): Going by his credit card bill, he bought a ticket for the first flight out of New York.

MJ: Clever.

LOCATOR CAP: Chelsea.

LOCATOR CAP: MJ's Nightclub.

Panel Six

SPIDER-MAN (o/p): But just to play it safe, I need you--

SPIDER-MAN (o/p): --all of his family and friends to come with me.

SAJANI (small): Great. That's another one I owe you, Parker.

LOCATOR CAP: South Street Seaport.

LOCATOR CAP: Horizon Labs.

Panel Seven

SPIDER-MAN (o/p): I have a secure location. We MUST hurry now. No dawdling.

NORAH: "Dawdling?" Who says "dawdling"?

SPIDER-MAN (o/p): And no lip.

NORAH: OR "lip"?

LOCATOR CAP: Midtown.

LOCATOR CAP: The Daily Bugle.

Panel Eight

JAY: Son?...

MJ: This might not be a good time Jay.

ROBBIE: Jonah? Unbelievable. How'd Spider-Man get YOU here?

JONAH: I hate to admit it, Robbie, but he knows what he's doing.

JONAH: And he is...an Avenger.

SPIDER-MAN: Thank you for your trust in me.

SPIDER-MAN: I'm sealing you in now. But I promise, I WILL be back for you.

Panel Nine

MAX: Spidey, if my team could have access to some equipment...

MAX: ...we could come up with tech to take out Doc Ock and his men. Like last time, remember.

SPIDER-MAN: Yes, Mr. Modell.

SPIDER-MAN: And I never found a way to REPAY you for that, did I? Very well...

PAGE 21

Panel One

SPIDER-MAN/CAP: "...I'll bring you what you need, and then you can get to work."

TRAPSTER: Can I help? Looks complicated...

PETER/OCK (weak): --koff--It is. FAR beyond you, but...

PETER/OCK (weak): ...I could use a pair of hands.

PETER/OCK CAP: There has to be a way to reverse this process. And I have to find it FAST.

PETER/OCK CAP: This whole body's shutting down. I can feel it. Just lost vision in my right eye...

Panel Two

SPIDER-MAN (electronic): Greetings, Otto!

PETER/OCK (weak): You?! H-how did you--?

SPIDER-MAN (electronic): Locate your secret base AND hack into your com-system?

SPIDER-MAN (electronic): Think about it.

PETER/OCK (weak): Right.

SPIDER-MAN (electronic): Trust me, I'VE out thought YOU at every turn. For example...

Panel Three

SPIDER-MAN (electronic): This time, OTTO, you won't be able threaten any of my loved ones--

SPIDER-MAN (electronic): --because they're ALL right here. WITH ME.

PETER/OCK (weak): No!

SPIDER-MAN (electronic): And there's NO WAY you'll find them...

Panel Four

SPIDER-MAN (electronic): ...before you DIE.

SPIDER-MAN (electronic): See? I've ALSO "hacked" your base's self destruct device.

SPIDER-MAN (electronic): Farewell, Octavius.

PETER/OCK (weak): Wait...

PAGE 22

Panel One

PETER/OCK (weak): ...d-do you mean THIS self-destruct device?

PETER/OCK (weak): Haven't we done this dance before? But in reverse?

PETER/OCK (weak): F-face it, "Spidey", we know all of each other's tricks by now.

Panel Two

SPIDER-MAN (electronic): Fine. Here's a NEW one.

SPIDER-MAN (electronic): I KNOW the location of your "secret headquarters."

SPIDER-MAN (electronic): It's a complex hidden under a trash landfill in Staten Island.

Panel Three

SPIDER-MAN (electronic): And I've TOLD the police. They should be there by now.

PETER/OCK (weak): What?! But I have super villains with me. Officers could get--

PETER/OCK (weak): You CAN'T do that!

SPIDER-MAN (electronic): What can I say?

Panel Four

SPIDER-MAN/CAP: I guess I'm playing by a whole new set of rules. Good luck.

POLICE (from helicopter): Anti-Spider Patrol! Deploy! Do NOT wait for confirmation!

POLICE (from helicopter): If you have a shot at Doctor Octopus, YOU TAKE IT!

POLICE (from helicopter): Now GO! GO! GO!

PAGE 23

Panel One

SFX: CHOOM TOOM TRUMM

TRAPSTER: They're shelling us! We gotta get outta here!

TRAPSTER: The teleporter--

PETER/OCK (weak): Needs time to charge.

PETER/OCK (weak): I--I have to finish this experiment! Th-that's all that matters.

Panel Two

PETER/OCK (weak): Scorpion! Hydro-Man! I need a distraction.

Panel Three

PETER/OCK (weak, o/p): But d-don't hurt them.

SCORPION: Why the hell not THIS time?!

PETER/OCK (weak, o/p): I--I might need them f-for questioning...

HYDRO-MAN: No prob, Doc. Got it. We need to save ONE of 'em for questioning.

Panel Four

PETER/OCK (weak): No. Wait. That's not what I mean.

TRAPSTER: Yeah. No offense, Doc, but you're acting really weird.

PAGE 24

Panel One

SCORPION: That's TWICE now with the "don't hurt the cops" garbage.

SCORPION: What's up with that?

HYDRO-MAN: I dunno. Guy's about to kick it. Maybe he's feeling guilty. Y'know, life of crime and all.

HYDRO-MAN: Seen the Vulture do the same kinda thing.

Panel Two

SCORPION: Well, he better not punch out BEFORE I get my six mill. That's all I'm saying.

COP (electronic): Scorpion! Stand down! That's an--AHHH

SFX: SWAKK

HYDRO-MAN: I'm with you. Let's speed this up.

Panel Three

PETE/OCK (weak): There. Finished. Now we can--

TRAPSTER: Brain swap.

PETE/OCK (weak): What?

TRAPSTER: I'm not an idiot. Those last circuits were neural relays.

Panel Four

TRAPSTER: You're dying AND building and brain swapping device. What's the plan?

TRAPSTER: Put YOUR brain in MY body? No way, Doc! Not while I--

Panel Five

PETE/OCK (weak, o/p): SO close. But no cigar.

TRAPSTER: WHAT?! My glue guns!

SFX: THWOP

PAGE 25

Panel One

PETE/OCK (weak): Hydro-Man! Scorpion! Leave them.

PETE/OCK (weak): We're getting out of here.

SCORPION: A getaway sub?! Yeah! There we go!

SCORPION: See? That's a hardcore mad scientist move there!

SFX (sub surfacing): Spushh

Panel Two

SCORPION: Sorry I ever doubted ya, Doc.

PETE/OCK (weak): Sh-shut up and get in.

HYDRO-MAN: Hold on. Where's the Trapster?

Panel Three

PETE/OCK (weak, inside sub): Captured.

PETE/OCK (weak, inside sub): Doesn't matter. He was slowing us down...

Panel Four

PETE/OCK CAP: "...we're better off without him."

OFFICER W/GUN DRAWN: Lieutenant?

OFFICER BEHIND THEM: What is it?

OFFICER W/GUN DRAWN: You better take a look at this.

Panel Five

OFFICER IN FOREGROUND: What the--?!

TRAPSTER: Mmphb bmpph

SIGN: Courtesy of your friendly neighborhood DOC OCK

PAGE 26

Panel One

LOCATOR CAP: "Spider-Man's" Secret Safe Room.

BEN: I can't reach the Bugle. Or my nephew.

GLORY: Sorry, Ben. I'm cut off from my office as well. Guess this is part of Spidey's lockdown.

JONAH: Thought you should know, before I got here, I had my people run a check.

JONAH: Peter bought a ticket to Brussels. It left earlier tonight. He should be safe.

Panel Two

MAY: Thank you, dear.

JAY: We appreciate it, son.

JONAH: What was I going to do? Let the poor woman, suffer? She's--

JONAH: Well, dagblastit, she's family now.

Panel Three

JONAH: And I may be a pig-headed fool...

JONAH: ...but it shouldn't take a plane falling outta the sky*...

JONAH: ...to remind me how important family is.

CAP: *See ASM #694--Steve.

Panel Four

JONAH: Glad you're both safe. Thank God we all are.

GLORY (whisper): Finally. Good on you, Jonah. Knew you had it in you.

PAGE 27

Panel One

MJ: Hm. Whattya know?

MJ: Maybe this IS the time for miracles.

Panel Two

MJ: Hullo? Spider-Man? You out there? We need to talk.

SPIDER-MAN (electronic): I'm busy, woman. Go away.

SIGN OVER BUTTON: Intercom

Panel Three

MJ (electronic): Oh REALLY?!

SPIDER-MAN: This is very important.

MJ (electronic): You know me. And you know I can keep pressing this button ALL night.

MJ (electronic): And I know YOU. You'll eventually give in. So let's just cut to the chase.

SPIDER-MAN: ...

Panel Four

SPIDER-MAN: Very well. What is it?

MJ: Stop. I know what you're doing.

SPIDER-MAN: You do?

Panel Five

MJ: You're scared. Worried something bad's going to happen to us...

MJ: ...and that you're not up for it. But there's

something you should know.

MJ: I believe in you. And not because you're Spider-Man...

Panel Six

SPIDER-MAN: THIS again?!

MJ: Wha--?

SPIDER-MAN: My head's FILLED with your trite pep talks.

PAGE 28

Panel One

SPIDER-MAN: That's all you are now.

SPIDER-MAN: The plucky best friend with the ONE motivational speech.

SPIDER-MAN: What's the POINT? Why are you still hanging around?

MJ: I...

Panel Two

MJ: I love you.

(space)

MJ: No matter what's gone on between us. How complicated it's all become.

MJ: That's it. The one, basic truth that trumps EVERYTHING. I know it all the way down to my soul. I love you.

Panel Three

MJ: Peter? Say something. Please.

Panel Four

Silence.

PAGE 29

Panel One

LOCATOR CAP: Underneath Columbus Circle.

 SCORPION: What is the place? Where are we?

 PETER/OCK (weak): The sewers below 58th and Broadway.

 PETER/OCK (weak): Now quiet. Trying to remember this code.

 HYDRO-MAN: This another one of your secret bases?

Panel Two

 PETER/OCK (weak): No.

 PETER/OCK (weak): --hack-

 PETER/OCK (weak): Enough questions.

 PETER/OCK CAP: Liver's failing. Both kidneys shot. Pain excruciating. Not much time left.

Panel Three

 SCORPION: 58th and Broadway...

 PETER/OCK CAP: This had better work...

Panel Four

 SCORPION (inside elevator): Why's that sound so familiar...?

 PETER/OCK CAP: ...'cause this is my last shot. I don't know where else to go.

PAGE 30

Panel One

SCORPION (going to the inset panel): Columbus Circle?

SCORPION (going to the inset panel): Doc?! Are you INSANE?! You just broke us into--

SCORPION (BIG, going to the inset panel): AVENGERS TOWER!

(space)

SCORPION (going to the inset panel): All night you been tellin' us to stay off their radar--

SCORPION (going to the inset panel): --and now you got us crashin' through their FRONT DOOR!

Panel Two

PETER/OCK (weak): C-calm yourself. It's all part of my plan.

SCORPION: What? For us to get our butts kicked by Thor and the Hulk?

Panel Three

PETER/OCK (weak): I--I know what I'm doing!

PETER/OCK CAP: And what I'm doing is getting this Gold Octobot to the Avengers.

PETER/OCK CAP: If an idiot like the TRAPSTER can figure out it's a brain-swapping device...

Panel Four

PETER/OCK CAP: ...then geniuses like Iron Man, Beast, or Giant Man will spot it in seconds.

PETER/OCK CAP: I have all the proof I need, I just have to find...

HYDRO-MAN: Where is everybody? Place is deserted.

PETER/OCK (weak): Of course it is. L-like I said, it's all part of m-m-my...

SPIDER-MAN (o/p): Your what? Your MASTER PLAN?!

PAGE 31

SCORPION: The Wall-Crawler!

SPIDER-MAN: Very clever, Octavius.

SPIDER-MAN: Activating all of your hidden Giant Octobots around the globe...

SPIDER-MAN: ...and drawing all my fellow Avengers away, so you'd have me ALL to yourself.

SPIDER-MAN: Makes me wonder what ELSE you have in store for me.

PETER/OCK CAP: Outmaneuvered again. Okay, Parker, what now?

PAGE 32

Panel One

PETER/OCK (weak): Of course that's my p-plan!

PETER/OCK (weak/BIG): GET HIM!

HYDRO-MAN: That's it? "Get him?"

SCORPION: Tell me THIS time we get to kill him.

Panel Two

PETER/OCK (weak): Y-yes! Whatever it t-takes!

HYDRO-MAN: FINALLY!

SPIDER-MAN: Do your worst!

 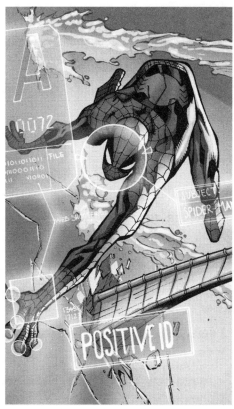

Panel Three

SPIDER-MAN: As you can see, I have taken necessary precautions to even up the score. Including...

SPIDER-MAN: ...augmenting the buildings security settings from "stun" to "KILL!"

SCORPION: Didn't know you had it in you, webs.

SCORPION: Whatever. I know I can take it. Can YOU?

Panel Four

SPIDER-MAN: Simpleton. I'm not a target.

SPIDER-MAN: These devices recognize me as a full member of the Avengers.

PAGE 33

Panel One

SPIDER-MAN: A pity the same cannot be said about you, old friend.

PETER/OCK (weak): W-won't win. C-can't let you--

SPIDER-MAN: What's that, Otto? No! Whatever you do, I'll NEVER reveal--

SPIDER-MAN: --where I've hidden JAMESON and his family...here in the tower!

Panel Two

SCORPION: JAMESON'S HERE?!

Panel Three

SCORPION: Morrie! You're with me. With you splashing around these floors, we'll find him in no time.

HYDRO-MAN: But Ock...

SCORPION: Screw 'im. This's my chance to finally get J. Jonah Jameson!

Panel Four

SPIDER-MAN: Tsk tsk.

SPIDER-MAN: Look what I've done. Now all my loved ones are in jeopardy.

Panel Five

SPIDER-MAN: I guess as "Spider-Man" I am honor-bound to get to those poor innocent souls first...

SPIDER-MAN: ...and "save" them.

SPIDER-MAN: Farewell, Otto. I'll leave you to all the guns and lasers. Good luck without any spider-sense.

PETER/OCK (weak): N-no! You monster!

PAGE 34

Panel One

HYDRO-MAN: Scorpion! Over here...

Panel Two

HYDRO-MAN: ...Think I've...

Panel Three

HYDRO-MAN: Yup! Found 'em!

Panel Four

HYDRO-MAN: Got the Mayor and a whole bunch a people all crammed in here...

HYDRO-MAN: ...like fish in a barrel.

GRADY: Oh, I got your barrel, dude. Right here!

BELLA: The extractor's ready, Max!

MAX: All right, Horizon Team--

Panel Five

MAX: --let's go!

MAX: Mr. Jackson, if you please?

UATU: Pump's at full suction! GRADY?!

SFX: SHWORP

Panel Six

GRADY: We have containment! BELLA?

BELLA: Isolated the prime molecule! SAJANI?!

SAJANI: On it!

Panel Seven

SAJANI: Draining excess fluid!

SFX: SPOSH

Panel Eight

JONAH: What? That's it?

MAX: Yes, Mr. Mayor. My scanner's confirming...

MAX: ...we've successfully extracted a drop of Hydro-Man containing, for lack of a better term, his "soul molecule."

MAX: We used a similar process to help capture Sandman last summer.

JONAH: Hm. Looks like you science geeks were finally useful for a change.

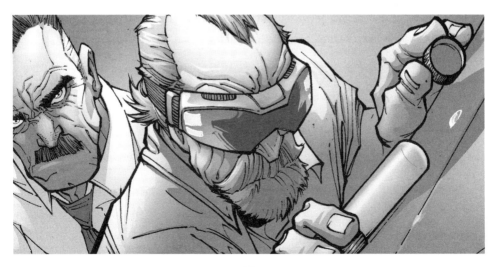

PAGE 35

Panel One

SFX: KRANGG

SCORPION (BIG): JAMESON!

Panel Two

SCORPION: There you are.

Panel Three

JONAH: Robbie! While he's focused on me, get everyone else out!

ROBBIE: Jonah, you won't stand a--

JONAH: JUST DO IT!

Panel Four

GLORY: This way. Through the hole he made.

UATU: Move it!

Panel Five

SCORPION: You care so much about 'em, Jameson.

SCORPION: Maybe there's better ways to hurt you? Your father...

Panel Six

JONAH: Forget him, Gargan! TAKE ME!

JONAH: You blame ME for getting you turned into a freak, don't you?!

JONAH: Well be a man, damn it! TAKE IT OUT ON ME!

PAGE 36

Panel One

SCORPION: That seals it then!

SCORPION: Jameson Senior it is! Or perhaps his lovely wife--

SPIDER-MAN (BIG): NO!

Panel Two

SCORPION: GNUHH!

SFX (behind SPIDEY): KER-WAKK

Panel Three

SPIDER-MAN: You will NOT harm that dear, sweet lady!

Panel Four

AUNT MAY: I'll never let you go, Peter.

AUNT MAY: I love you SO much.

PETER: I love you too, Aunt May.

Panel Five

SPIDER-MAN (small): What the hell was that?

PAGE 37

Panel One

SPIDER-MAN: Spider-sense!

Panel Two

SFX: WHHSSH

SPIDER-MAN: Enough of this!

Panel Three

SPIDER-MAN: Do you hear me, you brainless brute?! I said--

SPIDER-MAN (BIG): ENOUGH!

SFX: KRUNKCH

Panel Four

JONAH: Dear Lord.

JONAH (small): I always knew...

JAY: Look away, May.

MAY: So brutal. That poor man...

Panel Five

SPIDER-MAN/CAP: His jaw. The one place he wasn't armored. I took it clean off.

SPIDER-MAN/CAP: Never knew this body held so much power.

SPIDER-MAN/CAP: All these years, Parker must have been holding back...

Panel Six

JAY: Knew you had it in you, kid.

SPIDER-MAN (small): I didn't.

SPIDER-MAN/CAP: ...but I'm not Parker, am I?

PAGE 38

Panel One

PETER/OCK (o/p, weak): WHAT HAVE YOU DONE?!

OTTO/SPIDEY: --ukh

Panel Two

JAMESON: Spider-Man?! Dagblastit! I distracted him!

AUNT MAY: Jonah, be careful!

JAMESON: If anything happens to that wall-crawling
wonder now, I'll never forgive myself.

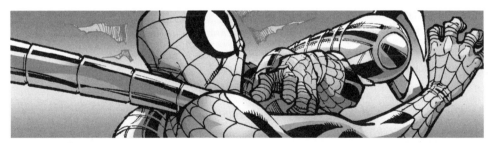

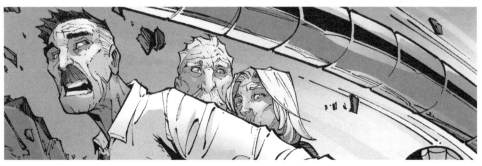

Panel Three

PETER/OCK (weak): I swear, if you've used THOSE hands to take a life...

PETER/OCK (weak): ...if Gargan dies--

OTTO/SPIDEY: Enough with the threats, "Otto." You're not doing ANYTHING!

JAMESON (small): Look at him! The brave fool!

MAX (small): Quickly. While Spidey's keeping him busy.

Panel Four

OTTO/SPIDEY: Think about it. How much time do you have LEFT?

OTTO/SPIDEY: Minutes? Seconds?

PETER/OCK (weak): More than enough to put an end to YOU.

OTTO/SPIDEY: I doubt that. No, you'll be far too busy...

Panel Five

OTTO/SPIDEY (o/p): ...tending to your FRIENDS.

SFX: THWOP THWOP

PAGE 39

Panel One

GLORY: AHH!

PETER/OCK/CAP: GLORY!

Panel Two

MAX: YARGH!

PETER/OCK/CAP: MAX!

Panel Three

MJ: UNGH!

PETER/OCK/CAP: MARY JANE!

Panel Four

PETER/OCK (weak): Impact webbing!

PETER/OCK (weak): That's meant for super villains, not regular people! You--

OTTO/SPIDEY: Ha! Look at you. Losing your grip.

OTTO/SPIDEY: You NEVER had the stomach for this game. Where I, on the other hand--

Panel Five

PETER/OCK (weak): --would go to ANY lengths.

PETER/OCK (weak): I--I can't allow that. Not with that body.

Panel Six

OTTO/SPIDEY: What?!

OTTO/SPIDEY: What do you think you're--?

PETER/OCK (weak): Ending this. Here and now!

PAGE 40

Panel One

SFX: KESHHH

Panel Two

 PETER/OCK (weak): I thought about it.

 PETER/OCK (weak): Seconds to live. Definitely seconds.

 PETER/OCK (weak): Bye, Otto.

 OTTO/SPIDEY (burst): Get off of me!

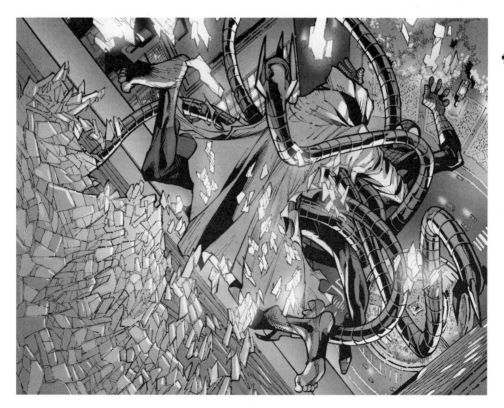

PAGE 41

Panel One

PETER/OCK/CAP: What's he doing? A web net from this height...

PETER/OCK/CAP: ...would be almost as bad as the pavement.

SFX: THWIP THWIP THWIP THWIP

Panel Two

PETER/OCK/CAP: That pattern?

PETER/OCK/CAP: Not just a web-cushion. An airbag. Like stuntmen use.

Panel Three

PETER/OCK/CAP: Clever.

PETER/OCK/CAP: Why didn't I ever think to do tha--

SFX: FWOPP

PETER/OCK/CAP: Spine shattered. Can't feel my legs.

PETER/OCK/CAP: Or much of anything. I think this is it...

Panel Four

OCTOBOT (electric): ...but I still have one trick left.

OCTOBOT (electric): You still win though, Otto.

Panel Five

OCTOBOT (electric): 'Cause even after I put myself back IN there...

OTTO/SPIDEY (whisper): No...

OCTOBOT (electric): ...I can never BE Spider-Man again.

PAGE 42

Panel One

OCTOBOT (electric): Even if you had minutes left, I KNEW what I was doing when I made that jump.

OCTOBOT (electric): I crossed a line I swore I'd NEVER cross.

Panel Two

OCTOBOT (electric): Now I'll have to find a way to LIVE with that--

SFX: KTING

OTTO/SPIDEY: No. You won't

Panel Three

OCTOBOT (electric): WHAT?!

SFX: TING TING TING

OTTO/SPIDEY: Carbonadium plating.

OTTO/SPIDEY: My cranium is COMPLETELY shielded. Or, in other words...

PAGE 43

Panel One

OTTO/SPIDEY: VICTORY IS MINE!

SFX: KE-RAKK

PETER/OCK (weak): GNHHH!

Panel Two

OTTO/SPIDEY: And now to finish this, once and for all!

PETER/OCK (weak): This can't be it.

PETER/OCK (weak): Has to be a way.

PETER/OCK (weak): It hurts...Can't even focus enough to use the arms...

Panel Three

COP: Stay back!

CARLIE: One side. I'm an officer.

COP #2: Cooper? What're you doing here?

CARLIE: Looking for Spidey. Thought I'd try the tower. It's true isn't it? He's fighting Doc Ock?

Panel Four

SPIDER-MAN: So long, Doctor Octopus!

PETER/OCK (weak): Gotta fight this.

PETER/OCK (weak): Have to think.

PAGE 44

Panel One

 PETER/OCK (weak): But I'm tired.

 PETER/OCK (weak): So tired.

 PETER/OCK (weak): Just let me...

Panel Two

 UNCLE BEN (no tail): You're not foolin' ME, Petey!

 PETER/OCK (weak): Huh?

Panel Three

UNCLE BEN: I know you're awake.

UNCLE BEN: And it's time for school!

Panel Four

PETER/OCK (weak): Gosh, Uncle Ben. You're worse--

Panel Five

OTTO/SPIDEY: --than a room full of alarm clocks!

Panel Six

OTTO/SPIDEY: Unhh! Wh--what are you DOING to me?!

OTTO/SPIDEY (burst): Get out of MY HEAD!

PETER/OCK CAP (these are like the OCTO CAPS from #699): I'm not in there, Otto. But my MEMORIES are!

Panel Seven

PETER/OCK CAP: Of course! The octobot beamed my brain patterns into this body.

PETER/OCK CAP: I may need a DIRECT link for a full transfer, but a link STILL exists...

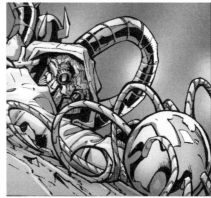

PAGE 45

Panel One

PETER/OCK CAP: ...and I know JUST how to use it!

OTTO/SPIDEY: Whatever this is--it won't work! This is MY life now!

PETER/OCK (weak): Eh-exactly.

PETER/OCK (weak): It's all flashing before my eyes...

Panel Two

PETER/OCK CAP: ...and I'm giving you a ringside seat!

OTTO/SPIDEY: GNH!

Panel Three

AUNT MAY: Cooked your favorite breakfast, Petey. Wheatcakes.

UNCLE BEN: Don't fatten him up TOO much, dear.

Panel Four

OTTO: A spider! It bit me! But why is it burning so?

Panel Five

VOICE (no tail): STOP! THIEF!

Panel Six

COP: Your Uncle has been shot--murdered.

Panel Seven

OTTO: That FACE! It's--Oh no. It CAN'T be!

PAGE 46

Panels One & Two

OTTO/SPIDEY (burst): STOP! I don't want this! I--

PETER/OCK (weak): You wanted to BE Spider-Man. Well guess what? It's MORE than the powers.

OTTO/SPIDEY: I'll--KILL--YOU!

PETER/OCK (weak): No. You won't.

Panel Three

PETER/OCK CAP: Because you know how valuable life is.

PETER/OCK CAP: And what a tragedy it is--

PETER/OCK CAP: --each and every time it's cut short.

Panel Four

OTTO/SPIDEY (small): Please.

OTTO/SPIDEY (small): No more. It's too much. I can't...

(space)

OTTO/SPIDEY (small): ...can't go on.

PAGE 47

Panel One

PETER/OCK (weak): Yes. You CAN.

PETER/OCK (weak): You'd be surprised how much you CAN do.

PETER/OCK (weak): How many things are WORTH fighting for.

Panel Two

OTTO/SPIDEY/CAP: No! This--EVERYTHING you're showing me--

OTTO/SPIDEY/CAP: --it's IMPOSSIBLE!

PETER/OCK CAP: I know. But you do it anyway.

OTTO/SPIDEY/CAP: And I can see it--

OTTO/SPIDEY/CAP: --I can FEEL it. You would do it all AGAIN?!

PETER/OCK CAP: Yes, Otto.

OTTO/SPIDEY: Even ME? Saving MY life? Even with all that's happened?!

Panel Three

PETER/OCK (weak): YES!

PETER OCK (weak): It's who I--we are.

PAGE 48

Panel One

ROBBIE: Everyone here?

MAX: Yes, Mr. Robertson. We're good.

ROBBIE: All right, Modell, let's get your kids to a safe distance.

BELLA (small): We bypass security on the Avengers' elevators, and we're still "kids."

BELLA (small): Whatever.

Panel Two

MJ: Carlie! What's going on down here? Is Spider-Man...?

CARLIE: He's fine, MJ. Over there, with Doc Ock. I think--

CARLIE: I think he's dying.

JONAH: Ha! Good riddance!

Panel Three

MJ: Can you hear them?

CARLIE: No. They're too far away.

MJ: We have to get--

POLICE: EVERYONE, KEEP CLEAR!

Panel Four

OTTO/SPIDEY: I--I don't want this.

PETER/OCK (weak): Too late. Careful what you wish for...Peter.

OTTO/SPIDEY: Tell me. Why do I--How can I do this?

Panel Five

PETER/OCK (weak): Because you HAVE to.

PETER/OCK (weak): Because...

PETER/OCK (weak): With great power...

PAGE 49

Panel One

OTTO/SPIDEY: ...must come great responsibility.

Panel Two

OTTO/SPIDEY: I understand.

PETER/OCK (weak): You better.

PETER/OCK (weak): You're Spider-Man now.

Panel Three

MJ: SPIDEY! Be careful!

PETER/OCK (weak): Th-they're all here. Let me see them.

OTTO/SPIDEY: Here.

PETER/OCK (weak): Promise me. You'll keep them safe.

OTTO/SPIDEY: I...promise.

PETER/OCK (weak): Hm. That's all I...

Panel Four

PETER/OCK (weak): ...ever--

OTTO/SPIDEY: Peter?

PAGE 50

Silent

PAGE 51

Panel One

OTTO/SPIDEY CAP: Farewell, Peter Parker.

Panel Two

OTTO/SPIDEY CAP: Know this, I will carry on in your name.

OTTO/SPIDEY CAP: You may be leaving this world, but you are not leaving it to a villain.

Panel Three

OTTO/SPIDEY CAP: I swear.

OTTO/SPIDEY CAP: I will BE Spider-Man.

Panel Four

OTTO/SPIDEY CAP: Better yet, with my unparalleled genius--

OTTO/SPIDEY CAP: --and my boundless ambition--

OTTO/SPIDEY CAP: --I'll be a better Spider-Man than you ever were. From the day forth, I shall become...

PAGE 52

OTTO/SPIDEY CAP: ...THE SUPERIOR SPIDER-MAN!

TEXT: The end...for now.

SPIDER-MAN

SUPERIOR SPIDER-MAN

PAGE 1

PANEL ONE: Picking up moments after we left off, SUPERIOR
SPIDER-MAN and SPIDER-MAN 2099 are battling Spider-Slayers with
Norman Osborn's face in the screens. The Spider-Men are striking
vulnerable points where the robots' arms and legs meet the body.
They could even be tearing off an arm or leg, but don't make it
look easy...these are pretty tough Spider-Slayers. Please make sure
Superior Spider-Man's costume is taking battle damage here, and
throughout this issue when there's opportunity...it'll be important
later when he changes into the classic costume.

1) **LOCATOR TEXT:** Empire State University.

 2) **SPIDEY 2099:** The armor's thinnest at the joints! Hit
'em where they're weak!

 3) **NORMAN:** Ooh, brilliant strategy from the Spider-Man
knockoff! That's what I was trying to do by killing the
web-slinger's pal, Lamaze...rest his chubby soul.

 4) **NORMAN:** But, just like these Spider-Slayers, Spidey's
gotten tougher. One has to try harder.

PANEL TWO: Close up of a Spider-Slayer's facial display screen.
Norman's smirking head is starting to warp and fizzle out as the
picture changes.

 5) **NORMAN:** A younger, more vulnerable victim. Perhaps
a damsel in distress! The lady-love of Peter Parker, a
fallen friend Spider-Man failed to save. Oh, the pathos!

 6) **NORMAN:** And, just to twist the knife, someone with...
how can I put this tactfully...special needs. Take it
away, my dear Menace!

PANEL THREE: The image changes to MENACE, dangling a tied-up ANNA
MARIA. Anna Maria no longer has on the gag she had last issue, or
it's down around her neck.

 7) **MENACE:** Look into the camera, sweetie. Show your
friend Spider-Man how terrified you are. Can you scream,
or do you need me to make you?

PANEL FOUR: Pull back slightly to show SSM's head in the shot as he watches in horror.

8) **ANNA MARIA:** Don't fall for it, Spider-Man! It's a trap!

9) **SSM:** Anna Maria!

PANEL FIVE: The image changes again, this time to the GREEN GOBLIN (not Norman). He is cackling.

10) **GREEN GOBLIN:** Oh, no! Auntie Em! Auntie Em! HAA HA HA!

PAGE 2

PANEL ONE: Pull back to show SSM and Spidey 2099 fighting the Slayers. SSM punches the face screen of the Slayer taunting him, shattering it. Spidey 2099 keeps pressing his remote control, confused that it won't work.

1) **SSM:** I'll kill you!

2) **SPIDEY 2099:** Why aren't my controls working? I helped build these shocking things! With tech from 2099! There's no way someone could hack it from outside--

3) **SSM:** Of course he could! The Goblin hacked my technology, which is centuries ahead of its time! Now be silent. I don't have time for your nonsense!

PANEL TWO: The Spider-Slayers stop fighting and move aside to create an opening through which SSM could leave. One of them could even reach out an arm toward the opening, as if offering him free passage.

4) **GOBLIN:** No, you don't. You have to save the helpless hostage...who'll be dead within the hour if you don't find her. But you have no idea where she is, do you?

5) **GOBLIN:** Here, I'll give you a free pass. You can start looking now. All you have to do is leave your mini-me to fight a battle he can't possibly win alone.

6) **GOBLIN:** What'll it be? Tick tock, tick tock...HAHAHA!

PANEL THREE: Close on Spidey 2099.

7) SPIDEY 2099: He's tipping his hand. He knows together we can beat these robots. Then I'll help you find the girl. Sound good?

8) SPIDEY 2099: Spider-Man...?

PANEL FOUR: Pull back to show that SSM is already swinging away, through the opening the Slayers made. The Slayers are moving back in to attack Spidey 2099. Spidey 2099 is shocked and furious.

9) SPIDEY 2099: You bithead! I knew you were a poser!

PANEL FIVE: The Slayers overwhelm Spidey 2099 with their greater numbers, erasing him from view!

10) SPIDEY 2099: The real Spider-Man would never--

PAGE 3

PANEL ONE: Back to the mindscape. Peter is still living out Doc Ock's life. Here, he is the decrepit Doc Ock launching his ENDS OF THE EARTH schemes...we see him in the midst of a high-tech lab where he is putting his plans into motion. Cammo, for these flashbacks you've been drawing Peter Parker's face in the place of Doc Ock's, but since Ock was all wrinkled and half-cyborg by this time, we're not sure it would be clear what's going on if Pete was in a similar state. We discussed keeping the face wrinkled and wasted/sickly, but giving it Peter Parker hair and eyes, no weird lenses...but if there's something you think would work better, we'd love to hear it.

1) LOCATOR TEXT: The mindscape. Peter Parker's persona reliving the life of Dr. Octopus.

2) GHOST PETE CAP: Yes...I remember now. I was dying. Enacting my boldest plan...and ensuring that, if it failed, there would be a contingency.

PANEL TWO: Focus on the GOLD OCTOBOT--as seen in the Dying Wish storyline. It's hooked up to machinery similar to the neurolitic scanner from SSM #9.

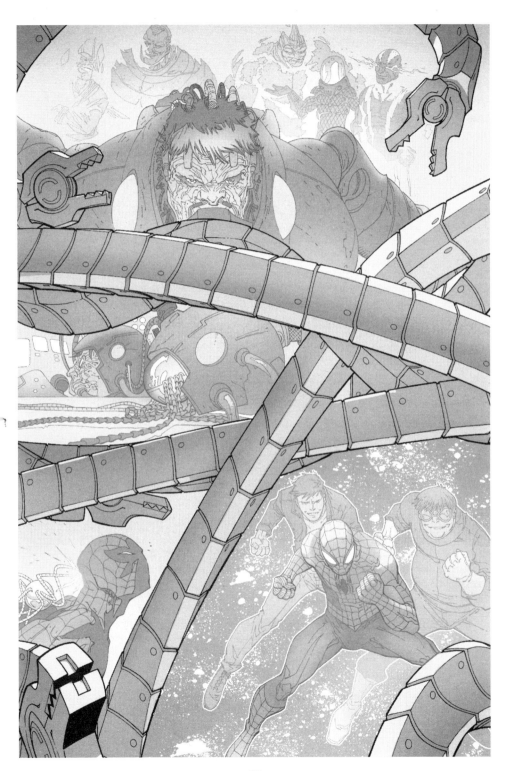

3) **GHOST PETE CAP:** My mind, my persona--everything I am--uploaded into an Octobot.

PANEL THREE: The Gold Octobot latches onto Spider-Man (in his classic costume) and initiates the transfer of Otto's persona. Ref. the Dying Wish story.

4) **GHOST PETE CAP:** Transferred into the body of my greatest enemy.

PANEL FOUR: Big panel--a heroic pose of SPIDER-MAN (classic costume)--as the mind-swap is a success. Ghosted on either side of him is GHOST PETE (in blue) and GHOST OTTO (in green).

[**LETTERING NOTE:** This next line is spoken by all three--Spider-Man, Ghost Pete and Ghost Otto--in a combined balloon with overlapping text (in ghost blue, black, and ghost green) that is slightly out of register, like looking at a 3D movie without the special glasses.]

5) **ALL THREE:** It worked! Now I, Otto Octavius, am Spider-Man!

PAGES 4-5 (DOUBLE PAGE SPREAD)

TOP TIER:

PANEL ONE: Long, panoramic panel. SSM looks out at a New York that is being consumed by violence. Multiple fires burn. Random Spider-Slayer robots fly around, raising hell, battling police helicopters.

1) **CAP (SSM):** Look at it. The city I swore to protect, far better than Parker ever could. In flames...racked with violence...the Goblin's hordes rampaging with impunity.

2) **CAP (SSM):** My base, destroyed. My men, gone. Parker Industries, in dire straits. The Mayor has turned on me, even as I've alienated my allies. Lamaze, my friend, is dead.

3) CAP (SSM): But all that pales compared to one thing. Anna Maria, the woman I love, in the hands of a madman.

4) CAP (SSM): And all of it--all of it--is my fault.

5) CAP (SSM): Like so many times before, the brilliant Otto Octavius...the "Master Planner"...the self-christened "superior" Spider-Man...

6) CAP (SSM): ...has failed.

BOTTOM TIER:

PANEL TWO: A couple NYPD COPS are battling Goblin Gang members. It's not going well. They're pinned down behind a police car while the Goblins throw pumpkin bombs. One cop fires his gun while the other yells frantically into his radio.

7) COP #1: There's too many of 'em! Can't the Avengers do something?

8) RADIO: That's a negative.

PANEL THREE: Cut to Thor, in the sky, whirling his hammer, battling a swarm of the Goblin's villains--MAULER, KILLER SHRIKE, UNICORN, MELTER. An army of villains. They're really bringing it, hitting him with a ton of energy that he's deflecting.

9) RADIO (link to previous panel): They've got their hands full.

PANEL FOUR: Cut to CAPTAIN AMERICA and IRON MAN helping a battle damaged CARDIAC pull surviving patients from the ruins of the H.E.A.R.T. Clinic. Cardiac is agitated. Cap is grim.

10) CARDIAC: The clinic had more patients than this! I've got to find them all!

11) IRON MAN: We will. But afterward, Cardiac...I can't ignore what I've seen here. An illegal medical facility trying unproven procedures? You have to answer for that.

12) CAPTAIN AMERICA: Spider-Man knew. He didn't just condone it...he participated. Iron Man, when this is over, we'll have to arrest him...

PANEL FIVE: Elsewhere in the city, the WRAITH (minus her mask's lenses, which she tore out in the Annual) is helping SPIDER-WOMAN, BLACK WIDOW, and WOLVERINE fight Spider-Slayers (their screens showing Mayor Jameson's face, not Norman or the Goblin).

13) **SPIDER-WOMAN:** Thanks for the help...Wraith, wasn't it? These robots just came out of nowhere!

14) **WRAITH:** No...they're the Mayor's. And they're supposed to be on our side. If they weren't safe, what was he thinking putting them in the field?

PAGE 6

PANEL ONE: Cut to a press room, where a flustered MAYOR JAMESON (who no longer has Glory Grant to support him) is facing a hostile mob of reporters.

1) **LOCATOR TEXT:** Mayoral Press Room.

 2) **REPORTER:** Mr. Mayor! Your taxpayer-funded robots have turned against authorities! Will you resign in the face of this unmitigated disaster?

 3) **JAMESON:** It's not my fault! It's Spider-Man's! He coerced me into--

 4) **REPORTER #2:** Coerced you? How?

 5) **JAMESON:** It--I--I didn't build the darn things! Alchemax did! They're to blame!

PANEL TWO: A reporter holds up an iPad type tablet showing LIZ ALLAN's face (she's Skyping).

 6) **REPORTER:** Mr. Mayor, I have Alchemax CEO Liz Allan here to address your charges.

 7) **LIZ:** False charges. I warned the Mayor the robots weren't ready, but he proceeded on his own.

PANEL THREE: Cut to Liz's office, where she holds up papers to her laptop camera.

 8) **LIZ:** These waivers, signed by him, prove it. And in accordance with our contract, Alchemax is severing all ties to the Jameson Administration.

 9) **LIZ:** We're doing all in our power to correct the Mayor's tragic mistakes. I'll have another statement when the crisis has passed. Thank you.

PANEL FOUR: Liz bends over to pick something up off the floor (we can't see what). Her laptop is off (if we see it). In the b.g., the door opens and little NORMIE pokes his head in.

 10) **LIZ:** Oh, God, tell me that wasn't in the shot.

11) **NORMIE:** Mommy? Can I come back in? I never get to see you anymore...

PANEL FIVE: Liz ushers her son out, kind but firm.

12) **LIZ:** Soon, honey. Mommy's busy, she has a company to run. But always remember, Normie...I'm doing this for you.

PANEL SIX: Now we see behind Liz's back...she is holding a GREEN GOBLIN mask!

13) **LIZ:** It's all for you.

PAGE 7

PANEL ONE: Spider-Man swings desperately through the sky, at a loss as to what to do.

 1) CAP (SSM): I...don't know where to begin. My Spider-Bots are no help. Anna Maria's probably underground, but the Goblins have miles of tunnels.

 2) CAP (SSM): I should have stayed and helped that fool. I need allies. I should never have quit the Avengers...

 3) CAP (SSM): Damn it, what would Parker do?

PANEL TWO: Suddenly there's laughter all around. SPIDER-MAN'S spider-sense is going off.

 4) SFX: HAHAHAHAHA

 5) SSM: Who--

PANEL THREE: SSM spins around and sees Menace flying through the sky, cackling.

 6) SSM: Menace! Away, woman. I have no time to waste on LESSER goblins!

 7) MENACE: Says the fool who's barely HALF a Spider-Man! But that works out nicely, doesn't it?

PANEL FOUR: Menace dives out of the sky toward the street level.

SSM swings after her.

 8) MENACE: 'Cause we have a girl who's barely HALF a hostage.

 9) MENACE: But not for long. It's her TIME that's running SHORT! HA HA HA!

PANEL FIVE: The chase continues to a subway entrance, which Menace is flying into. The subway signs have all been spray-painted/ graffiti-ed over to read, "The Goblin Underground."

 9) SSM: Save your taunts, woman. Now that I've found you, you can bet your life I'll pursue you...

 10) SSM: ...unto my dying breath!

PAGE 8

PANEL ONE: Cut back to the mindscape. We're flashing back to ASM #700, page 45. A victorious Spider-Man is standing over the decrepit Doc Ock (with Peter Parker's mind), who is moments from death. Over Spider-Man, show two ghosts out of register--PETER PARKER in ghost blue and DOC OCK in ghost green.

1) **LOCATOR TEXT:** The Mindscape.

 2) **CAP (GHOST PETE):** Peter Parker's mind entered Otto Octavius' dying body. He couldn't reverse the change... but enough of a link existed that he could force me to relive his memories.

 3) **DOC OCK/PETE BODY (weak):** It's all flashing before my eyes...and I'm giving you a ringside seat.

PANEL TWO: Close on Spider-Man as he winces, clutching his head, as on Panel 2 of Page 45 of ASM #700. We see the two ghosts--Ghost Pete and Ghost Doc Ock--also wince.

 4) **ALL 3:** GNH!

 5) **CAP (GHOST PETE):** W-wait. Not...not "his" memories.

PANEL THREE: Reverse angle. We see Spidey's head in the foreground, with ghosted Doc Ock and Ghost Pete. Past them, we see what they see: one of Peter Parker's memories. I say go with the "Cooked your favorite breakfast, Petey" Aunt May/Uncle Ben shot. (But don't make Teenage Peter in that scene look like Otto...he should look like Teen Pete from AF #15.)

 6) **CAP (GHOST PETE):** My memories.

PANEL FOUR: Reverse angle so we're looking at their faces again. Spider-Man looks up in fear. So do Ghost Doc Ock and Ghost Pete... but for Ghost Pete, it's not fear. It's wonder, understanding, and happiness.

 7) **SPIDEY AND GHOST DOC OCK:** Stop! I don't want this!

 8) **GHOST PETE:** I do.

PANEL FIVE: Reverse angle a final time. A blinding bright light is in the b.g., like a supernova coming toward us. Ghost Doc Ock looks away, toward us, as does Spidey (who, in the memory, has Dock Ock's mind). But Ghost Pete looks right toward the light, maybe raising an arm toward it, as if to touch it.

9) **GHOST PETE:** I'm Peter Parker.

10) **GHOST PETE:** And that's my life!

PAGES 9-10 (DOUBLE PAGE SPREAD)

PANEL ONE: In a giant double page spread (kind of like the double page spread of Madame Web you did in the DANGER ZONE story), GHOST PETER is surrounded with moments from the entire 50-year history of Spider-Man! Including moments beyond the ones we saw earlier in the dreamscape sequences of Goblin Nation. ANYTHING. Important moments--like pushing the massive machinery off him. Silly moments--like fighting the Big Wheel or driving the Spider-Mobile. Loving moments--kissing Mary Jane, walking through a park with Gwen, hugging Aunt May. Anything and everything.

In the center of it all, the figure of Ghost Pete is made whole again. Like we saw him before--classic Spider-Man costume, but no mask. Peter Parker's face.

[Silent.]

PAGE 11

PANEL ONE: Cut to Superior Spidey chasing Menace through the subway tunnels. SSM must dodge pumpkin bombs and/or razor-bats thrown by menace. Some tear up his costume further. It's a desperate, furious chase.

1) **LOCATOR TEXT:** The Goblin Underground.

2) **SSM:** I swear to you, woman--if she's been hurt, you'll suffer in ways you never dreamed possible!

3) **MENACE:** HAHAHA! Look at you! Barely even bothering to dodge! I don't think I've ever seen you so desperate.

PANEL TWO: Menace is taking pleasure in Spider-Man's desperation as she hurls more weapons that he is barely dodging.

4) **MENACE:** Good. My sister died because of you. And make no mistake, cupcake, you're gonna die too. But not until you've suffered.

5) **MENACE:** Oh, look. The Goblin Express is pulling into the station.

PANEL THREE: SSM sees that up ahead, a small figure is tied to the tracks (but not touching the electrified third rail). We can see the light of an oncoming train approaching from around a bend, but because of the way the tunnel bends, the light does not illuminate the person on the tracks...they're in shadow. (We want the readers to think it's Anna Maria, but really, it's a little girl Spidey saved in an earlier issue.)

6) **MENACE (OP):** Is this your stop?

7) **SSM:** Anna Maria!

8) **SFX (train):** HRRONNKKK

PANEL FOUR: We see that the train barreling around the corner has the cackling GREEN GOBLIN driving it!

9) **GOBLIN:** I've done bridges. This time I thought I'd go with tunnels!

10) **GOBLIN:** HAHAHAHAHA!

PAGE 12

PANEL ONE: Suddenly the light of the train illuminates the figure on the tracks. It's not Anna Maria...it's AMY CHEN, the little girl SSM saved in issue 9.

 1) SSM (can be OP): Amy Chen?

 2) GOBLIN (tailless, electric): Another one you saved, Otto! She's making a full recovery...although she's about to feel a mite run down.

PANEL TWO: On SSM as he hesitates.

 3) CAP (SSM): I-if I miss--if I'm hit--there'll be no one to save Anna Maria.

 4) CAP (SSM): What should I--

PANEL THREE: Suddenly the GHOST OF PETER PARKER/SPIDER-MAN is right there by his side, yelling at him!

 5) GHOST SPIDEY (burst): Jump!!

PANEL FOUR: SSM leaps, grabbing Amy. The train is barreling down on them!

 6) SFX: BRRMMMMMM

PAGE 13

PANEL ONE: SSM pulls Amy to safety just in time! The train, just missing them, barrels past them.

 1) SFX: KLAKLAKLAKLAK

 2) GOBLIN (tailless, electric): Oh, well done! That's one for you, Otto. One right move today, amid all the failures. But remember, the other little darling is still in play...

 2) AMY: S-Spider-Man?

PANEL TWO: SSM holds the little girl. Ghost Pete is beside him, looking down the tunnel.

 3) SSM: Shh. You're safe now.

 4) GHOST PETE: Train's gone...no sign of Menace, either. They're off to put together their next set piece. One thing you can always count on is a goblin's showmanship.

PANEL THREE: Ghost Pete faces SSM. Ready for what he presumes is a battle between them for survival.

 5) GHOST PETE: You screwed up, Otto. If there's time, you weigh your options. But when a life's at stake, you always do the right thing.

 6) GHOST PETE: Even if it means giving up the advantage...like I just did. Now you know I'm still here. And I know what that means: Round Two.

 7) GHOST PETE: Well, bring it. I'm ready this time.

PANEL FOUR: On SSM. We can't tell what he's thinking or feeling due to his mask.

 8) SSM: Yes.

 9) SSM: You are.

PAGE 14

PANEL ONE: On the street, SSM gives Amy to a POLICEWOMAN. Ghost Pete is looking around at the devastation in the city, shocked and horrified.

 1) SSM: Get her somewhere safe...if there's such a place left in this city.

 2) GHOST PETE: Oh my God. How could you let things get so bad?

PANEL TWO: SSM starts swinging through the city, with Ghost Pete/Spidey swinging at his side.

 3) SSM: I didn't really comprehend what I was in for. I was arrogant...

 4) SSM: ...no. It's more than that. We've both been in each other's heads. We know the truth.

 5) SSM: I'm arrogant, yes, but it's because I know... underneath it...that I'm not the best. I'm flawed. So I overcompensate.

PANEL THREE: SSM looks at Ghost Pete. Emphatic. Ghost Pete is surprised and even moved by what he's saying.

 6) SSM: But you...you're guilt-ridden because, deep down, you know you are smarter than others. Better. But it came at a painful price. So you sabotage yourself.

 7) SSM: That won't happen today. You said it yourself. When lives are at stake, you don't hesitate.

 8) SSM: Today, you will own up to it. Today you must accept that you...

PANEL FOUR: They touch down on a rooftop. SSM looking at Ghost Pete. Giving him the ultimate pep talk, even as he admits Pete is the better man. Pete is touched.

 9) SSM: ...are superior.

10) **SSM:** The superior hero. That is what I need...what your city needs. That, and nothing less.

11) **GHOST PETE:** Otto, I--I--

PANEL FIVE: Ghost Pete is stunned as he realizes the building across from them is PARKER INDUSTRIES, with its logo visible. SSM sets off toward it.

12) **GHOST PETE:** Wait. Parker Industries? What the what?

13) **SSM:** No time. Follow me!

PAGE 15

PANEL ONE: SSM walks quickly through Parker Industries. Ghost Pete is at his side, looking around in shock. SAJANI approaches, surprised to see SSM.

 1) **SAJANI:** Spider-Man? Shouldn't you be out fighting goblins?

 2) **SAJANI:** Whatever. It's a good thing you came, because we've had a--

 3) **SSM:** Silence, Ms. Jaffrey. I have no time for you now.

PANEL TWO: Sajani is offended as SSM shuts the door to Peter Parker's lab in her face.

 4) **SAJANI:** Hey! That's Peter's lab--

 5) **SAJANI:** Y'know what? Forget it. You deserve each other!

PANEL THREE: In the lab, SSM pulls out the neurolitic scanner (from SSM #9) that he used to "erase" Pete.

 6) **SSM:** Robot, ready the chair. I will be entering the mindscape.

 7) **LIVING BRAIN:** Click--yes, Doctor.

PANEL FOUR: SSM sits in the chair, pulling off the SSM mask as the Living Brain moves to place the headpiece over his head. Ghost Pete is by his side, wary of a trap.

 8) **GHOST PETE:** Just so you know, Otto, if this is some kind of trap...I'm ready for anything.

 9) **SSM:** I believe you.

PANEL FIVE: On Otto/Pete's face as the helmet descends on his head. He is grim, and sad, because he knows what he is about to do...but he is resolved. No Ghost Pete in this panel.

 10) **SSM:** That's why I'm doing this.

PAGES 16-17 (DOUBLE PAGE SPREAD)

PANEL ONE: In the mindscape, Ghost Spidey and a GHOST YOUNG OTTO OCTAVIUS stand together amid images from his childhood...his abusive father, his overbearing mother, Otto being bullied, any of the things you've already shown. These images are fading away.

1) **SPIDEY:** Your childhood...?

2) **OTTO:** Yes. It's vanishing.

PANEL TWO: In the real world, we see SSM--mask off, what we can see of the costume battle damaged--in the chair with the helmet on.

3) **SSM:** You must have no distractions. No confusion. I'm expunging all my memories...

PANEL THREE: Back to the mindscape. Now Spidey is beside a ghost DITKO-ERA DOC OCK. They look around at scenes of vanishing Doc Ock scenes from the Ditko/Romita era...working in the lab, fighting Spidey, etc.

4) **DOC OCK:** ...one after the other.

PANEL FOUR: In the real world, SSM's hands tap keys on a keyboard.

5) **SSM:** My life as a villain must be erased...

PANEL FIVE: Back in the mindscape. Now Ghost Spidey is with GHOST SUPERIOR SPIDER-MAN, amid a mindscape of Superior Spider-Man memories...but nothing with Anna Maria. And nothing brutal, like beating up Jester. Heroic stuff. Saving Amy Chen in SSM #9, saving people from Massacre's bombs, etc.

6) **GHOST SSM:** ...along with my heroic deeds.

PANEL SIX: In the real world, SSM's eyes are beginning to water with tears. He is about to give up what means the most to him. His face shows the pain and emotion of the moment.

7) **SSM:** And...finally...what I've held onto the most.

The longest.

8) **SSM:** But it must go as well.

PAGE 18

PANEL ONE: Back to the mindscape; we will stay here throughout this page. Ghost Spidey is with Ghost Otto/Pete (in his suit and tie). They are surrounded by the fading memories of his time with Anna Maria Marconi. Spidey looks around.

 1) **SPIDEY:** You...you really love her.

 2) **OTTO/PETE:** Yes.

PANEL TWO: Ghost Otto. Pete reaches out as if to caress the cheek of a fading image of a smiling Anna Maria (who is not looking at him; she's unaware of his presence, this being a memory). Her face dissolves into smoke where he touches her.

 3) **OTTO/PETE:** And to save her...I must give up every part of that love.

PANEL THREE: Ghost Otto/Pete turns to Ghost Spidey. He is intense. Serious.

 4) **OTTO/PETE:** For I know...if you are at your best... only you can save her.

PANEL FOUR: Show Ghost Otto/Pete fading away like mist.

 5) **OTTO/PETE:** Because you are the Superior Spider-Man.

PANEL FIVE: End on Ghost Spidey, alone, in his reclaimed mind.

[Silent.]

PAGE 19

[LETTERING NOTE: Entire page is silent!]

PANEL ONE: In the real world, PETER PARKER'S face has one of Doctor Octopus' tears. But his face doesn't have the emotion that goes with it. It's more like someone just waking up and becoming aware of their surroundings (in this case, his old body).

PANEL TWO: He wipes the tear away...

PANEL THREE: ...and looks at it. Almost clinically.

PANEL FOUR: He removes the mind transfer helmet.

PANEL FIVE: At a table in the lab, he sees a bunch of costumes in one of the containers (no stealth costume, please).

PANEL SIX: His hand reaches for the classic red and blues.

PANEL SEVEN: In an aspect shot, he pulls on a boot/legging.

PANEL EIGHT: In another aspect shot, he pulls on a glove.

PANEL NINE: In the final aspect shot, he pulls part of the Spider-Man mask over his face, about to cover his determined mouth.

PAGE 20

PANEL ONE (splash): Hero shot. THE ONE TRUE SPIDER-MAN IS BACK!

Whatever pose delivers the most impact of a big, dramatic "He's back!" moment.

1) SPIDEY: Okay.

2) FLOATING TEXT: To be concluded!

END OF ISSUE #30

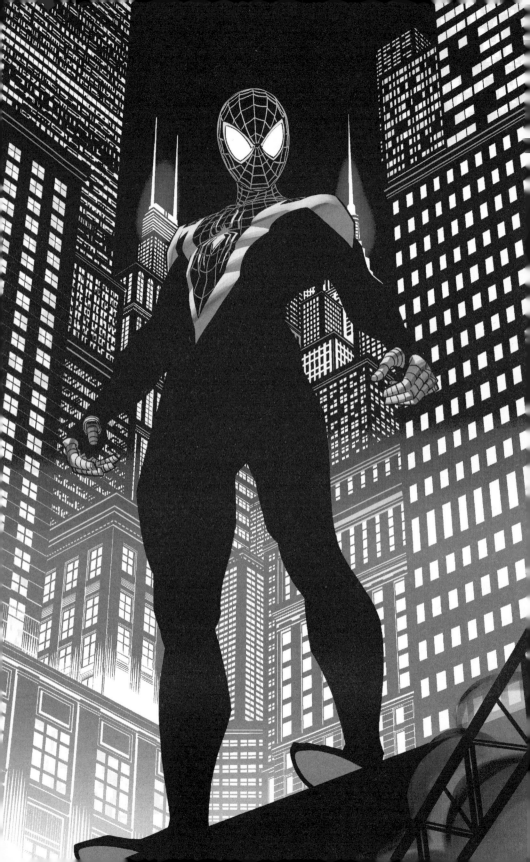

MILES MORALES: SPIDER-MAN (2018) BY SALADIN AHMED

AN INTRODUCTION BY **NICK LOWE**
IN CONVERSATION WITH **ANDREW SUMNER**

At its core, *Miles Morales: Spider-Man* is a book about a Brooklyn teenager who puts on a costume to make the world a better place, against great odds. Miles Morales creator Brian Michael Bendis was finishing his time at Marvel and finishing up writing *Miles Morales*, so we were ramping up for a new run, and I was racking my brain for who to get to write it; Brian was pretty much the only person to write Miles with any regularity since his creation, which was about seven years earlier. We knew the *Spider-Verse* movie was coming, and anytime I'm trying to cast a book, I'm thinking, "What is this book? What do I want out of this book?"

Brian's run as writer ended up going so big—he'd done everything with Miles you could think of to do—so what I was looking for was a grounded Miles book. I wanted something that felt very core, very Brooklyn. I wanted a Miles book that was like Peter Parker's original *Amazing Spider-Man* book, when he was in high school. I wanted to go kind of small, and I wanted a writer who could be a new voice for Miles, who could relate to a young readership but still speak to our core Spider-Man readership. Someone who had something to say, someone who was going to take it seriously and get down to the nitty gritty and be as human as you could go with it.

I had read Saladin's *Black Bolt* book with artist Christian Ward—an unbelievable book—and I thought, "You know, this guy might have it. I think this guy might have something." We had some conversations. Saladin is kind of an iconoclast; an underdog at heart, but a comics fan through and through. One of the things I love about him is that he's not afraid of getting a little goofy, so I had a good feeling about him coming on board. He's a wonderful collaborator, and I knew pretty much right when we started talking that I made the right choice, especially once we landed Javier Garrón to draw it—who is so kind, generous, wonderful, and also a

brilliant collaborator. So I knew I was in good hands there.

Saladin thrilled me with where we went in this book, how grounded he made it with Miles' family and Brooklyn. Saladin lived in New York City for a while, and immersed himself in it—his script just felt real. Different from Brian's, but authentically the same character. Looking through these first issues, I love the amount of community that he put in there: we tried to get real people onto the page, splash pages of Miles with actual people you might see in Brooklyn. We tried to get the kids to look like real kids, and we tried to give real problems to the characters that real-life people were dealing with. And I loved it.

Saladin was writing this while *Into the Spider-Verse* was being prepared, and the bits that I saw of the movie, I was like, "This movie looks crazy." I mean, I edited the original *Spider-Verse* story and I thought, "I can't believe they're actually trying to do this." Knowing where the movie was going and how many characters were going to be in it led us to do this very grounded story with Miles. Whenever there's a movie coming out my goal is: I want to give someone who walks out of that movie a comic that they can pick up, immediately understand, and follow more adventures with that hero, right? To show them who that hero is, on Marvel Comics' terms.

With regard to putting these scripts together, we'll usually talk as an editorial group in Marvel. Then we start the conversation, talking about what our goals are, about what we want the book to be. We go from there, building our common ground and the foundation for the book. At that point, Saladin writes up his vision for what he wants the run to be, and he sends that to me and the rest of the team. We read it, give Saladin some notes (mainly stuff like, "This is awesome, great work. Maybe this character instead of this character," making sure that the characters Saladin wanted to use were available at the time, that sort of thing). We build on that until we're all satisfied, and then Saladin writes the first script and we have a similar process of reading it and giving notes back.

Saladin wrote a really great first issue that encapsulated who Miles is and sent him on a journey towards meeting new antagonists. I think one of the things that I really loved about what Saladin brought to Miles is that super hero comics often contain very clear delineations of good and evil, of hero and villain. What Saladin and I love about Marvel Comics is that line can be blurry—you're able to empathize with our evil characters. In the case of characters like Doctor Doom or Magneto, they make bad choices most

of the time, but sometimes they make good ones. And that was something that very much interested Saladin: not everyone can be put into one category. One of the things I'm most proud of (you don't necessarily see as much in issues one and two, but you see later in Saladin's run) was that I wanted to start creating a rogues' gallery for Miles that was all his own. Often, we have these new *Spider-Man* books and you end up using all of Peter Parker's villains. You need to find a balance.

Rhino shows up in this first issue, and what Saladin does very quickly over the first three issues is establish that it's not as simple as Rhino being a villain with a capital 'V'. He commits crimes for very relatable reasons (usually to get money), but as soon as he sees kids that are being treated poorly, Rhino wants nothing to do with that. I'm a sucker for that kind of perspective, and I loved it when Saladin brought that up.

So after Saladin turns in his script, we go back and forth with editorial notes, and when we're all satisfied we send it along to our artists. I love stories and I love script, but to me the real magic of comic book creation is in the art. So, we sent issue one off to Javier for layouts. He's an incredibly skilled storyteller and a highly skilled designer, but he actively wants notes and wants to make sure he's making the best choices. We go back and forth on what he is doing and the choices he is making based off the script. Once we're satisfied with layouts, we give him the go-ahead for complete art, and Javier produces the pencils and inks.

When Javier's finished and we're satisfied with the final art, he'll send us high-res scans and they get set up by our wonderful production folks, our Marvel Bullpen, who send the files to our colorist (David Curiel, in this case) and our letterer Cory Petit (who has lettered nearly every Miles Morales solo comic since his creation over ten years ago, which is pretty wild) and they do their great work. In that final stretch, we approve what they do, it all gets put together into the final composite form (advertisements are dropped in, and the letters page is added by our production department) and we send it off to the printer. It is such a cool process—one of the things I love about it is that Saladin is in Michigan, Javier is in Barcelona, David Curiel is in Mexico, and Corey Petit is in Brooklyn. So we've got this creative team stretched all over the world, and that's another one of the things I love about working in comics, especially at Marvel: it's a truly global process, and we get to unify these creators and produce something so beautiful. I was just in love with this book from issue one.

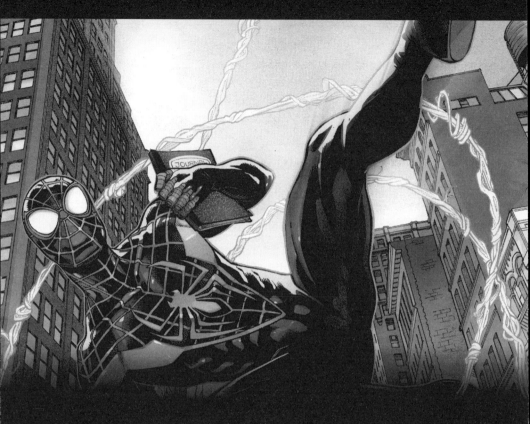

SPIDER-MAN

MILES MORALES: SPIDER-MAN
ISSUE #1
2018

"The Journal of Spider-Man"

By Saladin Ahmed

Art by Javier Garrón and David Curiel

PAGE 1

Big splash of SPIDER-MAN swinging through the city, old school marbled composition JOURNAL under his arm. Classic kinetic Spidey pose.

JOURNAL [this font needs to look hand-drawn but legible]: My name is Miles Morales. This is my journal.

JOURNAL: The journal of...[BIG, LOGO LETTERS] **SPIDER-MAN!**

JOURNAL: Okay, that was cheesy. If anyone ever saw this journal, I'd basically die of embarrassment.

JOURNAL: And probably die IRL, too.

PAGE 2

PANEL 1: Miles and Judge sitting next to each other in Creative Writing class. The chairs are arranged in a circle rather than rows and a hip-professorial-looking Asian American teacher with long graying hair and glasses is starting up class.

JOURNAL: The journal is a school assignment. I took creative writing because my buddy Judge is in it and it sounded easy.

PANEL 2: Teacher holding up a composition notebook.

TEACHER: Every single day you will write in one of these. Your journal is a sanctum for your innermost thoughts. Pen and paper. Un-hackable. Keep it close and NO ONE will see what you write there--not me, not your parents.

PANEL 3: Teacher extremely serious.

TEACHER: This is a sacred trust, people. A writer needs a place where they can be truly honest, and that requires privacy. Any student who reads another's journal will fail this course immediately. Now--

PANEL 4: Miles and Judge walking through school halls.

 MILES: I can't believe he wants us to keep a diary.

 JUDGE: A journal, bruh, not a diary. And, uhh, I already keep one.

PANEL 5: Miles surprised, Judge slightly embarrassed.

 MILES: Are you serious?

 JUDGE: Dead. My poetry teacher had us do it last summer and it just...stuck. I thought it was mad corny at first, too. But it helps, you know? A place to, like, let it out.

 Miles: Huh.

PANEL 6: Miles in his dorm room, writing in the notebook.

JOURNAL: Well, Judge was right. It does feel good to get this all out, even if no one's gonna read it. Especially because no one's gonna read it.

JOURNAL: My name is Miles Morales and I live a life of secrets.

PAGE 3

PANEL 1: Miles getting bitten.

JOURNAL: When I was 13, I was bitten by a genetically altered spider. It did things to me.

PANEL 2: Miles sticking to a bridge while keeping a car from falling into the water.

JOURNAL: I can stick to walls and pick up cars.

PANEL 3: Miles de-camouflage-ing while venom-blasting a mugger.

JOURNAL: I can blend in with my surroundings and stun my enemies with "venom."

PANEL 4: Miles and Peter swinging around NYC together.

JOURNAL: I can swing across the city on a thread. I'm Spider-Man.

JOURNAL: A for-real super hero. Endorsed by the original and everything.

PANEL 5: Big lovely panel of Miles writing. He's standing on a wall, horizontal to the building's vertical, the ledge of a high-rise and sunset Manhattan is splayed out before him.

JOURNAL: You'd think it would make my life easier. You'd be wrong.

PAGE 4

PANEL 1: Our first image of Jefferson, not as agent, but as standing-tall straight arrow dad.

JOURNAL: Secrets run in my family. For years, my dad, Jefferson, the man who taught me everything, was a S.H.I.E.L.D. agent. He only told my mom and me recently.

PANEL 2: Uncle Aaron, devil to Jefferson's angel. Two images of him--one as uncle in pork pie hat, the other masked and garbed as Iron Spider.

JOURNAL: Last year I learned that my Uncle Aaron, the coolest man I know, a man who would take a bullet for me, is also the super villain Iron Spider.

PANEL 3: Rio at a cartoonishly hectic Brooklyn hospital desk, deftly talking to three people at once--a doctor, a nurse, and a patient.

JOURNAL: The only truly honest one in my family, the real badass, is my mom. Her name is Rio and she's the Chief Nurse at Brooklyn University Hospital.

PANEL 4: Miles, scuffed up from a fight, is at his parents' house, putting his costume into a small in-apartment washing machine as his mom walks up, scolding.

JOURNAL: At first I kept my identity from my parents, but now they know.

RIO: Now I know, Miles Gonzalo Morales, that you are not trying to come into my home all stealth and wash blood off that costume without telling me what happened.

PANEL 5: Miles looking kind of shook. Jefferson walking up.

JEFFERSON: What she said. You okay, son?

MILES: There were these multi-dimensional spider-eating-vamp--It was pretty bad. But we saved a lot of people's lives.*

EDIT CAP: Miles ran the show in SPIDER-GEDDON!--Nick

PANEL 6: Mom, Dad, Miles family hug. Miles looking visibly healed by it.

JOURNAL: The original Spider-Man (did I mention we're friends?) told me to keep my super-life secret from my folks. For a while I did. But them knowing...it's helped so much.

PAGE 5

PANEL 1: Exterior of Brooklyn Visions. It's fall, racially mixed crowd of 'smart-looking' hiply-dressed HIGH SCHOOL (not college despite trappings & affectations) kids coming and going from classes.

JOURNAL: I mostly see my folks on the weekends, though. During the week I'm at Brooklyn Visions.

JOURNAL: I'm at that point in high school where I know my way around but am not yet freaking out about college.

PANEL 2: Judge and Miles talking in their dorm room. Judge is holding a book that says 'Gwendolyn Brooks' and gesticulating forcefully.

JOURNAL: I share a dorm room with two guys--my friend Judge, who says he wants to be a "professional peripatetic poet" when he graduates...

PANEL 3: Ganke walking into the room, fist-bumping Judge.

JOURNAL: ...and my best friend in the world, Ganke Lee. I've known him since I was 3.

 GANKE: My dudes.

PANEL 4: Miles and Judge are watching some internet video (whatever you like) on Judge's laptop, cracking up. Ganke lying down, looking at his phone.

JOURNAL: Ganke is the only person besides my parents and a couple of other super-types who know I'm Spider-Man.

 JUDGE: This !%@* is hilarious!

PANEL 5: Judge and Miles dying of laughter at the video. Ganke looking at his phone with concern now.

JOURNAL: We have fun together. When no one's in trouble.

 MILES: Yo, Ganke, you need to see this!

PANEL 6: Ganke showing Miles his phone surreptitiously. Twitter video of a burning building with text LIVE: NYFD UNABLE TO REACH TRAPPED TODDLER. Judge is still looking at his laptop.

JUDGE: ha ha ha--can't breathe heh--ha ha

GANKE (whispers): Miles, you need to see this.

JOURNAL: Thing is, someone's always in trouble.

PAGE 6

PANEL 1 SPLASH--a sort of bookend to p. 1: --Miles swinging away from a burning building with a toddler in his arms. People below cheering.

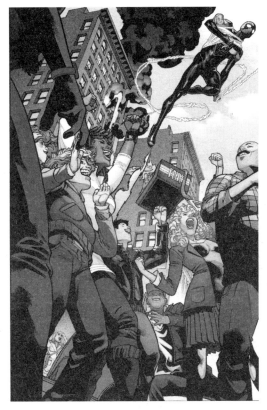

JOURNAL: "With great power there must also come great responsibility." It's something the first Spider-Man used to say to me.

JOURNAL: Well, I don't know if I have great power. I'm not Captain Marvel or Thor.

JOURNAL: But I use what I have to be responsible for as much as I can. Some days, that's enough.

PAGE 7

PANEL 1: It's night now, late, Miles is swinging back to Brooklyn Visions--we can see the campus.

JOURNAL: But some days I get home so late I don't know how I wake up the next morning.

PANEL 2: Climbing into bed.

JOURNAL: I go to bed, exhausted, hoping to sleep for three hours before class.

PANEL 3: Lying there, awake, miserable.

JOURNAL: But half the time after a fight or a rescue my adrenaline's pumping so hard that I can't sleep.

PANEL 4: Asleep at last!

 JOURNAL: And by the time I finally do...

PANEL 5: Judge heading off to class, trying to wake his exhausted friend.

 JUDGE: Miles, wake up!

 MILES: whassawhowhere?

 JUDGE: You're gonna miss class, man!

PAGE 8

PANEL 1: Miles shuffling in late to the aforementioned Creative Writing class.

 TEACHER: Glad you could join us, Mister Morales.

PANEL 2: After class, talking with Judge.

 JUDGE: Man, you are lucky we have Mister Sumida first period--any other teacher, you'd be dead by now, often as you're late.

 MILES: I know, Judge. Believe me, I know. There's just so much going on with my--

PANEL 3: Suddenly face-to-face with Barbara. A bit startled.

 MILES: --life. Hey, Barbara.

 BARBARA: Hey.

 JUDGE: I'mma leave you lovebirds alone. But Barbara, please take a moment to stress to your man the importance of punctuality, will you?

 BARBARA: Sure thing, Judge.

PANEL 4: Barbara playful, Miles flustered.

 BARBARA: So you're my man now? I thought we weren't putting labels on things.

 MILES: Ah I uh that is Judge is just...

PANEL 5: Barbara and Miles high school flirting

 BARBARA: Relax, Miles. You want to hang out this weekend? I'm babysitting my cousin and we're gonna go to Brooklyn Bridge Park and all that. If you don't mind kids.

MILES: No, that's cool, I love kids. I used to be one!

BARBARA: You're such a dork.

<u>**PANEL 6**</u>: Miles cheezin', Barbara charmed.

MILES: But a dork with a winning smile, right?

BARBARA: Oh my God, please leave now.

MILES: I'll text you Saturday. I'll be at my parents' house.

<u>PAGE 9</u>

<u>**PANEL 1**</u>: Miles sleepily coming into the kitchen. Rio having coffee and the paper.

MILES: Morning, mom.

RIO: Good morning, baby. Your father went out shopping. I was going to wake you...

<u>**PANEL 2**</u>: Rio pointing to a splashy newspaper photo of Miles saving the girl in the fire.

RIO: But he said you'd earned some rest.

<u>**PANEL 3**</u>: Rio confronting Miles, Miles defensive

RIO: Paper's a couple days old. My baby boy rescues kids from a fire and I don't hear about it until the weekend. That's wild.

MILES: Mom, I--

<u>**PANEL 4**</u>: Rio hugging Miles very tight.

RIO: It's ok. I just want you to know...sometimes I'm so

proud of you it feels like it's going to kill me. That sounds crazy, huh?

MILES: A little...

PANEL 5: Rio pointing to a different headline: "MORE IMMIGRANT CHILDREN DETAINED Protests planned Saturday"

RIO: This whole world's going crazy, Miles. Look at this. I see this and I think about if someone took you from me at that age...

PANEL 6: Miles and mom, looking out the window together, worried about the world.

RIO: People are afraid to bring their kids to the hospital. Afraid they'll be locked up. It's not right.

MILES: Feels like a lot isn't right these days, mom.

PAGE 10

PANEL 1: Brooklyn Bridge Park! Miles in semi-nice gear meeting up with Barbara, who's dressed in NYC-in-the-park-in-autumn cute clothes. She's with her little cousin Eduardo, who's 10. Early afternoon.

 BARBARA: Miles!

 MILES: Hey! Wow. You look...great.

 BARBARA: Uh, thanks.

PANEL 2: Barbara making intros.

 BARBARA: So this is Eduardo. He's here from Cali. He's ten but he thinks he's twenty.

 MILES: Mucho gusto, Eduardo, I'm Miles.

 EDUARDO: 'Sup.

PANEL 3: Miles is a nice guy! He and Eduardo walking ahead while Barbara looks on lovingly.

 MILES: I know it probably sucks getting stuck hanging with your cousin and her....uh, friend when you're here, but I promise you the ice cream at this spot will make up for it...

PANEL 4: They're all on the boardwalk at Brooklyn Bridge Park having ice cream. Eduardo's at the railing looking at the river/ships/bridges. Miles and Barbara are hanging back a bit speaking so Eduardo can't hear. (It's a little later in afternoon.)

 BARBARA: Poor kid. His father got deported last month. His mom is going through a whole situation trying to finally get them citizenship. He's been here since he was two.

PANEL 5: They're moving on to a new subject. Miles troubled.

 BARBARA: Anyway...not your problem. How've you been,

Miles? And what exactly is going on between us?

JOURNAL: I never have good answers for Barbara. Things would be easier if she knew I was Spider-Man...or maybe they'd be harder.

PAGE 11

PANEL 1: Miles swinging home, troubled. Early evening.

JOURNAL: Truth is, I'm confused.

PANEL 2: More swinging. Miles has noticed something below.

JOURNAL: Confused about Barbara. Confused about school.

PANEL 3: Miles is swinging over a long queue of homeless people leading out the door of a hardscrabble storefront church with a sign that says 'WARM MEALS.' Men, women, oldsters, and kids. Black, white, brown.

JOURNAL: Confused about the world....

PANEL 4: Close in on one person in the line--a little black girl, maybe 5, with braids wearing a threadbare fall jacket, holding her mom's hand. She's looking up at Miles, INTO him even, the only one who's spotted him. She's cute and sweet and already been dealt a losing hand in life and we feel for her.

JOURNAL: I'm Miles Morales, Spider-Man. And I've never been more sure of my power.

PANEL 5: Tight on Miles feeling like .

JOURNAL: But I've never been more confused about my responsibility.

PAGE 12

PANEL 1: Swinging home through Brooklyn. It's almost dark.

 MILES: Almost home! I can't wait to--

PANEL 2: Swinging, looking toward sound of alarm, annoyed.

SFX: BRRRRRRRRINNNNNNNNGGGGGGGGGG!!!!!!!

 MILES: A burglar alarm. Of course.

PANEL 3: Classic Spidey shot of Miles swinging over a robbery-in-progress--a hole blown in the wall of a tech lab. Four thieves, dressed in matching super villain henchman outfits (these should look simple but clearly 'super' and have masks--think the old Batman animated series). They're all kids, but we can't necessarily tell that from this shot. They're loading crates into a funky futuristic looking truck that matches their outfits.

 MILES: Well, this at least I understand.

PANEL 4: Big honkin' !!SPECTACULAR SPIDER-MAN!! action shot of Miles swooping down to land in the villains' midst.

 MILES: So I'm going to take a wild guess and assume that this stuff doesn't belong to you guys.

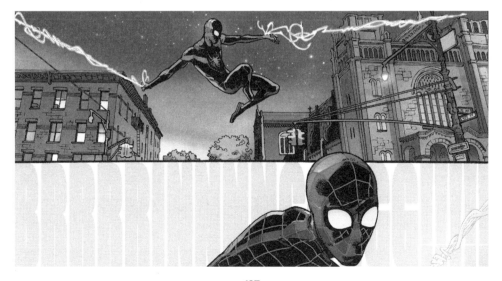

PAGE 13

PANEL 1: Miles facing off against 4 of the kids in masked costumes. No one's hitting anyone yet.

 MILES: Not talkative types? What the hell is up with you guys? You robots or something?

PANEL 2: Miles knocking one kid down as others close in on him, but this is still kid gloves (get it?) all around.

 MILES: Okay, this is creepy. Y'all are too quiet. Too passive.

PANEL 3: One of them is finally standing toe-to-toe in the light of a streetlamp so we really see these kids are even smaller than Miles, a high schooler.

 MILES: Too...small.

PANEL 4: SPIDER-SENSE!! Suppose we should talk about what this looks like?

 MILES: Spider-sense going nuts! But where--

PANEL 5: SOMETHING gray slamming into Miles at high speed, sending him flying.

SFX: WHAAAAM!

 MILES: unnnnh!

PANEL 6: Miles in a crumple, peeling himself from the wall of a brick building.

 MILES: [SMALL, HURT] what the...

 RHINO: Leave 'em alone, show-off!

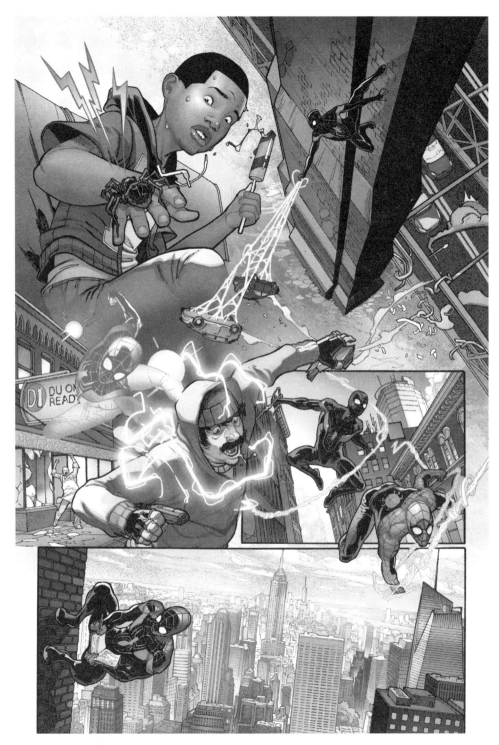

PAGE 14

PANEL 1: Splash: Rhino! I'd like the costume to look as classic as possible and our depiction to lean into the elasticity of Marvel ages to have him look as old as we can get away with--middle aged, I suppose. A prehistoric artifact of comics' Bronze Age that's somehow still walking around. He's craggy, weatherbeaten, world-worn, tired--but ALSO he's a MASSIVE, terrifying force of nature, an earthquake of a man.

> **RHINO:** Oh. It's you. That kid Spider-Man. Thought you was the other guy. Don't really matter, I guess.

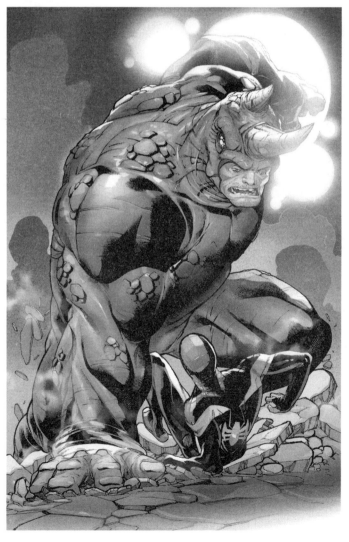

PAGE 15

PANEL 1: Miles getting back to feet

 MILES: The Rhino?

PANEL 2: Rhino worried about other things but ready to kick Spidey's ass if need be.

 RHINO: This is none of yer damn business, kid. Just go home and play Sega or whatever.

PANEL 3: Miles, smart-aleck body language.

 MILES: What's none of my business? And Sega?! Jeez, how old are you?

PANEL 4: Rhino starting to explain himself, but Miles isn't listening.

 RHINO: Look, twerp, I ain't done nothing wrong here, I'm just--

 MILES: Is this the part where you give me a speech rationalizing your crimes? Doesn't seem like your style, big man.

PANEL 5: Miles and Rhino leaping to attack each other

 RHINO: Ah, ferget it. You want to tussle? Fine.

 MILES: Tussle?! Seriously, how old are--

PAGE 16

PANEL 1: Rhino punching the ██████ out of Miles.

SFX: whomp!

PANEL 2: But Miles is fine and he's webbing up Rhino.

SFX: thwip

 RHINO: I seen you on the news a few times, kid. Trying to be like the real Spider-Man. But this ain't little league.

PANEL 3: Rhino breaking out of the webs like a beast!

PANEL 4: Rhino charging into Miles!

 RHINO: What gives, kid? You should be faster than this. The other guy is.

 MILES: yeeee-owww!

PANEL 5: Miles picking himself up. He's hurt but still GOING.

 MILES [SMALL]: just really tired okay

 RHINO: Couple more hits like that, kid, and you'll be paste. Go home, will ya?

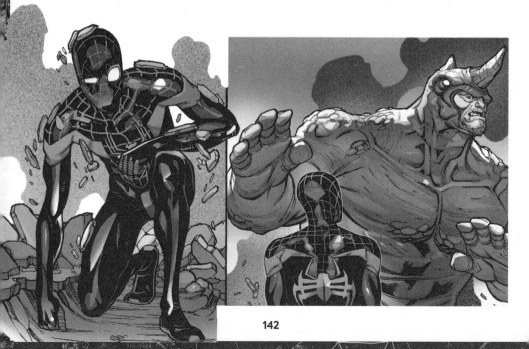

PAGE 17

A few more beats of MILES V. RHINO--this page will be silent [I
think you're going to want some Miles sass and jokes in this fight,
but we can always fill those in later] [OK--I figure we'll have
Javier draw the fight and then I'll drop a one-liner or two in.]
except for grunts/sfx, so the fight beats/layouts can be as you
wish, a place to play, but the essence is an even back-and forth
ending with Rhino absolutely cocooned in webbing.

[JAVIER! Let us know if you're cool driving here in the action
scene. If not, we'll break this down more.]

PAGE 18

PANEL 1: Rhino breaks out of webbing again!

 Sfx: RRRRIPPPP!

PANEL 2: Miles exasperated. Rhino's being incredibly patient.

 MILES: Are you serious!? I don't think my webbing can go
 any thicker than that!

 RHINO: Tough break, kid. I'll give ya one last chance
 to--

PANEL 3: Miles starting to go into camo mode, really ready to
fight now.

MILES: You're gonna make me use my super venom blast, aren't you? Do you know how tiring that is?

PANEL 4: Miles is camo'd now, Rhino looking around in vain.

RHINO: Super venom blast? How corny can you get? Hey! Where'd you go!?

PANEL 5: Miles SUPER VENOM BLASTING Rhino!!!!

MILES: Right here.

RHINO: ARRRRRRGHHHHHH!!!!

PAGE 19

PANEL 1: Miles, quite tired himself, standing over Rhino, who's recovering from the venom blast.

 MILES: call off ::huff:: the robbery ::puff:: Rhino...I can ::huff:: do this ::puff:: all day...

PANEL 2: Rhino getting to his feet. Not THAT hurt. He could keep fighting if this was to the death, but he's tired.

 RHINO: Yeah, yeah. You win, kid. But that robbery ain't my job.

PANEL 3: Miles confused. Rhino pointing.

 MILES: Huh?

 RHINO: I'm here lookin' for my niece. Someone snatched her, and those creeps were gonna lead me to her.

PANEL 4: The futuristic getaway vehicle, getting away.

 MILES: Wait, what?

 RHINO: They're gettin' away, sport.

PANEL 5: Miles thwips some webs toward the car...

 MILES: Like hell they are.

PANEL 6

Gunking up the car wheels with webbing--

NO DIALOGUE

PANEL 7: The vehicle has stopped, crashed into a storefront. The four masked operatives are out, with their hands up. One is in front of the others, and Miles is headed to meet him.

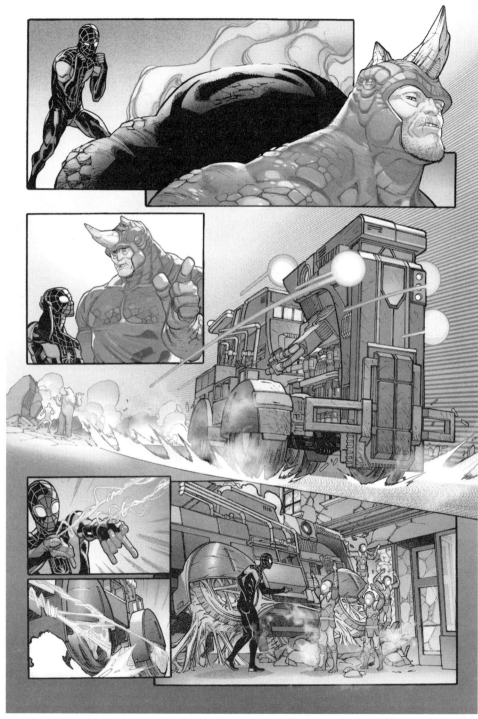

MILES: Surrendering? Smart. Finally something goes right.

PAGE 20

PANEL 1: Miles going to pull the mask off lead operative. Others are standing by passively. Rhino is trundling up.

MILES: Might as well take off these stupid--

PANEL 2: Reveal! It's Eduardo, Barbara's cousin, under the mask. His eyes are zombified, the whites or pupils of them displaying some visibly crazy effect from the Snatcher's mind-wiping.

MILES: E-Eduardo?

PANEL 3: Miles and Rhino's faces, visibly stunned.

MILES: What the hell is going on here?

RHINO: I don't know, kid, I swear!

PANEL 4: Eduardo, still dead-eyed, suddenly raising his hand to electrocute Miles and Rhino. Electro levels of power!

SFX: BZZZZZZZZZZZZZTTTTT!

MILES: Eduardo, what are you---AKKKKKKHHHH!

RHINO: UNNNHHHHHHHH!

PANEL 5: Miles watching Eduardo through swiftly dimming vision.

MILES: [small, weak] w-what...

PANEL 6: BLACK!

CAPTION: To be continued!

SPIDER-MAN

MILES MORALES: SPIDER-MAN

ISSUE #25

2021

"The Clone Saga"

By Saladin Ahmed

Art by Carmen Carnero and David Curiel

PAGE 1

PANEL 1: We're right at the end of last issue, with Miles looking at Rio's phone screen--displaying fake Miles kidnapping a scientist--in shock.

 JOURNAL: Nothing makes sense anymore, journal.

 RIO: It's all over the news, Papi!

PANEL 2: Rio and Jeff concerned, surrounding Miles with loving presence.

 RIO: We've been so worried about you.

 JEFF: They're saying Spider-Man kidnapped a scientist, robbed a warehouse--

PANEL 3: Miles baffled.

 MILES: What!? That's crazy! I never--

SFX: knock knock!

PAGE 2

PANEL 1: Rio going to open the door. Miles worried.

 MILES: Ma, careful!

 RIO: Relax, it's just--

PANEL 2: Ganke rushing in, looking a bit nervous. Miles happy to see him.

 MILES: Ganke! I've been texting you for days, man! Where'd you disappear to?

PANEL 3: Ganke's awkward and embarrassed.

 GANKE: Sorry, dude. But I came to talk to you about something important. Hi, parents.

PANEL 4: Miles showing Ganke the phone, Ganke looking at the clone image.

 MILES: Glad you're here, homie. But I saw it already.

 GANKE: "Spider-Man kidnaps scientist?!" What the heck?!

PANEL 5: Miles is confused now, Ganke playing it off.

 MILES: Wait, that's not why you're here? Then why did--

 GANKE: Later. This is more important.

PAGE 3

PANEL 1: Jeff looking at his own phone.

 JEFF: "Police have refused to name a suspect, but surveillance and cell phone footage has shown Spider-Man involved in an armored car robbery, a break-in at a scientific supply warehouse, and now the kidnapping of a prominent geneticist."

PANEL 2: Jeff showing Miles and Ganke a photo on his phone of the slumlord type Miles threatened last issue. He's complaining to reporters.

JEFF: Plus some real estate guy claims Spider-Man threatened him and vandalized his car!

<u>**PANEL 3:**</u> Miles sort of wincing as he admits his guilt to his Dad. 'Being honest when you know you'll get in trouble' energy.

MILES (small): Well, ahh, that last one might be true...

<u>**PANEL 4:**</u> Both parents are mad.

MILES AND JEFF AT SAME TIME: Excuse me?!

PAGE 4

PANEL 1: Miles moving quickly past that, desperate.

MILES: The rest wasn't me, though!

MILES: Someone's out there imitating me. Not just my costume but my powers.

PANEL 2: Close in on Miles thinking.

MILES: It's got to be that clone the Assessor grew. But I destroyed that thing!

ED NOTE: Miles may want to check out MMSM #19!--Nick!

PANEL 3: Ganke on his phone, going into problem-solving mode.

GANKE: Hmmm...Could be him. We need more info.

GANKE: Can I use your laptop? Be easier to do some digging.

PANEL 4: Miles and Ganke head out of the living room, up to Miles' room.

MILES: We're going to my room. Don't worry, I'll figure this out.

PANEL 5: Rio, worried, yelling after Miles. Jeff, worried, holding Billie.

RIO: "Don't worry" he says.

RIO: DON'T DO ANYTHING CRAZY, MILES!

PAGE 5

PANEL 1: Miles and Ganke trying to get to the bottom of things. Ganke is on Miles' laptop, Miles on his phone.

GANKE: So "you" robbed that laboratory and snagged that "OSCORP DNA SEQUENCER OS-40 SPECIFICATIONS" thing.

MILES: Then I stole that stuff from Dr. Alok Gupta having to do with whatever "Rapid Peptide Synthesis" is.

PANEL 2: Ganke reading as he speaks. Miles perplexed.

GANKE: Whatever this is, it definitely has to do with cloning.

MILES: I knew it! But this doesn't make sense.

MILES: Uncle Aaron called that clone a burner. Disposable. Even if it survived me smashing its head in, it should be dead by now.

PANEL 3: Ganke and Miles putting their heads together (figuratively). Ganke typing, Miles pacing. Let's make sure to see Ganke's phone on Miles's bed (or somewhere out of Ganke's reach), as it will ring in a few panels.

GANKE: Maybe that creepy Assessor guy you told me about grew a new one.

MILES: Hmmm. That dude's MEGA corporate. Why would he need to break into a warehouse?

GANKE: I...don't know.

PANEL 4: Something's popped up on Ganke's screen and he's pleased.

GANKE: Oooh! But I do know that this scientist they kidnapped won't be any use to them without some of the proprietary tech he helped develop.

PANEL 5: Ganke with a finger up, devilish smile, like 'We got 'im!'

GANKE: That tells us where he'll go next.

PANEL 6: Ganke typing. Miles changing into his spider-suit. Ganke's phone buzzing.

GANKE: Sending you an address now. The biotech startup I think he'll hit.

MILES: You're the best, bruh. I--

SFX: BZZZT! BZZT!

PAGE 6

PANEL 1: Miles starting to hand Ganke his phone...

 MILES: Yo, you have a message--

PANEL 2: Miles stops. holding Ganke's phone, squinting at it a bit disbelievingly. Ganke's suddenly excruciatingly uncomfortable.

 MILES: --from Barbara?

 GANKE (SMALL): Oh boy.

PANEL 3: Close in on Miles. He still has the phone. Something painful is dawning on him.

 MILES: That's...a lot of kiss emojis.

PANEL 4: Tight on Ganke, MISERABLE, explaining. These next few panels we don't see Miles.

 GANKE: That's what I came to tell you--what I tried to tell you back when that symbiote dragon attacked...*

 CAPTION: Back in #23--Notable Nick.

PANEL 5: Ganke more mortified.

 GANKE: Barbara and I...We're sort of...

PANEL 6: Ganke beyond mortified, feeling like the lowest worm on earth.

 GANKE (small): ...together now

<u>PAGE 7</u>

PANEL 1: Now we finally see Miles' reaction. He's WOUNDED.

 MILES: This is why you've been dodging me.

PANEL 2: The pain instantly converted to anger. MILES GRABS GANKE BY THE SHIRT FRONT! This is a big ugly moment for these two usually-sweeties, so let's give this center panel lots of space.

 MILES: I CAN'T BELIEVE YOU--

PANEL 3: Ganke, tough as hell even though he's facing Spider-Man. Angry. Big 'you crossed the line' energy.

 GANKE (small, angry): Get your hands off me.

PAGE 8

PANEL 1: Panel of Miles letting go of Ganke's shirt. Looking horrified at himself.

 MILES: I...I...

PANEL 2: Miles at the open window, pulling his mask on.

 MILES: I got to go.

 MILES: Explain to my folks, okay?

PANEL 3: Ganke watching out the window as his best friend who now hates him swings away.

 GANKE (small, weak): yeah.

PANEL 4: Ganke feels like trash. Collapsed on Miles' bed. Lonely and empty.

 GANKE (small, defeated): okay.

PAGE 9

PANEL 1: Big painful panels of Miles swinging through Brooklyn at night. He looks *disgusted* with himself.

 JOURNAL: I lost it, journal. I had no right to be that mad.

PANEL 2: As above.

 JOURNAL: Me and Barbara broke up months ago. And Ganke's my best friend.

 JOURNAL: I can't believe I put my hands on him. What's wrong with me? Was I really going to hit him?

PANEL 3: Very close in now on Miles, agonized, worrying for his immortal soul as it were.

 JOURNAL: All this fighting I do--is it making me a bad person?

PAGE 10

PANEL 1: Miles on a rooftop looking at a gleaming office skyscraper.

 MILES: That's the place.

PANEL 2: Miles, in stealth mode, crawling on the building's side.

 MILES: Be able to get inside easier if I'm cloaked....

 MILES: Need to find an open--

PANEL 3: Miles crawling around the side of the building--a big picture window has been blown out violently!

 MILES: --window.

PANEL 4: We're inside the building now, a slick laboratory space. Miles is just about inside, having crawled through the blown-open window. He's still cloaked. The place has been TRASHED.

 MILES: Looks like I'm too late.

 (CONT.)

(CONT. from last page)

PANEL 5: In the corner of the room, one scientist in a lab coat is standing over another one who's been lightly wounded (a knife wound). Let's make them different races and genders please. We have the sense that Miles is arriving moments after the lab was attacked. He's decloaking to talk to the scientists.

MILES: Hi! Are you hurt?

PANEL 6: The scientists are SCARED of Miles. Terrified. Miles trying to reassure them.

WOUNDED SCIENTIST: Aaaaaa! He's back! Don't let him cut me again!

SCIENTIST #2: We told you everything! You have the files! Please just leave us alone!

MILES: But I'm not--

PANEL 7: Miles' Spider-Sense goes off. He's turning toward a threat on his flank.

PETER (unseen): Sheesh, nobody listens to scientists anymore. They said--

PAGE 11

PANEL 1: PETER flies at Miles, punching him! The scientists are stunned watching two Spider-Men fight.

PETER: Leave them alone!

SFX: WHAM!

MILES: unh!

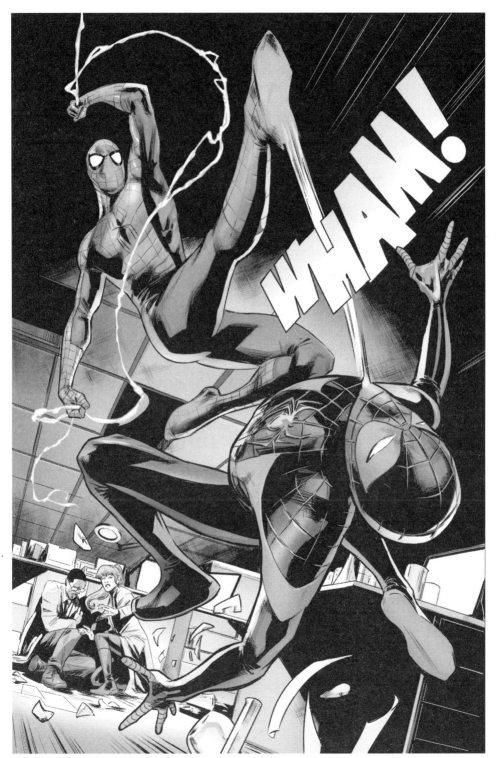

PAGE 12

PANEL 1: Peter pressing the attack. Grabbing Miles in an echo of Miles grabbing Ganke earlier. He thinks this is an impostor who's hurt his adoptive kid brother.

 MILES: Pe--er, Spider-Man?

 PETER: What have you done with Mi--with the real Spider-Man?!

PANEL 2: Miles slipping out of Peter's grip.

 MILES: Yo, I am the real Spider-Man!

SFX: THWIP

 MILES: I mean, the real Brooklyn Spider-Man.

PANEL 3: The two of them tangling amid the ruined lab, the wounded scientist behind them illustrating Pete's point.

 PETER: No way. The guy I know would never do this.

PANEL 4: Miles dodging a web shot.

SFX: THWIP

 MILES: I didn't do this! I'm being framed!

SFX: THWIP

PANEL 5: The hurt scientist screaming desperately.

 SCIENTIST: Don't listen to him, he nearly killed me!

PAGE 13

PANEL 1: Peter trying again to web up Miles, but Miles is cloaking as he dodges.

 PETER: Let's just all calm down and talk about--Hey!

 PETER (muttering): Stupid camouflage powers.

PANEL 2: Peter throwing a wild punch. Miles, even invisible, barely dodges.

> **MILES:** Dude! How did you get that close when you can't even see me?

> **PETER:** Experience, buddy. No substitute for it.

PANEL 3: SILENT. Miles has managed to sneak up behind Pete, his venom fist charging. Pete's Spider-Sense is flaring, but it's too late.

PANEL 4: Miles zapping Peter (lightly).

> **MILES:** Cool, cool. But I can do this!

SFX: bzzzzzzzt!

PANEL 5: Peter's only lightly singed. They're facing off.

> **MILES:** Sorry, Spider-Man. Tried to take it easy. You're like my big brother, but I don't have time for this.

> **MILES:** That fake is out there and I can't let him hurt more people while we're messing around here.

> **PETER (a little weak):** Now that sounds like Spider-Man.

> **PETER (small):** Wherever the heck you are...

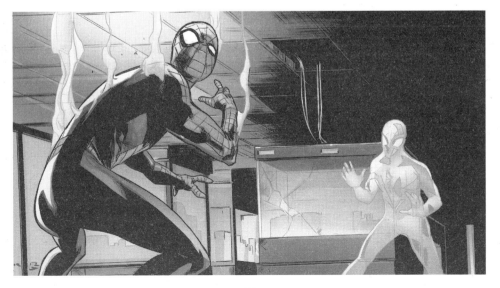

PAGE 14

PANEL 1: Again, sort of facing off as Pete actually listens.

 PETER: Is...is that really you?

PANEL 2: Miles, decloaking, exasperated.

 MILES: Man, I still have the crappy birthday card you bought me the last time someone was attacking labs in Brooklyn.*

 MILES: When you ruined my desk!

 MILES (small): Mom is still salty about that, by the way.

 CAPTION: [ED NOTE MMSM 10]

PANEL 3: Recognition dawns on Pete.

 PETER: Spider-Man!

 PETER (small): Please tell your mom I'm sorry.

PANEL 4: Pete explaining.

 PETE: When I saw there was someone in a Spider-Man suit committing crimes in Brooklyn I had to come investigate.

 PETE: I thought you were the impostor.

PAGE 15

PANEL 1: The unwounded scientist breaking in here. Bandaging wounded's arm (or whatever) with a first aid kit as they speak.

 SCIENTIST 2: If you guys really aren't with that other Spider-Man, you need to stop him. He was scary.

 MILES: First, we've got to get you guys some medical attention.

PANEL 2: Wounded scientists toughing up here.

 WOUNDED: I'll--ow!--I'll be okay. EMTs are on the way.

 WOUNDED: But if that guy with the knives is threatening

scientists, you've got to stop him.

PANEL 3: Miles a bit spooked.

MILES: Knives?

PANEL 4: Peter at the window, hurrying Miles.

PETER: C'mon, Spider-Man. Let's see if we can pick up the trail.

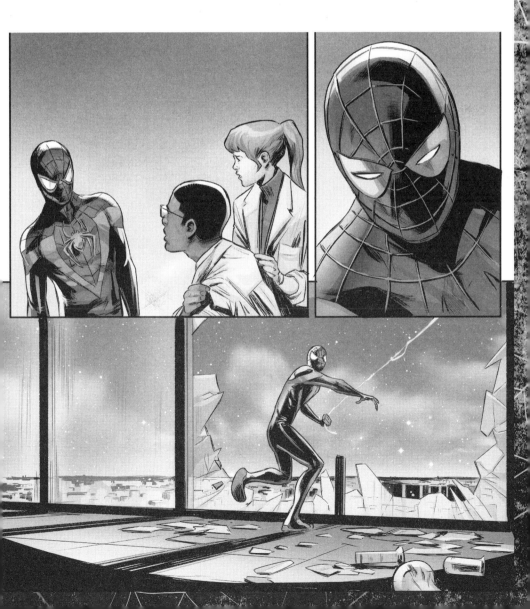

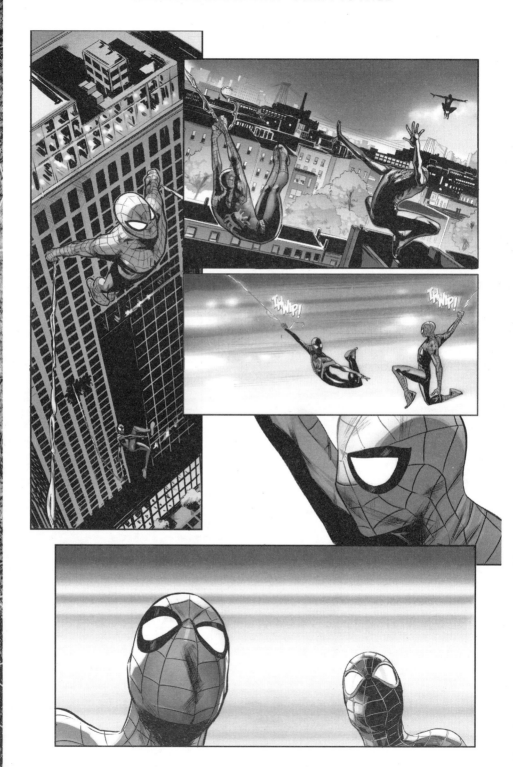

PAGE 16

PANEL 1: Miles and Pete swinging away from the building. Miles is pointing furiously. This chase and fight scene over these next few pages are happening amid the rooftops of Williamsburg, so other than the building they just exited, the buildings should be 3-6 stories, not skyscrapers.

> **PETER:** There's got to be somewhere we can--

> **MILES:** Look!

PANEL 2: In the distance, they can just barely see a figure jumping impossibly between rooftops, or maybe web-slinging between buildings.

> **PETER:** That's our guy.

> **PETER:** Any idea who he is? Did I miss an announcement about a new Spider-Person? You know how those newsletters pile up in your inbox...

PANEL 3: They're swinging or roof-leaping, chasing the speck in the distance, trying to close in. Miles, troubled, recalling something scary.

> **MILES:** You remember I told you about getting snatched off the street? About the Assessor and...and what he did to me?

> **MILES:** Well, he used that...research to grow a clone.

PANEL 4: Now tight in on Peter remembering something scary.

> **PETER:** Oh boy. Clones are bad news, take it from a guy who--

PANEL 5: Peter and Miles both suddenly stopping on a rooftop as their Spidey-Sense goes off. Let's make this roof plenty big for a fight scene and make sure there's an electric shed or rooftop AC unit or some such that they can web Gloopy to later.

> **GLOOPY (let's give him weird gross balloons):** STAWA!

> **MILES AND PETER:** What the--

PAGE 17

PANEL 1: A big reveal panel of Gloopy! His mask's off and he MOSTLY looks like Miles in the face here, but is melty/oozy in places so we clearly see this is something scary. He'd have snuck up behind our Spider-Men if not for their Spider-Sense.

GLOOPY: STAWA!

MILES: How'd he get behind us?

PANEL 2: Miles looks MAD, but Pete is trying to reach out.

PETER: Uh, excuse me, sir, but you seem to have something on your--

PANEL 3: Gloopy punches at Pete, Pete dodges.

PETER: Never mind.

PAGE 18

PANEL 1: This is a sort of reveal of Gloopy's 'slime elasticity'--even though Peter dodged the blow, Gloopy's arm twists and splits impossibly to grab him.

PETER: Whoa!

MILES: How can he do that? I can't do that!

PANEL 2: Pete fighting his way out of Gloopy's grip.

PETE (struggling but still sunny): Now you know how I felt---oof!--when I found out you can shoot lightning!

PANELS 3-5: A few panels of Miles and Pete fighting Gloopy--Gloopy evasive, morphing his body around to avoid blows, Miles and Pete frustrated.

SFX: THWIP

PETE: Unh!

MILES: Man, stand still and fight!

GLOOPY: STAWA!

PAGE 19

PANEL 1: Miles charging up his Venom-Blast.

 MILES: Forget this. I got something that'll make you sit still.

PANEL 2: Miles Venom-Punches gloopy right in the bread basket, unloading bioelectricity.

SFX: bzzzzzzzzzt!

PANEL 3: ...Gloopy, completely unfazed, grows an arm out of his chest to grab Miles.

 MILES: Ahhh! He's shock-proof, too?

PANEL 4: Pete webbing Gloopy, who's still wrangling with Miles, from behind.

SFX: thwip! thwip!

 PETE: I've got him!

PANEL 5: Pete has pulled Gloopy off Miles and they are both webbing him up very tightly.

 MILES: More webs! If we can make the weave tight enough he won't be able to gloop his way out of it!

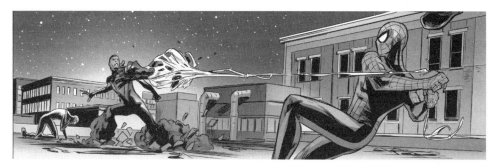

PAGE 20

PANEL 1: Gloopy has been bagged up, in a tight cocoon of webbing. Still on his feet, webbed to some small rooftop structure. His face here is only half-formed--some Miles features but mostly a gross not-face.

> **PETE:** Awww he looks so cute, all snuggled up for bedtime!

> **MILES:** This isn't funny, man.

PANEL 2: Now Gloopy shifts his face INTO A FLAWLESS IMITATION OF MILES! He looks crazed. Miles is PISSED.

> **GLOOPY:** LAGO! LAGO!

> **MILES (small, dangerous):** No.

PANEL 3: Miles turning all his anger on Gloopy, grabbing him. Gloopy's perfect Miles face is slipping now.

> **MILES:** No more.

PANEL 4: Miles, angry. This monster before him represents days of torture and months of pain Miles has lived through. We're pretty sure he's about to hit Gloopy.

> **MILES:** No more wearing my face. No more putting dirt on my name. You're gonna help me clear this up, or I swear to God--

PANEL 5: Peter, holding Miles' arm back.

> **PETER:** Whoa, whoa, Spider-Man! We don't hit people---or slime clones---who are tied up!

> **PETER:** Let's just stay calm and--

PANEL 6: The two Spider-Men are arguing now. Gloopy is out of this panel.

> **MILES:** You stay calm! You don't know what it's like to have your face stolen!

> **PETE:** Actually, I--

PANEL 7: Both Spider-Men's Spider-Sense going off as Gloopy starts to crackle with Venom-Blast energy (maybe his is a diff color from Miles'?)! He's not using his hands, the field is just building up around him.

SFX: bzzzz

 MILES: Look out!

PAGE 21

PANEL 1: Gloopy blasting Miles and Peter with a big Venom-Explosion!

 sfx: BZZZZZZTTT!

 PETE: ARRRRRGHHH!

 MILES: AAAAAA!

PANEL 2: Smoke rising on the rooftop. Pete is nearly KOed. Miles is just on his knees, hurt---the blast hasn't hurt him nearly as much. Gloopy is sort of simultaneously ripping away webbing and oozing through the rips to escape.

SFX: RRRIP!

SFX: THWUP

 GLOOPY: GOHO!

PANEL 3: Gloopy already airborne, web-slinging off. Miles helping Pete to his feet. Pete's pretty rough.

MILES: You okay, Spider-Man? Guess that didn't hit me as hard since I have bioelectric powers, too.

PETE (small, weak): S-so not fair.

<u>PANEL 4:</u> Pete trying to get to his feet, can't quite.

PETE (still weak): We n-need to go a-after....

<u>PANEL 5:</u> A silent panel of Miles thinking, finding the resolve to handle his own problems. He's looking at Pete, who's still wincing.

NO DIALOGUE

<u>PANEL 6:</u> Miles stepping up, looking bold and sure.

MILES: No, Pete. You're hurt. And besides---this is my fight. I...I think I need to handle it by myself.

MILES: Go home, man. I got this.

<u>PANEL 7:</u> Miles swinging off, relentless. Pete still trying to get to his feet.

PETE (weak): N-not gonna get rid of me that easy...

PETE (weak): J-just need a minute...

PAGE 22

PANEL 1: Miles swinging over a diverse Brooklyn crowd scene, folks on the ground pointing off panel in horror at something that's just passed.

 MILES: From all that shouting, sounds like he went this way.

PANEL 2: Miles on a rooftop.

 MILES: Gotta be somewhere around--

PANEL 3: Miles dodges a gloopy-looking punch that comes from out of nowhere as his Spider-Sense goes off.

 MILES: Ha! Too fast for--

PAGE 23

PANEL 1: Miles clutches his head from a psychic blast.

 MILES: AAAAGHHHH! Inside my skull! What--

PANEL 2: Now he's hit by a gloopy fist.

 MILES: Unh!

SFX: KRUMP

PANEL 3: And slashed by one of Selim's daggers!

SFX: SLICH

 MILES: Arrgh!

PANEL 4: Miles, momentarily stunned, looking toward an off-panel speaker.

 SELIM: I think we've softened him up enough, brothers.

 MILES (weak): W-who?

PAGE 24-25

PANEL 1: Big reveal of the clones. A huge, muscular, kinetic double page spread--big action poses. Pure super hero comics. Variant cover energy.

Gloopy on the left, in a fluid form, halfway between a Miles replica and a pile of goo.

Miles-Spider on the right looking cold and alien and deadly. Maybe some hint at his psionic powers?

And in the center, Selim. He has his mask off. Handsome, dashing, arrogant, cruel, vicious. Holding a dagger dripping with Miles' blood.

 SELIM: Name's Selim.

 SELIM: You and I have some things to discuss.

 NEXT ISSUE: BLOOD BROTHERS

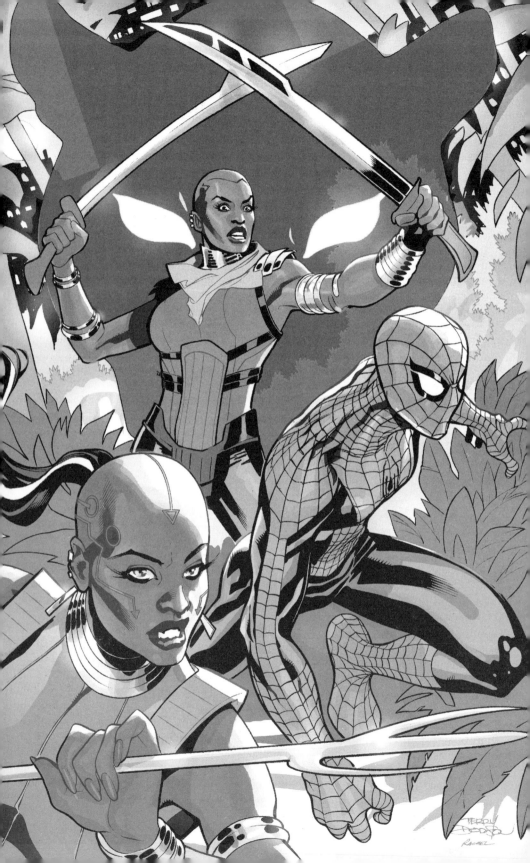

AMAZING SPIDER-MAN: WAKANDA FOREVER (2018) BY NNEDI OKORAFOR

AN INTRODUCTION BY **WIL MOSS**
IN CONVERSATION WITH **ANDREW SUMNER**

Wakanda Forever is a three-part series in which the Dora Milaje [Wakanda's special forces, an elite group of highly skilled female warriors] must take care of one of their own who's gone bad and turned rogue. And this leads to the Dora Milaje having to venture out of Wakanda and travel to all different parts of the Marvel Comics Universe—and the first hero they encounter is Peter Parker, Spider-Man himself. It's a really great story that brings the Dora Milaje center stage, capitalizes on their popularity from the Black Panther movie, and allows them to interact with years of established Marvel Comics history. Star writer Nnedi Okorafor achieved all of that and, with artist Alberto Jiménez Albuquerque, crafted a fun story that fans really liked and still respond to.

Amazing Spider-Man: Wakanda Forever came about because Black Panther was having a major pop culture moment—the movie was a massive hit and [celebrated writer] Ta-Nehisi Coates had launched his primary Black Panther comic book series, which had been super-well received. There was a lot of interest in Black Panther at the time, and we decided that it'd be great to shine a spotlight on the Dora Milaje characters created by writer Christopher Priest. And so that's how the three-issue Wakanda Forever miniseries came about—in each book, the Dora Milaje had to interact with a lot of different Marvel heroes: Spider-Man co-starred in issue one, the X-Men in issue two, and the Avengers in issue three.

Nnedi Okorafor is a phenomenally talented writer and, by the time we selected her for this, she'd already written another short Black Panther project—we liked that enough to know that we wanted to try her on this too. This eventually led to her also writing her Shuri mini-series, The Search for Black Panther [discussed in Titan Books' Black Panther: Script to Page].

Working with Nnedi was a really positive experience—she had to juggle a lot of elements because there were so many different continuity aspects to pick up on. We centered the mission and the main thread of the story on Nakia, who is T'Challa's love interest in the movie—but in the comics, it's way more complicated. When writer Christopher Priest introduced Nakia into the *Black Panther* mythology, he had her almost immediately go bad, so there's always been a disconnect there between the movie and the comics. We wanted to do something with Nakia as a character, but to acknowledge where she was within the Marvel Comics Universe. Nnedi came in and was able to pick up all those pieces for *Wakanda Forever*.

Nnedi excelled at jumping straight in and getting the lay of the land straight away. She built a fun story that was totally character-driven, and made the most of the opportunity to have the Dora Milaje interact with all these different Marvel characters. Seeing that interaction and reading the way Nnedi laid out the story was such a lot of fun.

Spider-Man himself always has a very specific voice, and it's tough to nail for some writers, but I think Nnedi did a great job of finding Peter Parker's Spider-Man voice—both the sarcastic humor side of Spidey, and the guy who takes responsibility very seriously. That sarcasm provided a nice bit of friction between Spider-Man and the Dora Milaje, but the key to Nnedi making them work so well together is that they are all super-dedicated to their jobs; it just takes the Dora Milaje a while to see that in Spidey.

Nnedi also had a lot of fun with using Hydro-Man as the villain in this story, trapping Spider-Man and the Dora Milaje in an underground facility that's also underwater, so it gets flooded in there and they're screwed! Nnedi had some really creative uses for the heroes' powers, and how they could defeat Hydro-Man.

The artist Nnedi worked with on this book, Alberto Jiménez Albuquerque, brought a lot to the story. I remember he had a great interpretation of Nakia, because she's not just supposed to be angry, she's becoming more and more crazy; and the climax of Nnedi's story essentially deals with Nakia losing it. She dies at the end of the story and, as it progresses, she looks worse and worse. Alberto did a great job of really making her look kind of unsettling and unhealthy, and he did a really nice job in understanding the tone of Nnedi's script. He didn't cut any corners in the detail—it really helps when an issue opens on a New York sidewalk within a New York block, and you see a bunch of pedestrian kids hanging around brownstones. Alberto really makes you feel that that's where you are, of capturing all the environments presented in the story.

Nnedi's script for *Amazing Spider-Man: Wakanda Forever* was filled with detail—lots of depth, lots of detailed reference. That's always so helpful for editors and artists, providing a strong degree of evocative clarity. And Nnedi's not the kind of writer who'll demand that if a visual reference is attached to the script, her reference always has to end up on the page—she's not precious about those extra details she puts in there. It's information that's there to be helpful to the artist, which is great. I think all artists appreciate having more reference at their disposal, while retaining the freedom to interpret the writer's page as they see fit. Nnedi lists a lot of specifics, and she provides her examples right there in the script, so her scripts are usually large files, but it's all incredibly helpful stuff.

The *Amazing Spider-Man: Wakanda Forever* script you can read here was very detailed, highly creative, and beautifully thought through.

SPIDER-MAN

AMAZING SPIDER-MAN:
WAKANDA FOREVER
ISSUE #1
2018

"A Strange Little Birdie"

By Nnedi Okorafor

Art by Alberto Albuquerque
and Erick Arciniega

Author's Note: Please make sure that Hydro-Man's eyes are green until the moment Okoye freezes him. From that point on they are blue, his normal eye color.

PAGE ONE

PANEL 1 (ROW 1):

Ariel view of Bed-Stuy neighborhood. It's a warm, sunny spring day. Some of the trees are in bloom and there are pigeons flying by. In the distance below, we can see some teens (about six) walking down the street, on their way home from school. Cars pass by on the street. And in the sky, a tiny puff of cloud (about the size of a motorcycle) hovers. There are a few other small clouds in the otherwise clear blue sky, but none moving with intent as this one is.

CAPTION/OKOYE: We Dora Milaje have always had secrets. Even after leaving the throne and making the Jabari-Lands our home. And we remain tight. We remain closed.

PANEL 2 (ROW 2):

We follow the tiny cloud down toward the block where the group of kids are walking. The point of view is from above the cloud, and we are just above the area between the tops of two tall brownstones.

CAPTION/OKOYE: But years ago, one of our own abandoned her duty and took secrets with her. Any African elder will tell you this: "Community rules. As an individual, one is dangerous." This is especially true for Dora Milaje.

PANEL 3 (ROW 3):

The cloud has swiftly descended to the sidewalk and is floating along. The point of view is from behind, but just under the clouds we can see the fluff from the tip of the cloud a bit, but mainly we see the kids (all of them are black, 4 boys, 2 girls) walking with their backpacks in a group. Boy3 is turned around staring at us/ the cloud with a shocked look on his face. There is a car passing on the road and there's a man coming up the sidewalk, though he's somewhat a distance away (he's also black). The panel should seem quietly menacing. Why the heck is a cloud stalking these kids?

CAPTION/OKOYE: We should have dealt with Nakia, the one known to many as Malice, long ago.

DIALOGUE/GIRL1: I'm so sick of this homework.

DIALOGUE/BOY1: I know. I've got a track meet tomorrow.

DIALOGUE/GIRL2: Told you. That's why I finished it yesterday. And I'm still going to win my heat in the 400M.

DIALOGUE/BOY2: Shut up, Kela.

DIALOGUE/BOY3: What the heck is that?

PAGE TWO

PANEL 1 (ROW 1)

The point of view is from above. The cloud is hovering before the kids, at their level. We get a good view of the proximity and size of the cloud compared to the kids. We also see that the cloud is now attracting a crowd of kids as more arrive.

The cloud is getting surrounded, but the initial kids who first spotted it are the focus. The kids are standing on the sidewalk and in the grass, and they are all now staring at the car-sized cloud. The man across the street has stopped to stare, too. From afar, there are more kids (some high schoolers, others younger, mostly black, all people of color...this is Bed-Stuy, NYC). They've all brought up their cell phones like shields.

To their left, a car has stopped on the road and its driver is looking out an open passenger window to see, his lips in an "o" shape. The driver is white and wearing a suit. He's holding up a cell phone, too.

DIALOGUE/GIRL1: What in the world?

DIALOGUE/GIRL2: Maybe it's from one of them chemtrails.

DIALOGUE/BOY1: Damani, run up on it!

DIALOGUE/BOY2: Hell no. You run up on it!

DIALOGUE/BOY3: I just saw it come from the sky. Like an alien or something.

PANEL 2 (ROW 2)

The point of view pulls back to show everyone. The cloud is surrounded by curious cell-phone-wielding teens. Most are still holding up phones, recording. Some are calling people, white headphones in their ears. Girl1 (the one who said "What in the world") is the only one brave enough to step to the cloud. Her eyes are wide and she is holding up a hand.

Two cars are in the road now, both stopped. One is beeping angrily for the other to move. The man in the suit in the car is still holding up a cell phone and ignoring the woman behind him beeping. The focus of the panel is on the girl with her fist inside the cloud.

In the shadows, between two brownstones to the left of the cloud and kids (away from the street) we can see Nakia/Malice. She looks very problematic. Her waist is grotesquely pencil-thin, her hips wide, her breasts Barbie-like, her big circular eyes plate-sized, her lips exaggerated, her hair is a huge Afro. She looks a LOT like a black Betty Boop. This is a sick woman suffering from progressed side-effects of using the Jufeiro herb, an herb she's been using all these years to manipulate men. She's dying. She's holding what looks like a talking drum under her arm and dressed in a gorgeous ankara printed pantsuit.

It has wires and panels embedded into its exterior (though it still clearly looks like a drum). The center of the talking drum (the place where it gets narrowest) is glowing purple (active vibranium is in there).

In her right hand, she holds the drumstick for the talking drum. She's detailed, but the way the panel is drawn, one's eye does not really notice her.

DIALOGUE/GIRL1: I'm gonna touch it!

DIALOGUE/GIRL2: Tamara, don't!

PANEL 3 (ROW 3)

Close on GIRL1 who has her fist in the cloud. She looks fascinated, not scared.

 DIALOGUE/GIRL1: It's...kinda warm. But it doesn't feel like it's anything. Just air.

PANEL 4 (ROW 3)

The point of view shifts to focus on Nakia/Malice, though in terms of distance it stays close to the cloud and the kids, Girl1 still playing around in the cloud. Everything is blurred except Nakia (let's just called her Nakia from now on. This is what the Dora Milaje know her as). She's about to hit the drum with the stick. Nakia's eyes are wide and she's excitedly grinning. We see clearly how messed up she looks.

 DIALOGUE/NAKIA: Yes! All of you get closer, just a little closer. What could a harmless cloud ever do to you?

PAGE THREE

PANEL 1 (ROW 1)

Close on Nakia as she hits the drum hard with the stick. Nakia's eyes are wide and she shouts as she hits it. There are purple waves blasting from the spot on the drum skin that she hits. There's a burst of purple light from the narrow portion of the drum.

 DIALOGUE/NAKIA: HA!

SFX: POOM!

PANEL 2 (ROW 1)

Pull back to show the vibration traveling over the kids to strike the cloud. Some of the kids are looking around, scared. Girl1 still has her hand in the cloud. The man in the car no longer has his cell phone up. He is looking with a frown at Nakia. Some of the kids are closing their ears. Nakia looks VERY delighted with herself as she watches. Boy3 (the smartest, most observant kid in the group) is already running off.

 DIALOGUE/GIRL2: What was that?!

 DIALOGUE/GIRL1: You feel that?!

PANEL 3 (ROW 2)

Close on Girl1 as she struggles to remove her hand from a now more solid-looking cloud.

 DIALOGUE/GIRL1: I can't get my arm out! Kela, help me! Oh my God!

PANEL 4 (ROW 2)

Point of view pulls back and we see the cloud solidifying and rippling. GIRL1 is still trying to pull her arm out, but now she's in all the way to her shoulder. GIRL2 is trying to pull her out. The other kids are stumbling back, still confused and shocked. The car is speeding off.

SFX: Blug Blug Blug Squelch!

PANEL 5 (ROW 3)

Close on Nakia standing between the brownstones grinning, holding the talking drum.

 DIALOGUE/NAKIA: My King T'Challa, you'll come when you hear about this. Then we can talk.

PAGE FOUR

This is a detailed, horrifying splash page. Pull back to show the entire section of the neighborhood. Nakia is standing between the brownstones in the shadows, though we can clearly see her looking on. The cloud has solidified into a huge ball of goop shooting out extensions of itself at all the children as they flee screaming and yelling. Some of the teens are being pulled toward the blob by the sticky extensions. It's like a giant white amoeba. Girl1 is swallowed to the waist by the goopy monster, her friend still trying to pull her out by her arms. On top of one of the brownstones on the other side of the street Spider-Man has just arrived, but he's not noticeable in the panel.

 DIALOGUE/GIRL1: It's going to swallow me!

 DIALOGUE/GIRL2: No it's not! I won't let it!

SFX (each time it hits and sticks to a kid): Slap!

PAGE FIVE

PANEL 1 (ROW 1)

Close on Spider-Man as he dramatically swoops down on a line of webbing to land on top a parked car nearby. The amoeba thing is pulling kids toward it while expanding.

> **DIALOGUE/SPIDER-MAN:** A giant killer amoeba, last thing you want to deal with after a long day of school.

PANEL 2 (ROW 2)

Standing on a car, Spider-Man shoots a web at two teens being pulled toward the amoeba.

> **DIALOGUE/SPIDER-MAN:** Looks like some kid made a lethal batch of slime. What people will do for their Instagram page.

PANEL 3 (ROW 2)

One of the kids Spider-Man saved is running from the gooey amoeba thing as Spider-Man is still pulling out the second. Two other teens are, in turn, being pulled to it. Girl2 is still trying to pull Girl1 out of the goo. Spider-Man is clearly fighting a losing battle.

> **DIALOGUE/SPIDER-MAN:** No fair! I only have two arms!

PANEL 4 (ROW 3)

Spider-Man shoots a web at a streetlight.

PANEL 5 (ROW 3)

Spider-Man swings from the streetlight over the gooey monster as he shoots webbing at the two kids who'd just been pulled in. Girl2 is still trying to pull Girl1 out.

PAGE SIX

PANEL 1 (ROW 1)

Spider-Man is hit with an arm of goo as the two kids he just pulled out flee. Girl1 is still stuck and almost swallowed by the goo and Girl2 is now stuck, too. From between two of the brownstones, Nakia is watching.

DIALOGUE/SPIDER-MAN: I hate my life.

PANEL 2 (ROW 2)

This is the same scene as PANEL 1, but from a different point of view. This one focuses on Nakia standing between the brownstones, to the left of the panel, grinning.

Across the street, past the trouble with the cloud turned amoeba-like goo that's slapping Spider-Man around and swallowing children, a Wakandan troop ship is coming out of stealth mode as it lands on the roof of another brownstone.

PANEL 3 (ROW 3)

Close on Nakia standing in the shadow between the brownstones.

DIALOGUE/NAKIA: Finally, my King T'Challa has come to see me.

PANEL 4 (ROW 4)

Close on the troop ship door opening.

PAGE SEVEN

This is a very dramatic splash page. Okoye is flying out of the troop ship door, spear in hand, teeth bared, eyes wide. Behind her, we can glimpse Aneka and Ayo standing behind her in the troop ship.

PAGE EIGHT

PANEL 1 (ROW 1)

The point of view is from behind Okoye as she throws the spear at Nakia. Nakia is in the distance looking up at her. In the street there is still chaos as Spider-Man (plus other kids) is pulled into the amoeba thing.

PANEL 2 (ROW 2)

Close on Nakia's terrified (strange) face as the spear lands right beside her. We really see her big eyes and strange body here. And we also see that her dark skin is crumbling.

PANEL 3 (ROW 3)

A shockwave explodes from the spear embedded in the dirt. Nakia is being blown off her feet, the drum she was carrying is also flying from her hands.

SFX: BOOM!

PAGE NINE

PANEL 1 (ROW 1)

The point of view is pulled back. The point of view is from the side, so we can clearly see Okoye's intense angry face as she points another spear at Nakia (make sure this spear looks different from the one she threw). We can see two more spears on the wall inside the troopship. Aneka and Ayo are below dealing with the goo monster. Aneka is pulling Girl2 out of the goo, Girl1 is holding on to Girl2 and thus also getting pulled out. Ayo is cutting the goo with her spear to free Spider-Man. Nakia looks angry as hell and the look makes her face even more grotesque.

DIALOGUE/OKOYE: Nakia!!

DIALOGUE/NAKIA: <Nakia is dead! I am MALICE!>*

*Spoken in Hausa, a West African language and the chosen secret language of the Dora Milaje

PANEL 2 (ROW 2)

The point of view is from behind Okoye as she shouts down at Nakia and Ayo shouts up at her. Aneka is dodging an arm of goo. Ayo is

holding on to Spider-Man as he pulls them up on a cord of web attached to the light pole to avoid a fist of goo.

DIALOGUE/OKOYE: <Stop this and come with us! We can cure you.>

PANEL 3 (ROW 3)

Close on Nakia as she grabs the drum. Her grotesqueness is incredible. She looks so cartoonish.

DIALOGUE/NAKIA: <I'm not going anywhere until I get what I want. Before this illness takes me, I'll see T'Challa one more time and he will love me.>

PANEL 4 (ROW 3)

Aneka stands looking at the amoeba thing. Ayo and Spider-Man hang from the light pole, looking down at the amoeba thing. The amoeba thing is glowing purple and looking more like mist. It's lost its solid form. Nakia is in the alleyway holding the drum and it, too, is glowing purple. Okoye is jumping down from the building.

DIALOGUE/NAKIA: <This is why I left the Dora Milaje. None of you will ever truly understand raw passion.>

DIALOGUE/AYO: <Never understand passion? Is she kidding?>

DIALOGUE/ANEKA: <She's a stupid woman.>

DIALOGUE/SPIDER-MAN: This is what makes New York City so great, you never know what language you'll hear.

PAGE TEN

PANEL 1 (ROW 1)

Focus on Nakia, who has stepped out of the alley in the sun, holding the drum. The insubstantial amoeba thing (from this point on, let's just call it the Mimic) hovers in front of her, merely a transparent mist.

DIALOGUE/NAKIA: <True power comes from the passion within us.>

DIALOGUE/SPIDER-MAN: Whoa, is she all right?

PANEL 2 (ROW 2)

Spider-Man quickly sets Ayo on the ground. The point of view is from behind them, on the other side of the street, so we can see Nakia in the distance and Aneka and Okoye on the street near where Spider-Man is placing Ayo. He is looking toward Nakia, so it's clear who he is speaking to.

DIALOGUE/SPIDER-MAN: Lady, I have no idea who you are. You might be a really good musician...

PANEL 3 (ROW 2)

Spider-Man runs at Nakia as he shoots webbing at her. Okoye is behind him; she's holding up a hand for him to stop. Ayo and Aneka stand there watching this happen. Aneka is not far from the light pole.

DIALOGUE/SPIDER-MAN:...But I think I should take that drum off your hands.

DIALOGUE/OKOYE: Spider-Man, don't...

PANEL 4 (ROW 3)

The Mimic suddenly solidifies, making Spider-Man's webbing useless against Nakia. It's shielding her. It's also shooting out a gooey arm, smashing into Spider-Man and Ayo. Okoye is dodging the one that comes at her. Aneka is leaping behind the light pole.

SFX: Guh!

PAGE ELEVEN

PANEL 1 (ROW 1)

Focus on Nakia, as she backs into the shadows between the brownstones, now shielded by the Mimic. She shouts her words at Okoye, her huge eyes bulging. Okoye stands tall before the Mimic and Nakia as she shouts at her. Aneka is freeing Ayo and Spider-Man is already using webbing attached to the light pole to pull himself free.

DIALOGUE/OKOYE: <Stop using it! You know what happens if you don't!>

DIALOGUE/NAKIA: <Why didn't King T'Challa come, Okoye?!>

PANEL 2 (ROW 2)

Close on Nakia as she is surrounded by the Mimic's cloud.

DIALOGUE/NAKIA: < Tell him that until he comes to see me, there will be trouble.>

PANEL 3 (ROW 3)

Nakia is whisked away by the Mimic as Okoye, Ayo, Aneka and Spider-Man watch her escape.

DIALOGUE/NAKIA: <Next time, I'll make it storm!>

PAGE TWELVE

PANEL 1 (ROW 1)

The four of them stand in the empty street. Beside Spider-Man, Aneka is helping Ayo to her feet and Okoye is on his other side, facing the direction Nakia had fled, looking angry.

DIALOGUE/SPIDER-MAN: Sorry about that.

PANEL 2 (ROW 2)

Okoye, Aneka, and Ayo look at Spider-Man, really seeing and acknowledging his presence for the first time. Spider-Man looks back at them. It's an awkward moment.

PANEL 3 (ROW 3)

Close on Spider-Man still hanging upside down. He's holding out a hand to Okoye.

> **DIALOGUE/SPIDER-MAN:** Hi. I'm Spider-Man. Super honored. I've wanted to meet you guys for like ever.

PANEL 4 (ROW 3)

Pull back to show the four of them. Spider-Man is shaking hands with Okoye, who looks at him skeptically. Ayo is smiling at Spider-Man.

> **DIALOGUE/ANEKA:** "Guys? We're not 'guys'."

> **DIALOGUE/OKOYE:** Ah, yes, you're the one Anansi blessed.

PAGE THIRTEEN

PANEL 1 (ROW 1)

Close on Spider-Man.

> **DIALOGUE/SPIDER-MAN:** Is King T'Challa here, too? Seems like everyone's in Brooklyn today, heh.

> **DIALOGUE/OKOYE:** You should be more concerned that there's a Mimic27 in Brooklyn.

> **DIALOGUE/SPIDER-MAN:** Oh I am. What's a...Mimic27?

> **DIALOGUE/OKOYE:** A weapon. Really, it's a Dora Milaje weapon. Only we know its secrets. We've been searching for it since Queen Divine Justice*. What you saw Nakia do with it isn't close to all it can do.

> **DIALOGUE/SPIDER-MAN:** Can you find her?

PANEL 2 (ROW 2)

Focus on Okoye. She looks tired, her eyes closed as she rubs her temples.

> **DIALOGUE/OKOYE:** Yes. The Mimic27 has a vibranium radiation footprint now. We can track it. So, S.H.I.E.L.D. stole this thing from us years ago, took it to a secret underwater facility. And now that they're no longer operating, we think it was left behind.

> **DIALOGUE/AYO:**...Because they couldn't unlock its worst power...but Nakia can.

> **DIALOGUE/OKOYE:** Last night, Nakia broke into that place. When she released the Mimic27, its footprint showed up, that's how we found her. If she uses it—and she will—we will find her again.

PANEL 3 (ROW 2)

Close on Okoye.

> **DIALOGUE/OKOYE:** Also, S.H.I.E.L.D. may have replicated the Mimic27. If they left more behind, anyone can get them. While we wait on Nakia, we go see about this.

PANEL 4 (ROW 3)

Pulls back to show all of them standing on the side of the street. A car is driving by.

> **DIALOGUE/SPIDER-MAN:** You're serious. S.H.I.E.L.D. has a secret facility in the ocean??

> **DIALOGUE/OKOYE:** Just off the coast. Five minutes away, for us.

> **DIALOGUE/SPIDER-MAN:** Sooo, can I come along and help where I can? I kinda messed up back there; let me make up for it.

PANEL 5 (ROW 3)

Focus on Okoye and Spider-Man. Behind him Ayo is looking confusedly at Aneka and Aneka is rolling her eyes.

DIALOGUE/OKOYE: We can handle this, Spider-Man. You don't have to--

DIALOGUE/SPIDER-MAN: I call shotgun!

DIALOGUE/AYO: What does he need a gun for?

DIALOGUE/ANEKA [in a smaller font]: Mschew. Rubbish.

PAGE FOURTEEN

PANEL 1 (ROW 1)

The troop ship flies over the ocean. Maybe we can see some buildings from New York City behind them in the distance. I'm not sure what you can see once over the ocean. We can see the Dora Milaje and Spider-Man in the front of the troop ship.

DIALOGUE/SPIDER-MAN: So let me get this straight, this Mimic27 is a sort of shape-shifting symbiotic super soldier thing? Basically a doomsday organic device?

DIALOGUE/ANEKA: That information is above your pay grade.

DIALOGUE/OKOYE: As I said, it's a weapon.

PANEL 2 (ROW 2)

The troop ship's wings have turned upward and the ship is dropping into the water. It is not underwater yet. We can see the four of them in the ship. Spider-Man has turned to look out the window, down at the water.

DIALOGUE/OKOYE: We do this quickly, so we can get back to finding Nakia.

DIALOGUE/AUTOMATED VOICE: Pressurizing.

PANEL 3 (ROW 3)

The troop ship is dropping into the water. Spider-Man is suctioned to the window. The Dora Milaje are standing behind him.

DIALOGUE/SPIDER-MAN: So your friend, no disrespect, she was looking kinda...rough.

DIALOGUE/OKOYE: Nakia isn't a friend. She was one of

us, a Dora Milaje, until she no longer was. For many years, she's used a toxic herb to manipulate minds. She probably looks unusual to all men.

PANEL 4 (ROW 3)

The troop ship passes close to us as it shoots through the water and we are face to face with Spider-Man, who is suctioned to the window. Okoye is driving, Aneka and Ayo stand beside Spider-Man looking out at us, Aneka is standing behind Ayo with her arms around her waist (this is a subtle moment where it's clear they are together in that capacity).

> **DIALOGUE/SPIDER-MAN:** Why'd she leave you guys? Why didn't you try to get her back before all this?

> **DIALOGUE/ANEKA:** It's complicated.

PAGE FIFTEEN

PANEL 1 (ROW 1)

The point of view is from behind the four of them inside the troop ship. They are zooming through the water. Up ahead is the S.H.I.E.L.D. underwater facility. It looks like a huge sunken passenger cruise ship.

CAPTION: S.H.I.E.L.D. Subaquatic Lab.

> **DIALOGUE/ANEKA:** Apparently, this used to be a passenger ship. The scientific lab is inside.

PANEL 2 (ROW 2)

The troop ship travels through a large opening near the bottom.

PANEL 3 (ROW 2)

The troop ship emerges from a large pool of water that opens into a huge room with underwater equipment (the docking room), control panels, empty docking stations, and a floor littered with trash, a capsized folding chair. The place is abandoned. Aneka is looking at a map projecting from her kimoyo beads. On the map, a square shines purple.

> **DIALOGUE/SPIDER-MAN:** Looks like someone threw a heck of a going-away party down here.

PANEL 4 (ROW 3)

All four of them stand in the docking room, having left the troop ship. They're looking around.

> **DIALOGUE/OKOYE:** Can you find where they'd have kept it?

> **DIALOGUE/ANEKA:** Yes. Easily.

PAGE SIXTEEN

PANEL 1 (ROW 1)

Close on ANEKA. She's pointing behind her to the far side of the docking room.

> **DIALOGUE/ANEKA:** There's a hallway back there that leads to the only room giving off powerful traces of vibranium radiation.

PANEL 2 (ROW 1)

Close on Okoye.

> **DIALOGUE/OKOYE:** Aneka, come with me. Ayo, Spider-Man, guard the ship and see what you can find here.

PANEL 3 (ROW 2)

Okoye and Aneka walk toward the hallway shining a pink light from Aneka's kimoyo beads. Spider-Man and Ayo stay in the docking room. Ayo is looking at a wall of dead screens and control panels that go all the way to the ceiling.

> **DIALOGUE/SPIDER-MAN:** If they left a weapon like a Mimic27, what else might be here?

> **DIALOGUE/AYO:** My thoughts exactly.

PANEL 4 (ROW 3)

Okoye and Aneka walk down the hall. There are old papers, a hanger, and a pen on the floor. Aneka's kimoyo beads shine a pink light ahead and up ahead there is a door where the light turns purple as if there's purple mist coming from behind the door.

DIALOGUE/ANEKA: Definitely this way.

PANEL 5 (ROW 3)

They arrive at the door and there is purple mist coming from under and around the door as Aneka shines her light on it. The point of view is from behind them.

DIALOGUE/ANEKA: What'll we do with Nakia when we catch her? She's broken every rule of the Dora Milaje. She's spilled and exploited our secrets, she's...

DIALOGUE/OKOYE: We bring her home...then deal with her as Dora Milaje.

PAGE SEVENTEEN

PANEL 1 (ROW 1)

Okoye and Aneka enter the Mimic27 lab. Aneka is in front of Okoye. It looks like a place that has been abruptly emptied. Drawers are left open, there are papers on the floor, there are a few broken and unbroken test tubes on the lab table in the middle of the room. The light that shines from Aneka's kimoyo bead lights up the room and the light shines a brilliant purple.

PANEL 2 (ROW 2)

Close on Aneka. Her light is shining in our eyes as she curiously looks around the very obviously empty lab. Behind her, we can see Okoye pulling at an open drawer.

DIALOGUE/ANEKA: See all the purple from the vibranium radiation. This was probably the only room they brought the Mimic27 from the day they brought it here.

PANEL 3 (ROW 2)

Okoye is throwing aside the empty drawer. Aneka is shining the light from her kimoyo bracelet as she looks at the lab table.

DIALOGUE/OKOYE: There's nothing in here.

DIALOGUE/ANEKA: At least we know.

PANEL 4 (ROW 3)

Close on Aneka.

DIALOGUE/ANEKA: But what if the Americans did replicate it and just moved those somewhere else?

PANEL 5 (ROW 3)

Close on Okoye.

DIALOGUE/OKOYE: No way to find that out right now. Nakia first.

PAGE EIGHTEEN

PANEL 1 (ROW 1)

Cut back to Spider-Man and Ayo. Spider-Man is hanging from his web upside down near the ceiling looking at the control circuit boards near the ceiling. Ayo is below looking up.

DIALOGUE/SPIDER-MAN: Even if we could override the system, this place isn't made to flood.

DIALOGUE/AYO: Places like this always have a self-destruct plan.

PANEL 2 (ROW 1)

Close on Spider-Man. There are squiggles coming from his head, as his spidey-sense tingles.

DIALOGUE/SPIDER-MAN: Why's my spidey sense tingling?

PANEL 3 (ROW 2)

The point of view is from beside the troop ship. We can see that the water beside the troop ship (in the pool it's floating in) is bubbling. Spider-Man and Ayo are across the docking room looking at the wall of computer screens and circuit boards, Spider-Man near the ceiling on his web, Ayo below.

DIALOGUE/SPIDER-MAN: Does this Nakia, a.k.a. Malice, know a lot of, ah, people in New York?

DIALOGUE/AYO: "Know" is one way to put it. Manipulated plenty with her Jufeiro herb is another.

DIALOGUE/SPIDER-MAN: Then I think we've got a problem.

PANEL 4 (ROW 3)

The water is bubbling violently around the troop ship now, causing it to rise up and down. Ayo and Spider-Man have turned to stare at what's happening. Spider-Man has leapt from his web to suction himself to the wall of circuit boards, ready to fight. Ayo has her spear up, also ready to fight.

PAGE NINETEEN

This is a splash page full of motion, detail and colors.

An enormous elaborate ornate splash of water is bursting from around the troop ship as Hydro-Man erupts from the top of the huge splash. His lower body is water. His trajectory is clearly toward Spider-Man. Ayo is leaping away while talking into her glowing kimoyo beads and Spider-Man has crept to the ceiling. His eyes glow plant green because he's under the influence of the Jufeiro herb.

SFX: PLASH!

 DIALOGUE/HYDRO-MAN: Spider-Man! Oh this is too perfect.

 DIALOGUE/AYO [talking to her kimoyo beads]: We have trouble.

PAGE TWENTY

PANEL 1 (ROW 1)

Spider-Man swings away from a huge fist of water thrown by a grinning Hydro-Man. Ayo has fled to the other side of the docking room. She's talking to her kimoyo bracelet, an image of Okoye's face is projecting from it.

 DIALOGUE/SPIDER-MAN: Fancy meeting you here. Mind me asking why?

 DIALOGUE/AYO: Come quickly. Some kind of man of water.

PANEL 2 (ROW 2)

Hydro-Man now stands (with legs) on the floor of the docking room, he's grinning and evil looking. He's ridiculous. A vertical column of water is rushing past him from the pool where the troop ship bobs. Spider-Man is being blasted back by another fist of water that has been thrown by Hydro-Man.

 DIALOGUE/HYDRO-MAN: Have you seen the rent in Brooklyn lately?

SFX: Oof!

PANEL 3 (ROW 3)

Aneka rushes to the dripping, water-pounded Spider-Man. The point

of view is from behind Hydro-Man's hulking figure.

DIALOGUE/HYDRO-MAN: Came here treasure hunting and met a strange-looking little birdie. She thought her mind control tricks would work on me.

PANEL 4 (ROW 3)

Close on Hydro-Man's watery face evilly grinning, his eyes glowing herb green.

DIALOGUE/HYDRO-MAN: I told her, "Don't you know? You can't control the water." I've been here ever since... waiting for...for...well, I don't know why I'm waiting.

PANEL 5 (ROW 3)

Close on Spider-Man.

DIALOGUE/SPIDER-MAN: Dude, you don't even know when you've been manipulated. You give water on the brain new meaning.

PAGE TWENTY-ONE

PANEL 1 (ROW 1)

Hydro-Man is in a huge and mushrooming fountain of water that he is drawing from the water behind him. The place is filling rapidly with water now as Hydro-Man pulls it in. Ayo is already on it, she's putting a breathing apparatus into her mouth.

> **DIALOGUE/HYDRO-MAN:** Spiders should stay away from the water, especially the ones with big mouths.

PANEL 2 (ROW 2)

This is a detailed panel. Spider-Man and Ayo are tumbling in the water-filled docking room. Ayo has the breathing apparatus on, but she's facing away from us in a way where we can't see this. Spider-Man has been knocked out; he's limp. Hydro-Man is hovering to the left of the panel, grinning. Debris, pens, a folding chair, papers, swirl around.

PAGE TWENTY-TWO

PANEL 1 (ROW 1)

Water rushes through the corridor that Okoye and Aneka walked through. It carries paper, a coffee cup that says "Miss Me with that", and a gym shoe.

PANEL 2 (ROW 2)

The water rushes around a corner in the hallway. The debris is the same, but it has tumbled around in the wave.

PANEL 3 (ROW 3)

This is from the point of view of behind the water. The water is rushing toward the open door leading into the empty lab in which Okoye and Aneka stand. We can see Aneka and Okoye standing there staring at the approaching water. Part of the panel is underwater. They both look doomed. They carry breathing devices in their hands, but these are drawn in a way that the reader does not notice them.

PANEL 4 (ROW 4)

Aneka and Okoye dive right into the wave of water as it smashes into them. They were indeed ready, for in their hands we can see that they each carry breathing devices.

PAGE TWENTY-THREE

PANEL 1 (ROW 1)

Aneka and Okoye are now underwater in a swirl of empty drawers, the "Miss Me with that" coffee mug, the shoe and papers. They are both putting on their breathing devices. Both of them still carry their spears.

PANEL 2 (ROW 1)

Okoye speaks and the waves of her voice are clear as they move through the water. This is Wakandan tech. Aneka is looking at her.

 DIALOGUE/OKOYE: Stay close.

PANEL 3 (ROW 2)

Hydro-Man is coming fast behind Ayo, who is pulling an unconscious Spider-Man as she swims for her life. Ayo is clearly holding her breath, her breathing device on Spider-Man (his mask is pulled up to show the lower half of his face). They are at the entrance to the troop ship.

PANEL 4 (ROW 3)

This is a tricky point of view because we have to be able to see Ayo pressing her hand to a panel on the side of the troop ship door, Spider-Man is floating behind her, and Hydro-Man behind Spider-Man coming upon them fast and angry.

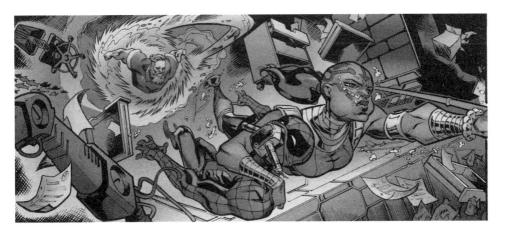

PAGE TWENTY-FOUR

PANEL 1 (ROW 1)

Ayo and Spider-Man tumble into the troop ship, both soaking wet and splashing water on the floor. Behind them an air bubble shields the door. Hydro-Man is so close now, about to burst into the ship.

PANEL 2 (ROW 2)

The point of view is from further inside the ship, behind Ayo and Spider-Man (Spider-Man is slowly getting to his knees, weak but alive), facing the door as it shuts just quickly enough for Hydro-Man to smash into the door (which is mostly glass, so we see Hydro-Man's mashed face and all the bubbles).

SFX: THUNK!

DIALOGUE/SPIDER-MAN: Cough cough! Ayo, you're a lifesaver.

PANEL 3 (ROW 2)

Spider-Man stumbles to the troop ship's controls. There's a panel right in front of him.

DIALOGUE/SPIDER-MAN: Can this ship create an electric shock? Like an electric eel. That'll cripple him.

DIALOGUE/AYO: Touch and swipe that panel.

PANEL 4 (ROW 3)

Close on Spider-Man's hand about to touch the pad.

DIALOGUE/AYO: Wait! Look!

PAGE TWENTY-FIVE

PANEL 1 (ROW 1)

The point of view is with Aneka and Okoye as they swim into the room. Hydro-Man looks terrifying across the docking room as he gathers himself, preparing to attack the troop ship. From afar, we see the soaked Ayo and Spider-Man inside the ship looking at Aneka and Okoye.

PANEL 2 (ROW 2)

We are back with Spider-Man and Ayo looking out past Hydro-Man at Aneka and Okoye. Hydro-Man has turned around to face Aneka and Okoye, too. Ayo talks to Okoye through her beads, we can see a projection of Okoye from Ayo's beads.

DIALOGUE/SPIDER-MAN: Whoa, I nearly electrocuted them!

DIALOGUE/AYO: Spider-Man says this is Hydro-Man.

PANEL 3 (ROW 2)

Hydro-Man swims at Okoye fast, a rush of water swirling bubbles. Okoye is watching Hydro-Man come at her as she takes something from her spear. Aneka swims to the left, getting out of the way.

PANEL 4 (ROW 3)

Okoye (wearing her breathing device) swims at Hydro-Man. Hydro-Man swims at Okoye. This is a dramatic panel. There is a lot of motion in the water, more from Hydro-Man.

PAGE TWENTY-SIX

PANEL 1 (ROW 1)

Okoye twirls around, letting Hydro-Man zoom past her like a bull in an arena. As she turns, she's throwing something golden blue at Hydro-Man.

PANEL 2 (ROW 2)

This is a full panel of Hydro-Man freezing up, a comically stunned look on his face. His eyes are no longer green, they are a normal blue. Okoye looks hardcore as she floats back in the water.

PANEL 3 (ROW 3)

Close on Okoye as she floats before the frozen floating Hydro-Man. Aneka is floating in the water, snickering. Both Okoye and Aneka still have their breathing devices on their faces.

DIALOGUE/OKOYE: Yes, we even have a weapon for nonsense like you.

PAGE TWENTY-SEVEN

PANEL 1 (ROW 1)

Okoye, Aneka, Ayo and Spider-Man are inside the troop ship. The docking room (and the rest of the facility) is still flooded with water. Outside, Hydro-Man floats, frozen in his block of ice. He's floating in a way that makes him stare at them with a side eye (note: his eyes are no longer green, they are blue), but his face is still in the stunned expression (except his eyes, which look like they are pleading with the four of them to let him go).

> **DIALOGUE/OKOYE:** I'd rather us not be here when the authorities arrive. Too much paperwork.

PANEL 2 (ROW 2)

Spider-Man has turned to look out the window at the floating Hydro-Man. Ayo and Aneka are holding hands.

> **DIALOGUE/SPIDER-MAN:** No worries. Happy to babysit him until they get here if you give me one of those breathing devices.

PANEL 3 (ROW 3)

Close on Okoye. She's smiling.

> **DIALOGUE/OKOYE:** We've got something better than that.

PAGE TWENTY-EIGHT

PANEL 1 (ROW 1)

Spider-Man is in an air bubble-like floating device (more Wakanda tech) with a molded chair and a small speaker in the side that he can talk to the Doras through (it looks like a glowing blue circular button embedded in the bubble). The bubble is mostly transparent, but make it a bit opaque...it's not perfect tech. The bubble is hovering beside the frozen Hydro-Man, who still looks angry with pleading eyes. He's floating upside down now, slightly diagonal to show that he's floating and in motion. Spider-Man is between Hydro-Man and the troop ship. Okoye, Ayo and Aneka are standing close to the window and Spider-Man can hear them through the speaker in his bubble.

CAPTION: Five minutes later...

> **DIALOGUE/SPIDER-MAN:** This is cool.

PANEL 2 (ROW 2)

Close on Okoye, Ayo and Aneka looking out at Spider-Man in the troop ship.

> **DIALOGUE/OKOYE:** We have to go. It's only a matter of time before Nakia will use the Mimic27 again.

> **DIALOGUE/SPIDER-MAN:** That's fine. It's warm and comfy in here. I'll get some much-needed chill time while I wait.

> **DIALOGUE/ANEKA:** Okoye, we can't find Nakia until she uses the Mimic27. What do we do until then?

PANEL 3 (ROW 3)

Close on Spider-Man.

> **DIALOGUE/SPIDER-MAN:** Go do some tourist stuff.

PAGE TWENTY-NINE

This is a splash page of Okoye, Aneka, and Ayo wearing civilian clothes at the Statue of Liberty. Ayo has a tour pamphlet in hand and Aneka is pointing up at the Statue of Liberty. They still carry their spears. There's a tall skinny Sikh man with a bushy black beard and a red turban wearing jeans and a stylish red shirt standing nearby, taking a picture of the three of them with his cell phone. They don't care that he's doing this.

PAGE THIRTY

PANEL 1 (ROW 1)

Okoye, Aneka, and Ayo are at the top of the Empire State Building looking down with other tourists, some of whom are staring at them, pointing, snapping photos with their phones. They're clearly having a good time.

> **DIALOGUE/ANEKA:** Just like in the movies.

DIALOGUE/AYO: The skyscrapers in Birnin Zana make this look so small.

DIALOGUE/OKOYE: The Americans really try, I give them that.

PANEL 2 (ROW 2)

Okoye, Aneka and Ayo are coming out of a Jamaican Restaurant called "The Hummingbird". Aneka and Ayo have their arms around each other's waists, Ayo is leaning her head on Aneka's shoulder. Both are smiling. Okoye is in front and her kimoyo beads are glowing red.

DIALOGUE/AYO: We should have Jamaican Wakanda fusion restaurants back in Wakanda. Can you imagine jerk chicken with jeweled pilau?

DIALOGUE/ANEKA: Oh, that would be delicious!

DIALOGUE/OKOYE: Quiet. The tracker! Nakia just hit that drum again. The Mimic27 is going to be much stronger.

PANEL 3 (ROW 3)

Close on Okoye's kimoyo beads with Okoye looking at the projection and Ayo and Aneka crowding around it. They all look worried. We see a projection of "WaZoBia African Grocery" with purple vibrations coming out of the front door.

DIALOGUE/OKOYE: WaZoBia Grocery in Brooklyn. Remember who used to talk so fondly about this grocery store back in Wakanda, when we were her personal guards?

DIALOGUE/ANEKA: She's going after Storm!

PANEL 4 (ROW 3)

Close on Okoye, looking right at us.

DIALOGUE/OKOYE: We are coming, Ororo.

TO BE CONTINUED...

SPIDER-MAN: LIFE STORY (2019) BY CHIP ZDARSKY

AN INTRODUCTION BY **TOM BREVOORT**
IN CONVERSATION WITH **ANDREW SUMNER**

pider Man: Life Story examines the life and publishing history of the Amazing Spider-Man, Peter Parker, adding into it the element of the passage of time that comic books typically don't bother with. It's a story about the very first teenage super hero from the early 1960s, taking that iconic character and progressing his life into his twenties, thirties, forties as the real-world decades go on, all the way up to the present day of 2019. *Life Story* is a narrative that encapsulates the Spider-Man character and looks at the events of his life, at the things that happened over the course of his publishing history, in a different way. It's a celebratory event, an entire self-contained narrative in a single accessible volume. You really don't need to have read any other Spidey comics in order to enjoy it. At the same time, it's also a quintessential Spider-Man story, one in which the character gets old and grows and changes—and relationships develop and break apart in ways that are much more difficult to achieve in the ongoing, regular, monthly, *Amazing Spider-Man* series (where the character remains young and will presumably do so for all time).

It was an idea that various writers had pitched over the years. Chip's version was called *Marvel Age*—it was going to be the Marvel characters aging in real time, starting in the 1960s, all the way up to the present. While the idea of the real-time progression was interesting, the fact that it was all the characters meant the story was very unfocused. We could never crack it; we could never come up with a way to make that work. Then one of our younger editors, Darren Shan, said, "You should just do that with one character—do it with Spider-Man." And it was like a light bulb went on over my head—I was like, "That's exactly right. I'm gonna do that!"

I went back and reached out to Chip. "How about we just focus it on Spider-Man, so there's a narrow enough throughline that you can actually

develop the character—his supporting players, the villains—over the course of that time, but it's more focused and therefore a lot simpler." I told Chip, "You can still use other characters, but you don't have to worry about working out every single beat of every character's life: if, say, you want to use Reed Richards in the 1980s, then you just need to figure out where you think Reed is in his life in the 1980s, just for this story—and it's all in relation to where Peter and his life are."

Right from there, Chip went off and did an outline. He was very candid and said, "Even with just the one character, I still need a lot of room because every issue covers the span of a decade." Ultimately, we decided to publish 30-page *Life Story* issues, which is not typical for Marvel because it's very difficult to find any artist who was fast enough, even with the lead time that we had, to illustrate six 30-page issues and make sure that they were all going to come out on time. Essentially, you're adding another half a comic to every book.

It was very fortunate that [long-running, highly prolific Spider-Man artist] Mark Bagley was available to do it. Mark is fast enough to be able to work like that, but also, because of his very long association with Spider-Man going back to the 1990s, he's like the modern-day John Romita Sr. [longtime Marvel art director and prolific Spider-Man artist]. His involvement gave the project some real validity—the book felt like a legitimate Spider-Man project.

I first became aware of Chip when he started working with Matt Fraction on their creator-owned Image Comics book, *Sex Criminals*. With his artist hat on, he did a couple of covers for me, and wrote a couple of short, one page almost-gag strips. He would even do covers, variant covers and things for us that would also have a writing component to them—he was interested in moving over into writing. Somewhere along the line, we wound up working on *The Invaders* (2019), and *Marvel Two-in-One*, and a bunch of other things over the years, including *Life Story*.

Chip was great to work with. Because of his art background, he had an interest in taking a stronger hand in the design of projects. For *Life Story*, he did all the covers, and all of the design for the recaps, the page designs and so forth, to give it a unique feeling when it was on the stand; there was something a little distinctive and a little special about it. That

was a way of trying to separate it from the other half-dozen Spider-Man comics that would be out each month.

Chip's very funny, witty, and entertaining. His public persona is humorous—he wants to be a goofy, funny guy. But Chip, when you get down to it, and particularly get into his writing, is surprisingly thoughtful, and brings a surprising amount of depth to what he does and how he approaches stories. He's really multi-faceted. He can do everything, play any position on a given comic, so he has a wide range of abilities and talents to bring to bear on a project. He can be funny, but he can also deliver genuine pathos and emotion. He's the whole package.

Most of the storytelling choices in *Life Story* were made by Chip. My take on this was always that we were going to set Spider-Man's life against the real world. So, when we're in the seventies, I want to accurately reflect the 1970s, and in the eighties, I want to accurately reflect the 1980s. I was more concerned about that than I was about the Spidey characters' history. When Chip came to it, while he was trying to be reflective of the various decades we were in, he was also very much trying to reflect what was going on in the actual comics at that point. It's no coincidence that we get the black Spider-Man costume in issue three (AKA the 1980s issue) or that, by the last issue, we have Miles Morales as the new, young Spider-Man, because Chip was very focused on doing both of those things—which to my mind made it all a lot more complicated. But that was the challenge that he set for himself. As long as it all worked, I didn't mind.

I think ultimately, the fans came through and really enjoyed it. The ship was so well-steered in terms of keeping the events of those eras inside those areas, and reflecting those real eras, even though it was often with an older Peter or an older Mary Jane—or even an older Norman or Jonah. It was like an extra set of Easter eggs for people who were fans.

Chip and Mark's *Life Story* really cut through. It's become a perennial title with multiple editions and releases over the years. One of the things I had said to them was, "If it goes well, we could approach the concept with any character, and it could be individually focused with each series." But all of that really just comes down to the voodoo of having the right people and then those right people making the right book.

SPIDER-MAN

SPIDER-MAN: LIFE STORY

ISSUE #2

2019

"Our Fathers' Way"

By Chip Zdarsky

Art by Mark Bagley, Drew Hennessy,
and Frank D'Armata

PAGE ONE

Okay! So! This issue takes place in 1977. I WAS going to bounce around from year to year, but I think it works best emotionally if we keep it as one point in time. I stuck on '77 so we could see MJ in Studio 54 to REALLY get the 70s vibe happening.

This makes PETE and his gang 30. Whatever that looks like to you, Mark, I trust you. As long as we stay with era-appropriate fashions, I'm cool.

1.1 It's a gray day establishing shot of a GRAVEYARD. We see, from a DISTANCE, PETER standing in front of a GRAVE. It's clearly FALL.

 PETER: ...and HARRY, well, he's in CHARGE now.

1.2 CLOSE on PETER, talking to NO ONE. A small smile on his face.

 PETER: I think he's HAPPY? It's hard to tell. Running his dad's business isn't EASY, but I think he's found his place...

 PETER: Speaking of: remember Professor Warren? He LEFT the university, started his own BIO-ENGINEERING COMPANY. Cutting-edge stuff, man.

1.3 We see GWEN walking up BEHIND PETER as he talks. She smiles. Her HAIR is different now. Nothing crazy, still recognizable as GWEN, but possibly it's just SHORTER.

 PETER: GWEN went to work for him, actually. CHIEF BIOLOGIST, if you can believe it.

 PETER: It's a good thing I have a healthy EGO, cause having my WIFE make MORE than me raises a few eyebrows, I tell you...

 GWEN: You don't mind it when PAYDAY comes around...

1.4 PETER turns to GWEN, a little surprised to see her.

 PETER: Honey! I thought you were--

 GWEN: Skipped out early. Figured I'd find you here.

 GWEN: Anniversary of his death, your unreasonable Parker Guilt...

1.5 PETER looks back at the GRAVE, SOLEMN.

PETER: I ...I could have saved him, Gwen. I KNOW it.

PETER: It's ...it all feels HARDER when everything is clicking into PLACE. When we're doing well, when we're all HAPPY.

PETER: How can we be HAPPY? How can any of us when--

1.6 GWEN holds PETER'S FACE so he looks in her EYES.

GWEN: Peter, I love you.

GWEN: You're ALLOWED to be HAPPY. The world is--the world always serves up challenges and sadness. It's NEVER in short supply.

GWEN: But you CAN'T let it drive you. The dead don't want you to WALLOW, they want you to LIVE ...

PAGE TWO

2.1 BIG PANEL, a lot of GREY SKY and CLOUDS MOVING IN. PETER and GWEN have walked past the GRAVESTONE, so we see it LARGE in the FG, with them getting smaller as they walk away in the BG. Kind of a SPIDER-MAN NO MORE shot, y'know?

BIG HELVETICA TEXT, matching last issue: 1977

GWEN: ...so let's LIVE.

The TOMBSTONE SAYS:

EUGENE "FLASH" THOMPSON

January 20, 1947-April 16, 1974

2.2 NEW SCENE. We're outside the BAXTER BUILDING now. It's a SUNNY DAY.

PETER CAP: Gwen's right. She's ALWAYS right.

PETER CAP: But I still dwell on the PAST...

PAGE THREE

3.1 In the LAB/WORKSPACE. PETER is working with a SOLDERING IRON on a CIRCUIT BOARD. He's wearing a DRESS SHIRT, OPEN COLLAR, NO TIE.

> **PETER CAP:** ...when my mind should be in the PRESENT.

> **REED (OP):** Unbelievable...

3.2 REED RICHARDS is in the LAB as well, though he's wearing a LAB COAT over his civilian clothes. He's around 55 here, so the WHITE is HIGH on the sides, and he's sporting a VAN DYKE. He's sitting at a DESK, reading the FRONT PAGE of a NEWSPAPER. PETER looks over at him.

> **PETER CAP:** Or the FUTURE.

> **PETER:** REED, EVERY DAY with this...

> **REED:** Well, it's INSANITY. This war...it just drags ON and ON...

3.3 We see what REED is looking at. The FRONT PAGE has a BLURRY PHOTO of CAPTAIN AMERICA, deep in the JUNGLE, deflecting BULLETS with his SHIELD. We don't see his FACE here. A SECOND PHOTO is of IRON MAN FLYING OVER THE JUNGLE, with GIANT MAN BEHIND him. Both of their COSTUMES have been updated. IRON MAN is ALL camouflage now, and GIANT MAN has AMERICAN FLAG elements, and some BODY ARMOR.

> The paper is THE DAILY GLOBE.

> The HEADLINE says: CAPTAIN AMERICA ON THE RUN

The SUB-HEADLINE says: Military insists IRON MAN handling situation as Viet Cong make inroads into Phuoc Long.

REED (OP): ...and it's all our fault.

3.4 PETER engages REED, who STRETCHES an ARM to put the NEWSPAPER in the TRASH.

REED: The only SANE "super hero" in that conflict is CAPTAIN AMERICA.

REED: Going ROGUE, saving lives on BOTH SIDES.

PETER: I guess, but THAT'S probably why it's still GOING.

3.5 ON REED, frustrated.

REED: NO, it's still GOING because STARK and his IRON LACKEY keep us in the GAME, as if winning is a POSSIBILITY there. And NOW they drag GIANT MAN into it?

REED: What if the VIET CONG take him? What if they figure out the SCIENCE that makes him the SIZE of a BUILDING?

3.6 On PETER, he agrees, but barely. This is an exhausting conversation.

REED (OP): A NATION of GIANT SOLDIERS.

REED (OP): "Super heroes." Unable to THINK THROUGH their actions...

PETER: We have a MORAL RESPONSIBILITY to help! If we have GREAT POWER, we need to--

PAGE FOUR

4.1 A DOC OCK ARM enters the PANEL, offering PETER a COFFEE.

OCK (OP): GENTLEMEN. ALWAYS with the DEBATES.

4.2 It's OTTO OCTAVIUS, smiling, working away at a WORKSTATION. He's dressed relatively CASUAL. He's pushing 60. A bit more DIGNIFIED than we're used to. He's got his ARMS, but the ENDS of them feel less VIOLENT. Like FINGERS instead of CLAWS, y'know?

PETER CAP: Otto Octavius. Hard to believe he was trying to MURDER ME a few years ago.

OCK: We do the GOOD WORK HERE. The FUTURE FOUNDATION is FINALLY changing the WORLD for the BETTER.

OCK: Mobile communications! Advanced prosthetics! Safe dimensional travel! These are things to be PROUD of!

4.3 REED stands up and rubs the bridge of his NOSE.

PETER CAP: But after his HEART ATTACK, he realized there was MORE to life than accumulating WEALTH and POWER...

OCK: But you always INSIST on CHASTISING others for the paths THEY'VE taken.

OCK: I took a similar path for so long, until you offered this chance. And I found MAY...

PETER CAP: ...THAT also helped. Now he's "Uncle Otto." Of all the things I've had to get used to over the years, THAT one is the hardest...

4.4 PETER walks away from REED and OCK, COFFEE in HAND. He heads down a HALL.

PETER CAP: But Otto knows how to bring REED out of his FUNKS, whereas I just get RILED UP thinking about some of his INVENTIONS that he HOARDS...

PETER CAP: He has his REASONS. But the more I look at the world...

PETER CAP: Nixon resigning ...the WAR still GOING ...

PETER CAP: I just keep thinking ...

4.5 PETER looks out a BIG WINDOW, overlooking the CITY.

PETER CAP: ...shouldn't we do MORE?

PAGE FIVE

5.1 We're in a PRISON. We're behind HARRY as we look at a PRISON GUARD accepting items from HARRY at a CHECK-IN desk. HARRY can be in SILHOUETTE.

HARRY: This seems EXCESSIVE--

GUARD: You'll get 'em BACK after your visit. Safety precautions.

5.2 On HARRY as he walks into the ...what do you call it? The room where everyone talks through glass at inmates? THAT PLACE. Though we don't see the GLASS here. We're focused on HARRY'S FACE and a DIFFERENT GUARD behind him who let him into the ROOM.

HARRY is dressed in a 70s SUIT AND TIE. He looks rough. He's clearly into cocaine culture. Maybe he has a mustache?

GUARD 2: Ten minutes.

5.3 HARRY takes a SEAT and HOLDS the PHONE to his EAR. He looks a little freaked out.

HARRY: I--

HARRY:--hey, dad.

5.4 On NORMAN now. He looks 55/60. Some GREY in his HAIR. Not entirely pleased with how his son looks. RECEIVER to his ear.

NORMAN: Harry.

NORMAN: You look like #$@%.

5.5 On the TWO of them, talking. HARRY is perturbed, but still scared of his old man. NORMAN needs to win him back.

HARRY: I--I didn't COME here to be--to be INSULTED. I--

NORMAN: I'm...

NORMAN: ...I'm sorry, son. This place just ...it brings out the WORST...

NORMAN: I'm glad you came. You've ...you're DOING me

PROUD. You know that, right?

5.6 On NORMAN, trying to be kind.

NORMAN: I still get NEWSPAPERS here. I SEE you weathering the recession, bringing OSCORP out of it as STRONG as it can be. I know it can't be EASY being "the son of Norman Osborn, suspected madman"...

NORMAN: I appreciate it, Harry. I just WORRY...

PAGE SIX

6.1 HARRY softens up a bit, looks down. His father can see he's struggling.

NORMAN (OP): ...you LOOK like you're--

HARRY: Everything's ...everything's under control, dad. Just tell me why you wanted me here.

6.2 NORMAN leans in as this is TOP SECRET.

NORMAN: I've ...been hearing word that the GEMINI PROJECT is out of control. I need you to ...rescue the ASSET before all is lost ...

NORMAN: You've helped me SO MUCH with this, son. I just need you to see it THROUGH and...

6.3 HARRY stands, upset, but leaning in enough to still be talking on the PHONE.

HARRY: I--no! This--this PLAN is CRAZY!

HARRY: I've helped ENOUGH! I need to SAVE THE COMPANY! Not run around, TERRORIZING people, dressed as a--a--

NORMAN (OP): PLEASE, just listen...

6.4 On NORMAN, pleading.

NORMAN: ...You're the ONLY person in the world I TRUST, son. I ...I told you the truth about me being the GREEN GOBLIN, about my SICKNESS ...

NORMAN: ...about SPIDER-MAN ruining my LIFE. Not giving me a CHANCE.

6.5 Back on HARRY, standing, wondering what's going on.

NORMAN (OP): If you DO this, he MAY interfere...

NORMAN (OP): ...and if he DOES...

6.6 On NORMAN. He should look SERIOUS, but not EVIL.

NORMAN: ...I have ONE MORE SECRET to TELL you...

PAGE SEVEN

7.1 We're outside a much SMALLER BUILDING than the BAXTER. It houses Professor Warren's company. The TOP, LARGE FLOOR has its WINDOWS BLACKED OUT as it's where all the delicate SCIENCE takes place.

> **LOGO ON BUILDING:** SCIPRO-GENESIS
>
> **PETER (from BUILDING):** ...and then OTTO stepped in.

7.2 INSIDE. It's a DARKER LAB than the BAXTER BUILDING. GWEN is in a LAB COAT, sitting on a STOOL at a WORKSTATION as PETER has COLLAPSED into a big COMFY CHAIR, in a spot clearly designed for conversations.

> **PETER:** Which is for the BEST, 'cause I'm starting to get TIRED of all the same REED conversations...
>
> **GWEN:** Honey, I LOVE you. But you NEED to stop poking him.

7.3 PETER stands up and walks toward GWEN, who is looking in a MICROSCOPE.

> **GWEN:** You have a chance to work with one of the GREATEST MINDS on the planet, and you keep having these "ethical debates"...

7.4 PETER is by GWEN now, but looking at a MEDICAL GLASS TUBE-CASE with a HAND FLOATING inside in LIQUID, TENDONS and NERVES extending from it a bit.

> **PETER:** Yeah, well, easy for YOU to say...
>
> **PETER:** ...you and PROFESSOR WARREN are actually doing GOOD. Recreating LIMBS for people.

7.5

> **PETER:** You even managed to help fix poor CURT CONNORS.
>
> **WARREN (OP):** Yes, well...

7.6 PROFESSOR WARREN walks in, also in a LAB COAT. He's around 60 here.

WARREN: ...GWEN and I couldn't have done THAT without you concocting a CURE for "The Lizard" first, Peter.

7.7 PETER is kind of 'aw, shucks' as WARREN shakes his HAND.

PETER: Heh. Well, I may have ended UP more in electrical engineering, but your BIO CLASSES never left me, sir.

WARREN: Please, please, son, call me MILES. We're a good DECADE out of SCHOOL!

PAGE EIGHT

8.1 GWEN stands and puts her hand behind PETER'S BACK as they talk with WARREN.

WARREN: So, what brings you by?

GWEN: PETER here isn't content with just disrupting HIS workplace, he insists on interrupting MINE as well.

PETER: Hey! I just wanted to see my WIFE before I hit THE CLUBS!

8.2 GWEN smiles as she goes to USHER PETER away.

GWEN: My DEVOTED HUSBAND is going to a NEW DISCOTHEQUE tonight to "support a friend."

PETER: I don't WANT to! I'm THIRTY! I should be HOME doing my TAXES!

8.3 WARREN puts a HAND on PETER'S SHOULDER before he gets ushered away.

WARREN: Peter ...before you go ...

WARREN: If things get BAD with DR. RICHARDS ...I'd absolutely LOVE to have you here.

PETER: Whoa, REALLY?

PETER: I'm not exactly up to DATE on genetic biology, but--

8.4 WARREN lets him go as GWEN again USHERS him toward a DOOR.

WARREN: No, no, Gwen and I have THAT covered. Honestly, we need help with the MACHINES and COMPUTERS, which are a little beyond my scope...

PETER: Oh ...wow. Thanks, profes--MILES. I'll definitely keep it in mind...

GWEN: Come ON! I've got WORK to do!

8.5 From BEHIND WARREN as we see, across the ROOM, GWEN give PETER a KISS as he's about to get in the ELEVATOR.

PETER: All right! Don't wait up!

GWEN: Give my best to the BEE GEES and the EM JAYs...

8.6 Just on WARREN now, looking LONGINGLY at a LOVE he can't have. OR CAN HE??

PETER CAP: Professor Warren's always been there for GWEN and I...

PAGE NINE

9.1 SPIDEY! It's NIGHT and he's swinging through the CITY!

Now, it's been 14 years since he became SPIDEY, so his COSTUME should have some changes here. Maybe nothing major at this point. A UTILITY BELT on the outside. The BLUE PARTS can be more BLACK, like they're a leather material, and the RED parts can have more of a SHINE to them, utilizing more 70s fabrics. Some more PROTECTION, basically.

> **PETER CAP:** ...even walking her down the AISLE since her father died.

> **PETER CAP:** Not sure if my MARRIAGE could SURVIVE working together though....

9.2 SPIDEY lands on a ROOFTOP.

> **PETER CAP:** Besides, the lab ...CREEPS me OUT. Maybe it's all the FLOATING LIMBS, but something just gently pokes at my SPIDEY-SENSE.

9.3 PETER looks over the EDGE of the BUILDING, wary, BOTTOM-LIT, as he CHANGES into his CIVILIAN CLOTHES, which would be very much DISCO-ERA.

> **PETER CAP:** Speaking of my SPIDER-SENSE, I WISH it were going off right now. I've fought THE RHINO, KRAVEN, THE LIZARD, and yet here I am, scared...

9.4 From BEHIND PETER, we look down at the CROWD around STUDIO 54. It's pretty HOPPING.

> **PETER CAP:** ...of DISCO.

PAGE TEN

10.1 PETER entering the CLUB. It's full of fabulous PEOPLE and he is quite uncomfortable, though he's dressed to fit in. He's SMALL in the panel, in the BG near the DOOR. A DISCO WOMAN is moving toward him. She's TALL and very GRACE JONES.

> **PETER CAP:** Just suck it UP, Pete ...at least you were on the LIST ...

> **GRACE:** Mr. PARKER?

10.2 PETER surprised. GRACE is cool. VERY cool as she gestures to a

ROPED-OFF STAIRCASE.

 GRACE: PLEASE, you're expected in the VIP SECTION...

 PETER: Oh. Of ...of COURSE...

 PETER CAP: I always FORGET that HARRY is, like, CRAZY RICH.

 PETER CAP: And if HARRY is crazy rich, so is his FIANCÉ...

10.3 MARY JANE walks quickly to PETER with OPEN ARMS, happy to see him. She is FULL DISCO. Her hair is more FARRAH FAWCETT than classic MJ now.

 PETER CAP: ...MARY JANE WATSON.

 MJ: PETEYYYY!!!

10.4

 PETER: Uh, HEY, MJ. Did I miss your SET?

 MJ: Oh GOD no! I don't hit the DJ BOOTH until MIDNIGHT!

 PETER: MIDNIGHT?! Oh man, I don't think I can LAST that long! This isn't--isn't REALLY my SCENE...

10.5 PETER looks around, uncomfortable. MJ has that COKE ENERGY flowing through her.

 MJ: Haha! when did you get so OLD?!

 PETER: I've ALWAYS been old! Put an old BEATLES 45 on and I'm fine...

 MJ: UnbeLIEVABLE! Just give something NEW a CHANCE for once!

 PETER: Yeah, yeah ...where's HARRY?

10.6 MJ gestures over to a COUCH, where HARRY is sit-lying, his eyes closed.

 MJ: Ol' HARRY didn't quite get the UPPERS/DOWNERS combo right...

 PETER: Oh man...

 MJ: It's FINE. Just means I don't have to BABYSIT HIM all night and listen to his stupid HIGH FINANCE TALES...

PAGE ELEVEN

11.1 A COOL SERVER brings MJ a COCKTAIL, which she GLADLY accepts.

 MJ: Ah! FUEL! Want one, PETE?

 PETER: I'm--I'm good.

 PETER: Are you and HARRY ...OKAY?

11.2 MJ a little perturbed at PETE'S QUESTION as she holds her DRINK. PETER is a little concerned.

 MJ: What? We're FINE.

MJ: It WORKS, PETE. We can't ALL be PERFECT like you and your little LAB BUNNY.

PETER: Come on, MJ, that's not--

MJ: Not WHAT? Not FAIR?!

11.3 MJ is getting UPSET.

MJ: Out of EVERYONE in our GROUP, you're always the STICK IN THE MUD, the guy with the FAUX CONCERN over others!

MJ: But you don't actually DO anything, DO YOU?

11.4 PETER turns to WALK AWAY. MJ still shouts out after him.

PETER: Okay, you've had too much to DRINK or WHATEVER. I'm going--

MJ: Easy to just point out everyone's PROBLEMS than to ACT, yeah?

MJ: You have troubles at WORK? Then $#@% QUIT!

MJ: You don't like hanging out with your FRIENDS? Then DON'T!

11.5 Close on MJ, really letting LOOSE.

MJ: You just WALLOW in REGRETS! You LOVE them!

MJ: Instead of telling him he was making a MISTAKE, you could have SAVED FLASH!! With all your $#%@ POWER!

PAGE TWELVE

12.1 WIDE PANEL of PETER turning back toward MJ, a space of about TEN FEET between them.

NO DIALOGUE

12.2

NO DIALOGUE

12.3 MJ, calmed down a bit, but still pissed off at PETER. MAKING motions with her HAND indicating PETE scurrying to and fro about the house.

MJ: I KNOW, Pete.

MJ: I've known since I was FIFTEEN. Watching you come and GO from MAY'S house.

12.4 PETER goes back to MJ. Is this TROUBLE?

PETER: I don't--I don't--

MJ: Oh, shut UP. You have more power than anyone in this ROOM. And what do you DO?

12.5 MJ turns and walks away toward passed-out HARRY.

MJ: You've spent a DECADE in your OWN "club outfit," playing the CLOWN. CONVINCING yourself you're doing the RIGHT THING ...

MJ: ...while PETER PARKER gets to be the COWARD.

12.6 On PETER, a DISTANCE SHOT, through the VIP section, as he watches MJ OP, leaving.

MJ (OP): And our friend is dead.

PAGE THIRTEEN

13.1 It's the next day, and we're close on PETER in the BAXTER BUILDING, using an ELECTRICAL TESTER on some CIRCUITRY. He looks rough. STUBBLE from not shaving.

PETER CAP: I don't really sleep. I tell myself it's because I'm worried about MJ telling HARRY.

PETER CAP: But it's really because her words HURT. That she may be RIGHT.

13.2 PULL OUT to see PETER working and REED walking in with the NEWSPAPER. REED is wearing a BLACK TURTLENECK.

PETER CAP: Should I have GONE to 'Nam?

PETER CAP: Am I just spinning my wheels swinging around New York, arresting purse-snatchers?

REED: You're in EARLY, Peter.

13.3 REED sits down and STRETCHES to reach the COFFEE-MAKER. The STRETCHING is the focus here as PETER pays more attention to it than normal. The TURTLENECK STRETCHES with REED'S ARM.

 PETER: Couldn't sleep.

 REED: Ah, YES. You went to that "Studio 54" last night, right?

 REED: A FASCINATING study in human behavior, I'm--

 PETER: Reed.

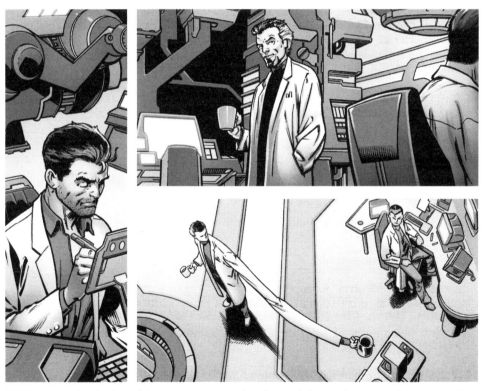

13.4 REED is bring his COFFEE MUG back to him and turns his attention to PETER.

 PETER: Your clothing. The clothes you made for you and ...the rest of the FANTASTIC FOUR.

 PETER: Adaptable to FLAME, STRETCHES with you, doesn't get dirty...

REED: Yes, the UNSTABLE MOLECULES. What about them?

13.5 PETER is getting SERIOUS.

PETER: Youwe work on PROJECTS. Helpful ones, sure. But you've invented VIRTUALLY INDESTRUCTIBLE CLOTHING.

PETER: Why haven't you made that public? You could change the WORLD...

REED: I ...I know where you're going with this, Peter. And believe me, I've given it a LOT of thought.

13.6 On REED, calmly explaining.

REED: The TEXTILE industry is worth, well, TRILLIONS of dollars. Every person on the planet utilizes them. Tens of millions of people's LIVELIHOODS depend on the industry...

REED: The INTRODUCTION of this technology would, well, it would create a global UPHEAVAL. It ...wouldn't be RESPONSIBLE.

PAGE FOURTEEN

14.1 PETER STANDS. This is IT.

PETER: Wouldn't be ...

PETER: WHY do you always act like you're from some other PLANET? Like you can't--can't INTERFERE with "humans?"

PETER: These are OUR PEOPLE, REED. WE'RE HUMAN!

REED: But Peter ...

14.2 On REED, standing now, realizing this is an ARGUMENT.

REED: ...I'm NOT.

REED: And neither is GIANT MAN, or IRON MAN, or any OTHER "super hero" with "MAN" in their name, like they're trying to CONVINCE the world they're still just like them.

14.3 PETER is DISGUSTED with REED.

REED: Things have CHANGED. The WELLSPRING of POWERS, the growth of MUTANTS.

REED: We NEED to be careful or we'll end up RULING THE WORLD, creating a massive level of INEQUALITY.

PETER: God, LISTEN to yourself...

14.4 CLOSE on PETER, really turning the SCREWS now.

PETER: ...you're so NOT HUMAN...

PETER: ...that even your WIFE left you for a man who lives under the SEA.

14.5 REED SLAPS PETER.

PETER CAP: My SPIDEY-SENSE warns me in time, but I let the SLAP LAND.

14.6 PETER WALKS OUT. REED looking down, embarrassed at what he's done.

PETER CAP: It's the least I can do.

PAGE FIFTEEN

15.1 We're at HARRY and MJ's place. A HUGE PENTHOUSE APARTMENT, with VERY 1976 decorating choices. MJ is sitting at a COUNTER, looking a little rough. It's MIDDAY but she just got up. She reads the PAPER with a freshly finished BREAKFAST and a BIG MUG of COFFEE. In the BG, HARRY is walking out of their BEDROOM in a ROBE, also looking ROUGH and perturbed.

HARRY: Nhhh...what TIME is it?

MJ: Two.

HARRY: ...Did I have a good TIME?

15.2 MJ doesn't look at him as he slides in nearby to grab a piece of FRUIT. She just goes to have another SIP of COFFEE.

MJ: Sure.

HARRY: What's the skinny with YOU this morning? Did I do something STUPID at the club?

MJ: It's not you...

15.3 On HARRY. He knows PETER's SECRET, so he's surprised and unhappy he missed him.

MJ (OP): ...it's PETER. He showed up last night while you were stoned. Was classic "holier than thou" Parker.

HARRY: I ...I SEE ...

15.4 The PHONE RINGS. It's across the ROOM near PATIO DOORS letting midday light in. HARRY turns toward it. MJ still doesn't move.

MJ: 'S no big deal. I'll talk to him later ...

SFX: BRRRING!

SFX: BRRRING!

15.5 HARRY answers the PHONE. We see him from BEHIND, so we see the CITY through the PATIO DOOR.

HARRY: ...Hello?

HARRY: Yes ...I'll accept the charges ...

HARRY (balloon w/ own tail): Father?

15.6 On HARRY now, looking subtly evil angry.

HARRY: Of course.

HARRY: I'm READY.

PAGE SIXTEEN

16.1 SPIDEY swinging through the CITY.

PETER CAP: I blew it.

PETER CAP: Working with the GREATEST MIND IN THE WORLD, and I ...I just QUIT.

16.2 CLOSER on SPIDEY, still SWINGIN'.

PETER CAP: God, Gwen's gonna KILL me. We JUST bought the townhouse...

PETER CAP: I hope Professor Warren's offer still stands...

16.3 In WARREN'S LAB. GWEN is pressing BUTTONS on a TUBE filled with LIQUID and a FULL ARM. WARREN is walking toward her.

PETER CAP: ...I'd better head over and STRIKE while the iron's HOT...

WARREN: So, did PETER have a nice TIME last night?

GWEN: It didn't SOUND like it. Home early, in bed without a WORD...

WARREN: Hmm...

16.4 WARREN distracts GWEN from what she's working on.

WARREN: ...Peter is a QUIET sort, isn't he? It always feels like he's holding onto so MUCH...

GWEN: I ...sure, I suppose. He lost his parents when he was pretty YOUNG, and then his UNCLE ...

GWEN: He tends to keep people at a distance.

16.5 WARREN puts a HAND on GWEN'S SHOULDER. She doesn't think much of it. He's always been a little too close.

WARREN: Well, I just HOPE he knows to never push YOU away. You're ...the BEST thing to ever happen to him--

SFX (OP): SkrEEEE!!

16.6 From a DISTANCE, GWEN and WARREN turn toward us. In the FG, we see the SILHOUETTE of an ARM PUSHING an ELEVATOR DOOR OPEN.

WARREN:--What--

VOICE (OP): Pardon ME...

PAGE SEVENTEEN

17.1 BIG SHOT of THE BLACK GOBLIN emerging from the ELEVATOR. There's no ELEVATOR there, just the EMPTY SHAFT and the freshly opened doors, CRUSHED.

BLACK GOBLIN is, obviously, a take on GREEN GOBLIN. He looks COOL, almost entirely SHINY BLACK with some GOLD ACCENTS. His EYES are GOLD. He has a POUCH for GOBLIN BOMBS.

HE FLOATS on an updated GOBLIN GLIDER.

 GOBLIN: ...but I have some BUSINESS to conclude.

17.2 GWEN is scared. WARREN is NERVOUS.

 GWEN: Oh my GOD, who--

 WARREN: PLEASE, just--just--we can TALK about this...

17.3 GOBLIN moves IN, ASSURED, standing STRAIGHT on his GLIDER.

 GOBLIN: There's nothing to SAY, PROFESSOR. Your BENEFACTOR, the man who PAID for all of this, would like what was PROMISED.

 GOBLIN: He's heard ...WORD ...that you've BROKEN your AGREEMENT and gone ahead with future INSTALLMENTS ...

17.4 GOBLIN picks up WARREN by the NECK. GWEN is freaking OUT.

 GOBLIN: ...which could RUIN his plans, so he sent THE BLACK GOBLIN to take what's rightfully HIS!

 WARREN: I wouldn't--GKK!--

 GWEN: STOP IT! LEAVE HIM ALONE!

 SPIDEY (OP): Yeah, pal--

PAGE EIGHTEEN

18.1 SPIDEY is on the scene, PUNCHING GOBLIN off his GLIDER!

 SPIDEY:--he gave at the OFFICE!

SFX: kerACK!

 GOBLIN: NH!!

 SPIDEY: Oh, WAIT! This IS the office!

18.2 GOBLIN sends his GLIDER at SPIDEY, which SPIDEY manages to AVOID. GOBLIN pulls out a GOLD PUMPKIN BOMB.

 SPIDEY: So, what are you LOOKING for then? Money? A NEW super villain theme that isn't so PLAYED OUT?

 GOBLIN: I'll SHOW you what I'm looking FOR...

18.3 GOBLIN taps the side of his HEAD and his EYES become a SERIES of GOLD and slightly DARKER GOLD HORIZONTAL LINES.

 GOBLIN: ...once I SCAN the PREMISES...

SFX: Tak

18.4 GOBLIN tosses the BOMB across the ROOM at a WALL. SPIDEY jumps and looks like he's going to try and WEB it.

 GOBLIN: ...THERE!!

 SPIDEY: Whoa! What are--

PAGE NINETEEN

19.1 An EXPLOSION! WARREN protects GWEN as the BOMB explodes the WALL.

SFX: SKRA-BOOM!!!

19.2 SPIDEY jumps over to GWEN as her and WARREN look up from the GROUND at what was REVEALED. WARREN looks like he has SHAME.

 SPIDEY: GWEN! Are you--

19.3

 GWEN: I'm ...I'm fine ...

 GWEN: I ...

WARREN: I didn't mean to ...

GOBLIN: My god ...

19.4 SPIDEY stands, in SHOCK. Behind him is BLACK GOBLIN, taking off his MASK, revealing HARRY, but they're BOTH staring in disbelief at what was revealed.

SPIDEY: This ...this can't be ...

HARRY: ...what have you DONE

PAGE TWENTY

20.1 REVEALED! THREE LIQUID-FILLED TUBES with PEOPLE inside! All are wearing WHITE BODYSUITS with wires and TUBES attached, leading to the TOP and BOTTOMS of the TUBES. Inside are l-r, PETER 2, NORMAN 2 and GWEN 2

Professor WARREN now stands in-between his CREATIONS and the others.

WARREN: I--I can EXPLAIN...

20.2 HARRY is now ANGRY, yelling toward WARREN. SPIDEY looks at HARRY, somewhat surprised.

SPIDEY: I--Harry?...

HARRY: This was--this was supposed to be JUST MY FATHER! Why--

WARREN (OP): N-No! He--

20.3 WARREN pleads with HARRY.

WARREN:--he wanted a CLONE of HIMSELF, to pin his past CRIMES ON...

WARREN: ...but he also wanted one of P-PETER ...I don't know why ...

GWEN (OP): And--and why...

20.4 GWEN touches the TUBE with GWEN 2 in it. She's thoroughly freaked out.

GWEN (quiet): ...why me?

20.5 WARREN looks down, somewhat ashamed. HARRY gets it now and is ANGRY. His GLIDER is behind him, SWOOPING around, ready to come to HARRY.

> **HARRY:** Parker ...PARKER ...he--he wanted a PETER PARKER to be his HEIR!

> **HARRY:** Even after ALL THIS TIME, after ALL I'VE DONE--

PAGE TWENTY-ONE

21.1 HARRY has JUMPED onto his MOVING GLIDER and has GRABBED SPIDEY by the NECK.

> **HARRY:**--it's always about YOU!!

> **SPIDEY:** Nff!

> **SPIDEY:** Harry, DON'T--

HARRY: It's ALWAYS ABOUT YOU--

21.2 CLOSE as HARRY tears the MASK from SPIDEY as he FLIES toward the CEILING.

HARRY (OP):--PETER!

PETER: D-don't let your--your DAD r-ruin us--

21.3 HARRY and SPIDEY SMASH through the CEILING! Debris everywhere! Obviously, SPIDEY takes the BRUNT of this!

SFX: KRNCH!!!!

PETER: GNH!!

21.4 GWEN, meanwhile, has RUN away from WARREN, and is heading down the STAIRS in the STAIRWELL. We see WARREN at the DOORWAY.

WARREN: GWEN! I--I can EXPLAIN!

GWEN: G-get AWAY from me!!

GWEN: This is SICK!

21.5 WARREN chases down the STAIRS.

WARREN: Please, it's not what it LOOKS like! I NEEDED to--

PAGE TWENTY-TWO

22.1 GOBLIN FLIES UP with SPIDEY still in FRONT, but SPIDEY manages to SHOOT WEBS back where they came from.

GOBLIN: You were my FRIEND! You sent my FATHER to PRISON!

GOBLIN: He REJECTED me because of YOU!

PETER: Nf! Harry--

SFX: THWIP! THWIP!

22.2

NO DIALOGUE

22.3 HOLDING tight to the TAUT WEBS, SPIDEY has his FEET on HARRY's CHEST as HARRY goes flying OVER him, losing his GLIDER. (Can you picture this, Mark? I'm afraid I'm not describing it well. whatever you do will undoubtedly be better than what I'm thinking)

PETER (FLOAT):--your FATHER--

22.4 HARRY goes crashing down onto a NEIGHBORING ROOFTOP, as SPIDEY flips over, letting GO of the WEBS.

PETER:--is INSANE!

HARRY: GRAH!!

22.5 SPIDEY lands, as HARRY tries to get UP.

PETER: I put him AWAY before he could hurt anyone ELSE! But he's STILL HURTING PEOPLE!

PETER: You! Me! And now GWEN through the PROFESSOR with that--that ABOMINATION!

22.6 CLOSE on HARRY, looking down, his face scrunched up as he realizes he's being played by his father.

PETER: DON'T give him this POWER over you!

HARRY (weak): Hhh ...P-Pete ...I'm sorry ...he just ...

HARRY (weak): ...GETS in my HEAD ...

PAGE TWENTY-THREE

23.1 HARRY, at the EDGE of the BUILDING, throws TWO PUMPKIN BOMBS. PETER, a bit behind him, reaches out as if to say NO.

HARRY: But you're right ...

HARRY: NO more ...

PETER: HARRY, WAIT!

SFX (trailing bombs): fszzz

23.2 From INSIDE the LAB, we see the TWO BOMBS fall down through the HOLE in the CEILING. One is in mid-fall, the other has hit the FLOOR and bounces/rolls along.

SFX: szzz

23.3 CLOSE on the TWO BOMBS, which have STOPPED ROLLING, but start to GLOW. BEYOND them we see the CLONE TUBES.

SFX: szzzsss

23.4 From outside, we see the ROOF blow off and WINDOWS on the other FLOORS blow OUT as the BOMBS go OFF.

SFX: KRA-BOOM!!!

PAGE TWENTY-FOUR

24.1 We see that GWEN and WARREN are OUTSIDE the building, SHIELDING themselves from some falling DEBRIS. SMOKE comes out of the SHATTERED WINDOWS.

WARREN: NOOO!!!!!

24.2

WARREN (weak): Nooooo...

PETER: GWEN!!

PETER: Thank GOD you're OKAY! I can't--

GWEN: Th-the building was EMPTY except for those ...those CLONES!

24.3 SPIDEY lands, grabbing GWEN, so happy she's SAFE. WARREN is on the GROUND, a MESS.

GWEN: You have to SAVE them!

PETER: I--but they're--

GWEN: They're LIVING PEOPLE! We can't--

24.4 SPIDEY SWINGS up to enter the BUILDING, against his better judgement. GWEN yells below.

PETER: Okay! Okay, I'm ON IT!

PAGE TWENTY-FIVE

25.1 SPIDEY in the BUILDING. FIRES have STARTED all AROUND. He covers his MOUTH.

> **SPIDEY:** KOFF! Koff!

> **PETER CAP:** This is--this is MADNESS!

25.2 SPIDEY sees the SHATTERED remains of the TUBES, and two BODIES.

> **PETER CAP:** But if GWEN wants them SAVED...

25.3

> **PETER CAP:** Dammit.

25.4 SPIDEY kneels next to NORMAN 2, who is DEAD and a little grisly. SPIDEY is checking his PULSE. GWEN 2's BODY is NEXT to NORMAN 2, but we don't see her FACE, it's either cut off by the PANEL or DEBRIS in the FG.

> **PETER CAP:** Both "Norman" and "Gwen" didn't make it...

> **PETER 2 (OP, weak):** Hnnnh.....

25.5 We see that PETER 2 is still ALIVE, on the FLOOR near more DEBRIS and FIRE.

> **PETER 2 (weak):** ...nnhnghh...

> **PETER CAP:** He's alive! Of course!

> **PETER CAP:** If he's based on ME, he'd have SPIDER STRENGTH!

25.6 SPIDEY jumps OUT of the BURNING BUILDING with PETER 2 to SAFETY!

> **SPIDEY:** Sorry, GANG.

25.7

> **SPIDEY:** Could only save--

PAGE TWENTY-SIX

26.1 SPIDEY lands with PETER 2. GWEN is horrified at everything, and WARREN runs toward the BUILDING.

 SPIDEY:--FRANKENPETER, here...

 WARREN: No ...NO!!

 WARREN: GWEEEEENNNN!!!

26.2 SPIDEY SHOOTS a WEB to STOP WARREN from RUNNING into the BUILDING.

SFX: THWIP!

 SPIDEY: Whoa, PROFESSOR! Calm DOWN! I'm SORRY your CREEPY EXPERIMENTS didn't--

26.3 WARREN COLLAPSES to the GROUND.

 WARREN: YOU DON'T ...you don't u-understand...

 WARREN: I ...I wanted G-GWEN all to m-myself ...

 WARREN: N-no s-substitutes ...

26.4 On PETER, GWEN coming up behind. It's starting to sink in.

 PETER: W-wait ...what are you--

 WARREN (OP): You would n-never KNOW...

26.5 On WARREN, CRYING, ASHAMED, GRIEVING.

 WARREN: ...that your w-wife was a clone ...

 WARREN:while I held onto m-my Gwendolyne...

 WARREN: ...until we could l-leave and be together...

PAGE TWENTY-SEVEN

27.1 SPIDEY, his FACE pure PAIN, JUMPS back into the BUILDING.

SPIDEY (large): NO!!!

27.2 SPIDEY, inside, looking around, FRANTIC, but the FLAMES are too BIG now, they engulf everything.

SPIDEY: GWEN!! GWEN!!!!

27.3 BACK OUTSIDE the BUILDING, looking UP, we see GWEN, from BELOW, kind of losing her MIND, hands to her HEAD, that real GIL KANE STARE, y'know? BEHIND and ABOVE, in the SKY, is HARRY on his GLIDER. SMALL in the shot, and in SILHOUETTE.

GWEN: Th-this ...this can't be real ...I ...I'm MEI'm

27.4 Push in CLOSE on HARRY'S FACE. He knows what he's done now, his HANDS up to his MOUTH, his EYES giving away pure SORROW and GUILT.

GWEN (OP): ...I'm not

27.5 BIG SHOT, looking down at a SMALL SPIDEY, encircled by FLAMES as he cradles GWEN 2'S BODY. We only see his hunched-over BACK, and we don't see her FACE. It's a sad, solitary shot.

This is a VERY SAD SHOT.

SPIDEY (weak): Gwen....

SPIDEY (very weak): Gwen, no

PAGE TWENTY-EIGHT

28.1 CLOSE as we see a GLOVED HAND put a BAG in the TRUNK of a CAR. It's WINTER. There's LIGHT SNOW falling

PETER2 (OP): ...I think that's everything.

28.2 PETER2 CLOSES the TRUNK, but hasn't turned to us just yet. In the FG is the SILHOUETTE of MJ. We're in a MANHATTAN SIDE STREET, lined with TOWNHOUSES.

BIG HELVETICA TEXT: 1978

 MJ: I--I'm sorry PETER didn't come down ...

 MJ: He just ...

28.3 PETER2 has TURNED and we see he's got a FULL BEARD. GWEN2 is WALKING up with a HANDBAG over her SHOULDER. Her hairstyle has changed somewhat. Definitely no BLACK BAND in it. MJ looks roughly the same, maybe she's toned down her "party look" a bit.

 PETER2: I get it. Trust me.

 PETER2: It's taken me a LONG TIME to accept ...what I am. Even AFTER all the test results.

 PETER2: Having PETER'S memories ...his FEELINGS ...

 GWEN2: But we get a SECOND CHANCE now...

28.4 GWEN2 puts her ARMS around PETER2 and looks UP at him.

 GWEN2: ...as BEN and HELEN PARKER.

 GWEN2: Two COPIES, starting a new life in a new town...

 MJ (OP): I STILL can't wrap my head around it all...

28.5 MJ hugs GWEN2. There's SADNESS there for MJ.

 MJ: ...my FRIEND is gone, but you're ...

 GWEN2: Oh, MJ ...

 GWEN2: ...I have ALL of Gwen's memories ...which means you and I?...

28.6 The CAR drives away, as MJ holds herself against the cold.

 GWEN2 CAP: "...we'll ALWAYS be friends..."

PAGE TWENTY-NINE

29.1 FROM BELOW, we see MJ look up at the UPPER WINDOW of the TOWNHOUSE. PETER's SILHOUETTE WATCHES from the WINDOW, pulling a CURTAIN back to see.

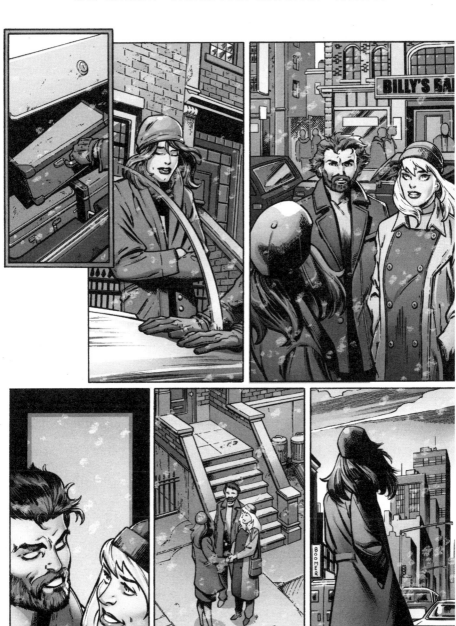

NO DIALOGUE

29.2 On PETER, sitting in a CHAIR, just STARING at a WALL. He looks ROUGH. STUBBLE, an old T-SHIRT. This is his and GWEN'S home, and it's a MESS.

 MJ (OP): Hey, tiger.

29.3 MJ has just walked in, uneasy.

 MJ: They're gone.

 MJ: I ...get that you couldn't see them again, but I ...I think they'll be okay.

29.4 MJ walks toward PETE, who isn't having ANY of it.

 MJ: Their new NAMES, new IDENTITIES will--

 PETE: Will WHAT?

29.5 PETE stands now, incensed. MJ taken aback.

 PETE: Give them a NEW LIFE?!

 PETE: And YOU? HARRY disappeared and left you MILLIONS!

29.6 On MJ, starting to CRY and SHOCKED at the CRUELTY.

 PETE (OP): You got the "new life" YOU always wanted and you don't even have to SLEEP with him anymore!

29.7 PETE RAGES, SMASHES a BOOKSHELF NEARBY.

 PETE: WELL, WHAT ABOUT ME?!

 PETE: WHERE'S MY NEW LIFE?!

PAGE THIRTY

30.1 PETE turns AWAY from MJ so she won't see him crying, and moves toward the WINDOW.

>**PETE (quiet):** I ...it's all ...

30.2 On MJ, TEARS in her eyes. His words hurt, but she's crying because of what he's going through.

>**PETE (OP, quiet):** ...I have nothing ...

30.3 On PETER, SIDE SHOT at the WINDOW, leaning on it, so very sad. One HAND against his EYES as he CRIES.

>**PETE (quiet):** ...nothing...

30.4 SAME, but MJ's HAND touches his SHOULDER and PETER pulls his HAND away from his EYES to turn his GAZE a bit.

>**MJ:** Oh, PETER...

30.5 MJ HOLDING PETER as he collapses in her ARMS.

>**MJ:** ...that's not true at all.

>**PETER (weak):** Hhh...M-Mary Jane ...

30.6 We pull BACK on the TWO holding each other, both lost.

>**PETER (weak):** ...what are we going to do now?...

NEXT: OUR SECRET WARS

SPIDER-MAN

SPIDER-MAN: LIFE STORY

ISSUE #6

2019

"All My Enemies"

By Chip Zdarsky

Art by Mark Bagley, Drew Hennessy,
and Frank D'Armata

PAGE ONE

So! We're opening and closing with similar scenes. FIVE WIDE PANELS. Each one pushes in on the scene more.

1.1 A SHALLOW PANEL that's just BLACK.

PETER CAP: "I've been having the same dream lately."

1.2 It's the famous scene of the BURGLAR running by SPIDEY. It's a long hallway and we see SPIDEY and the ROBBER about to go past him, coming from the right.

PETER CAP: "Of the day Uncle Ben died."

1.3 PUSH in as the ROBBER just goes past SPIDEY, toward the right of the panel, as SPIDEY turns to watch him.

PETER CAP: "The day I let the robber get away."

1.4 PUSH in close on SPIDEY, still watching toward the left of the panel. The ROBBER no longer in the panel.

PETER CAP: "It's so ...REAL. But the FEELING is different this time..."

1.5 MATCH SHOT ON PETER, now. All 72 years of him. He's clearly telling this to someone. Some sadness on his face.

PETER: ...the robber RUNS, but--

MJ (OP): Peter...

PAGE TWO

2.1 MJ kissing PETER. They're both 72 now. MJ is dressed fashionably as always, but casual. PETER is now basically UNCLE BEN with muscles, like BATMAN from DARK KNIGHT. His SPIDER-MAN costume is still rocking the looser pants and SPIDEY boots, but more combat looking. I think he should be wearing a dark JACKET over a SPIDEY-style top, and he still wears GLOVES. He has a UTILITY BELT now as well. There're elements of TECH and ARMOR sprinkled throughout his look, as is the modern way of things. Whatever looks modern and appropriate for a thicker man in his late 60s, early 70s.

They're in a HANGAR, and behind them we see just edges of the hangar for context, but it's mostly just the flat outside land and trees off in the distance. Just outside of the hangar, on the other side of PETER and MJ, is a shuttle looking similar to a QUINJET, angled at 45º for a launch. We DON'T see it from above. I only mention that because we want to reveal a thing on the HOOD of it.

DUSK SUNLIGHT fills the background, light rays stream in and around PETER and MJ. It's beautiful. There's a light SILHOUETTE feel to them to be handled in color, Frankie.

CAPTION: 2019

2.2 MJ strokes PETER's face, smiling, as MILES MORALES comes up to them. He's MASKLESS and has a JACKET on over his costume, which is unchanged from how we know it. He's 21, looking a lot more serious here. He's holding a SMALL BOX.

MJ: ...other people's dreams are BORING.

MJ: And you can bore me with yours when you get back safe and sound, okay?

MILES: Ms. Watson, it's time for us to go.

PETER CAP: I knew she was going to say that.

2.3 PETER's kids, now both 32, come up to join MJ in saying goodbye to dad. CLAIRE is now SPIDER-WOMAN. A cool new design with some tactical armor elements as a result of the drawn-out Civil War. No mask on. BENJY is just dressed like a normal person. Dress shirt and jeans.

BENJY: Just REMEMBER, dad: Once you install the COMPONENT, it'll take at least five minutes for it to charge up and--

CLAIRE: I wish you'd let me JOIN you.

PETER CAP: I knew what my KIDS would say as well.

PETER CAP: Life is remarkably SHORT on surprises the older I get.

2.4 PETER walks toward the SHUTTLE while talking with CLAIRE. MILES also walks behind them, but talks with BENJY about something else. Maybe, just maybe, we see a flagpole somewhere outside. It would have an AMERICAN FLAG, but also a LATVERIAN FLAG, for our eagle-eyed readers.

PETER: You know I need you to stay behind. Protect your mother. Protect your brother.

PETER CAP: CLAIRE is twice the hero I was at her age. No doubts. No hang-ups. Just decisive leadership.

PETER CAP: Shaped in the SUPER HERO CIVIL WAR. A war that's OVER, with BOTH SIDES losing.

2.5 PETER and MILES jump to enter the SHUTTLE through a ROOF HATCH.

PETER: MILES and I'll be BACK before you KNOW it.

PETER CAP: Heroes fighting heroes only leads to one end:

PAGE THREE

Mark, I apologize. This page is DENSE with words and panels. It's the only proper spot for EXPOSITION CITY, so it's out of necessity. I promise it gets better as we go!

3.1 The SHIP BLASTS off. We're looking at it from above as it comes toward us at an angle, as if it would go past us. On the HOOD of the ship, or front, depending on how you'd like to design it, is a metal DR. DOOM FACE embedded into it as a design element. This is clearly some sort of DOOM SHIP.

PETER CAP: The villains win.

MILES (from ship): We'll be at the space station in five minutes. I'll say THIS for Victor Von Doom...

3.2 INSIDE the COCKPIT, it's PETER and MILES, pilot and co-pilot. There's an angle to the viewpoint just to give them the sense of traveling upward. They both have activated their MASKS/HELMETS, which reflect their real masks, but they're, y'know, more helmet-y and bigger. They look like all-glass plates, very futuristic. I picture the "webs" giving off a glow. Slight PURPLE GLOW on PETER'S, emanating from the black line, and RED on MILES. The big difference here is that the WHITE of the eyes is no longer white. It's just TRANSPARENT, so we can see their eyes inset.

MILES: ...he designs a solid SPACESHIP. Remind me again, WHY didn't we just take a proper QUINJET?

PETER: DOOM allows transfer runs to the MOON COLONIES, so we're basically pulling a "Return of the Jedi" and pretending to--

PETER:--sorry. You're probably not up on your 80s classics...

3.3 On MILES, looking ahead, serious.

MILES: I'm familiar.

MILES: Okay, as far as we KNOW, Doom has no idea about Stark's old space lab. There weren't a lot of instructions in the wake of Tony's disappearance...

MILES: ...but if we do this RIGHT, the DOOMSDAY MACHINE will shut down all of DOOM'S TECH on a global scale. Then the station's AUTO-DESTRUCT kicks in, ensuring that

no one can reverse the process.

PETER CAP: MILES MORALES is incredibly smart. He's been growing leaps and BOUNDS with his scientific studies lately. It's hard to believe...

3.4 FB PANEL! If we can somehow do this as a WIDE PANEL--which will be tricky here, I know, sorry--then we can do it almost exactly like PANEL ONE from ISSUE ONE, except it's MILES' HAND getting bit by a spider.

PETER CAP: ...that the same thing happened to HIM that happened to ME all those years ago.

PETER CAP: Bit by a spider. Became a hero.

PETER CAP: He even called himself "SPIDER-MAN" while I was presumed DEAD for a while, if you believe it...

3.5 On PETER and MILES as PETER works some CONTROLS.

PETER CAP : ...but I don't mind. He EARNED it.

PETER: Then the RESISTANCE gets the jump, and voilà! A toasty Victor Von-fire and dancing Ewoks.

MILES: This really isn't the time for levity, Peter.

PETER: Oh Miles, you've gotten so SERIOUS. I went through that phase too, but you'll soon learn that you'll NEED the jokes to keep yourself sane. Trust me.

MILES: Hm. Well, we should still be on HIGH ALERT up here.

3.6 On PETER, looking up and out of the COCKPIT, a little bit of sadness in his eyes.

MILES (OP): If Doom suspects anything, he'll surely send your ENEMIES after us.

PETER CAP: He means well. He's eager and strong, a great new HERO.

PETER CAP: But he's young. And I'm OLD...

PAGE FOUR

4.1 BIG SHOT of our SHIP approaching Tony's SPACE STATION. It's not HUGE, but it's not SMALL either. Goldilocks and the three space bears would find it to be just right. It's big enough that there's more than one room in it. My suggestion would be to figure out layouts for the rest of the issue to gain a better sense of what the outside of this thing should look like. Again, MOST of it is a long BOX, which is its HALLWAY, where a lot of our action is going to take place.

 PETER CAP: ...and all my villains are dead.

4.2 From inside the STATION, PETER and MILES enter. There's gravity in here. PETER holds the SMALL BOX. MILES looks around, making sure it's safe.

Now, an important note on the STATION. On one end is the LAB, and on the other is the ESCAPE POD, but what's holding it all together, where most of the action will take place, is the HALLWAY. I know, a hallway, right? Not that exciting! But it will be! I just know it! The reason I want the action centered on the hallway is so it kind of mirrors the dream PETER had of that hallway where he let the robber get away. It's a subtle thing, but if anyone picks up on it we'll look like real smarty-pants. Cool?

 PETER CAP: It's not just the villains. Cap, Tony, Reed, Jessica ...everyone is either dead or missing. DOOM tore through us.

 PETER CAP: The world was tired of heroes fighting heroes, and Victor Von Doom gave them a steady iron hand.

4.3 PETER and MILES jog toward the LAB, MILES looking at a READOUT on his WRIST telling him where they should go.

 PETER CAP: I'm the leader now, by virtue of age and experience, I guess. But this NEW generation of heroes like Miles and Claire and Kamala are so much more PUT TOGETHER than I was at their age...

4.4 MILES looks over his SHOULDER at PETER at the entrance of the LAB.

 MILES: This is it. Let's get to WORK.

 PETER CAP: My responsibilities have changed over the

years. I still need to help the world, but now...

4.5 CLOSE on MILES in the FG, walking in, with PURPOSE. PETER behind him, looking over at MILES.

PETER CAP: ...my GREATEST responsibility is to help this generation, give them everything I've GOT before I--

MILES: I think the COMPONENT goes THERE.

PAGE FIVE

5.1 PETER goes to INSTALL the COMPONENT in a CENTRAL MACHINE that rises from the FLOOR. It sits on top, but needs to be PLUGGED in with various wires coming from the MACHINE. MILES looks around, nervous, as he works.

PETER: Phew! I was RIGHT in thinking TONY used AX inputs on the machine. Finishing the FINAL COMPONENT while thinking like Tony was tricky. Had to become a real ASS and be wrong about everything else in life--

MILES: God! ENOUGH with the JOKES, PARKER! We're on the CLOCK!

5.2 PETER puts in the last CABLE, and TURNS his HEAD, eyes narrowed, not liking what he's hearing.

SFX: chk

PETER: ..."Parker?"

PETER: Miles, you REALLY need to take it down a notch before--

5.3 PETER and MILES look up as the LIGHTS go OFF. There's a backup power source, but just enough for some life support lights and to keep the MACHINE running. Their EYES light up a bit from the inside of the HELMETS, which, no, doesn't make a lot of sense, but is a fun visual.

PETER: ...Uh oh.

MILES: Is the MACHINE...

5.4 MILES checks out the MACHINE as PETER heads to the HALLWAY.

MILES: On the backup power source, thank god. It'll still need TEN MINUTES to charge up and create the GLOBAL DISRUPTOR PULSE. I don't think this will disrupt the auto-destruct either...

PETER: Okay, good. I'll go see what's going on. Hopefully TONY just has the station power set to cycle for conservation.

5.5 PETER in the hall. It's DARK, but there's some light coming in from a WINDOW.

PETER CAP: Miles is under a lot of pressure. I need to give him some SLACK. I didn't even ASK him if this is his first time in SPACE.

PETER CAP: It can really mess you up the first time.

5.6 On PETER's FACE as he sees outside the WINDOW. It's NOT GOOD.

PETER CAP: The feeling of being utterly alone, in such a cold, hostile...

PAGE SIX

6.1 From PETER'S POV, we see outside the STATION and, backlit by the SUN peeking out from behind EARTH, is the wreckage of their SHIP, floating in SPACE.

NO DIALOGUE

6.2 PETER turns from the WINDOW, shouting.

 PETER: MILES! PROTECT THE MACHINE! WE HAVE VISITORS!

6.3 PETER, in a DEFENSIVE POSE, looks around. There's NOISE coming from all around.

 PETER CAP: Dammit, it's NEVER easy.

 PETER CAP: Spider-sense isn't going off, though, so maybe whatever it is is FRIENDLY...

SFX: TAK

SFX: TOK

SFX: TNK

6.4 PETER moves farther into the STATION'S DARKNESS, looking around.

 PETER CAP: ...which would be a FIRST.

 PETER CAP: No matter WHAT, I should draw it AWAY from MILES and the MACHINE. Still need time for it to--

 KRAVENOM (all in the VENOM style) (floating): Peeeeter Parkerrrr.

6.5 CLOSER on PETER, wide-eyed, looking around. SWEAT seen on his face through the MASK'S EYES.

 KRAVENOM (floating): We once told you...

 KRAVENOM (floating): ...that we'd go to the ENDS of the EARTH...

 PETER CAP: NO.

PAGE SEVEN

7.1 BIG PANEL! From above we see KRAVENOM pounce to attack from the SHADOWS!

It's as it sounds! KRAVEN combined with VENOM! So, still all BLACK and WHITE, but where KRAVEN'S LION VEST usually is, it's now more VENOM-Y tendrils instead of fur, billowing off him like creepy hair. Any other touches you want to add to make him recognizable as KRAVEN, yet VENOM, go for it! Maybe the strip which would be his CHEST/STOMACH is straight BLACK, and the SPIDER SYMBOL is split in two, like it's the vest!

 KRAVENOM: ...TO HUNT YOU!

7.2 KRAVENOM manages to get the DROP on PETER, KNOCKING him BACK.

 KRAVENOM: It turns out we'd even go BEYOND EARTH!

 PETER: NGH!

 PETER CAP: Kraven! THAT'S why my SPIDER-SENSE wasn't going off! The SYMBIOTE doesn't TRIGGER it!

7.3 KRAVEN delivers a mighty PUNCH to PETER, sending him FLYING. He's SHATTERED the HELMET.

 PETER CAP: The older I GET, the more I RELY on it to--

 SFX: KraSKRAH!

 PETER: NGH!!

PAGE EIGHT

8.1 PETER skids past MILES, who is RUNNING to FIGHT.

 MILES: I've GOT this.

 PETER: Nff!

8.2 MILES avoids a STRIKE by KRAVENOM.

 KRAVEN: Ah yessss...

KRAVEN: ...the LITTLE SPIDER. I was going to WAIT to hunt you. Until you were READY...

8.3 MILES lands a BLOW.

KRAVEN: ...until you were a CHALLENGE, a--HNH!

SFX: shTOK!

MILES: You'll find I'm MORE than enough for you, SERGEI. You're just an OLD MAN in a fancy su--

8.4 KRAVENOM GRABS MILES by the HEAD, smashing him into the WALL, CRACKING his MASK/HELMET.

SFX: sKRNCH!

MILES: hNGH!

KRAVENOM: Simple CHILD...

PAGE NINE

9.1 CLOSE on MILES'S HEAD, the MASK/HELMET falling APART as KRAVENOM'S TENDRILS are reaching in and essentially suffocating him.

> **VENOM (OP):** ...you don't KNOW power yet. So here's a TASTE...

> **MILES:** Gkk ...mf

9.2 On KRAVENOM, enjoying this.

> **KRAVENOM:** Let my OTHER INFECT you, let it become a PART of you and we can do great THINGS together, you and--

9.3 SAME, but KRAVENOM is a little SHOCKED and DELIGHTED.

> **KRAVENOM:**--I.

> **KRAVENOM:** You.

> **KRAVENOM:** Ha ha. HA HA!

9.4 On PETER, getting up from the GROUND, his HELMET is fully off/ shattered now. He's adjusting something on his WEB SHOOTER.

> **KRAVENOM (OP):** Oh, this is RICH! Well PLAYED, old friend!

> **PETER:** nhh...Kraven...

SFX: tak

9.5 CLOSER on PETER as he looks ANGRY, holding his SHOOTER/FIST up, the SHOOTER charging up his FIST with SONIC ENERGY.

> **PETER:** ...you're not anyone's FRIEND...

SFX: sweeEEEEEE

PAGE TEN

10.1 BIG PANEL! PETER has LEAPT and PUNCHED KRAVENOM with a SONIC PUNCH! The SUIT just EXPLODES off of KRAVEN, who, we learn here, is just a SKELETON! Just BONES, about to tumble to the GROUND! MILES drops as he's released! A lot going on here, apologies!

SFX: EEEEEKRAH!!!!

 VENOM SUIT: SkkYAHHH!!!!

10.2 The SKELETON drops to the GROUND, the costume has dissipated, is essentially unconscious.

SFX: tak tok tak

10.3 MILES is GETTING up, no more MASK, looking a little rough. PETER in the FG, back to MILES, shutting down his SONIC WEB SHOOTER. PETER looks serious.

 PETER: ...and all my enemies are dead.

 PETER: Isn't that right...

PAGE ELEVEN

11.1 WIDE PANEL with some distance between them as PETER turns to look at MILES.

 PETER: ...OTTO?

11.2 On PETER, serious.

NO DIALOGUE

11.3 On MILES, looking like he has barely concealed rage.

NO DIALOGUE

11.4 SAME. But now he's SNEERING.

 MILES: Parkerrr...

11.5 MILES shoots TWO WEBS, aggressively, toward PETER's FACE as PETER pulls a semi-Matrix back lean, his SPIDER-SENSE warning him as HE shoots a WEB toward MILES, which misses him as MILES jumps

UP. Basically, we're showing them with their SPIDER-SENSES going off, warning them of their respective attacks.

SFX: THWIP! THWIP!

SFX: THWIP!

PAGE TWELVE

12.1 MILES goes to PUNCH PETER, but PETER dodges, using SPIDER-SENSE.

 PETER CAP: TWO MEN with SPIDER-SENSE should make it IMPOSSIBLE to land anything...

12.2 PETER tries the SAME, but MILES' SPIDER-SENSE warns him. ALSO, he's using his CAMOUFLAGE ABILITY now.

 PETER CAP: But MILES has tricks that I DON'T, throwing me off VISUALLY ...

12.3 MILES, CAMOUFLAGED, indeed LANDS a PUNCH.

 PETER CAP: ...and my REFLEXES aren't what they used to--

 PETER: NHH!

12.4 MILES GRABS PETER by the NECK, PUSHING him into a WINDOW,

which is CRACKING. At this point, the STATION is taking so much
damage there should be SPARKING and CRACKING spreading, like it
could fall apart.

 MILES: It was PERFECT!

 MILES: PERFECT! How did you--

 PETER CAP: Keep him talking until you can figure a way
out...

 PETER: Hnh! At first ...little things...

12.5 Close on PETER.

 PETER: Funny sayings ...using Kraven's real name ...and
then HE clearly SAW something when the symbiote grabbed
you...

 PETER: But really, your TECHNICAL work was TOO GOOD,
Otto. And more than that ...it was ...

PAGE THIRTEEN

I'm loading this page up with panels, Mark. Only to 1. torture
you, and 2. to give a sense of claustrophobia before the next page
reveal.

13.1 MILES, still holding PETER by the NECK as PETER tries to pry
his HANDS off. MILES'S FACE has moved in CLOSE to PETER.

 PETER: ...OLD. Outdated.

 PETER: Like y-NGH!.

 MILES: It was going to be YOU! I'd planned it for so
LONG!

13.2 On MILES.

 MILES: My body, weak and ancient, locked away in
CRYOSTASIS as I inhabited my GREATEST ENEMY.

 MILES: But YOU'RE almost as BROKEN as I am. And THIS
young man ...

13.3 On PETER.

MILES (OP): ...an entire life AHEAD of him, of US...

PETER (weak): H-how did you...

13.4 We see this from OUTSIDE the STATION, the CRACKS SPREADING ALONG THE WINDOW. PETER'S BACK, MILES'S FACE.

MILES: DOOM was the key. He UNLEASHED the POWER OF MY MIND, and all he needed from ME was to keep TABS on YOU!

MILES: But I TURNED ON HIM! Don't you SEE?! I'm a HERO now! SUPERIOR to ANY OF YOU!

13.5 On PETER, choking, struggling.

PETER (weak): Nhh...real "hero," Otto ...

PETER (weak): S-sentence a young man to DEATH ...and murder an OLD MAN with his body ...

PETER (weak): A g-genius ...who c-couldn't even prove it ...just a BRUTE ...

13.6 On MILES, grinning and angry.

MILES: I could EASILY kill you with this body.

MILES: But it would be more REWARDING to best you in the only way that matters ...

13.7 MILES'S head CLOSE to PETER'S as WHITE LIGHT starts to flood the panel.

MILES: ...with my MIND.

PETER (weak): wh--what're y--

PAGE FOURTEEN

14.1 BIG PANEL, ALL WHITE, YOU'RE WELCOME, MARK. We're in PETER'S MIND. PETER is small in the panel, looking around. He's in his current SPIDEY costume, no mask, no injuries.

FRANKIE! This whole scene should have a lovely glow to it, to heighten the dreamy ethereal nature.

PETER:--ou...doing ...

14.2 PETER turns and sees DOC OCK. We see his BACK.

 OTTO: It's simple, PARKER...

14.3 On OTTO. It's an idealized version of himself. I'd say the version from your SECRET WARS panel, Mark. Full OTTO, but not so old that he has problems. He has his TENTACLES. He's CALM.

 OTTO: I'm going to DESTROY your mind.

 OTTO: The BRILLIANT disciple of REED RICHARDS, of MILES WARREN, of NORMAN OSBORN...

 OTTO: I'm not going to TAKE OVER your BRILLIANT BRAIN like I did with YOUNG MILES...

PAGE FIFTEEN

15.1 I'm picturing a slightly low angle, looking up at DOC as he lifts his ARMS, like a satisfied dictator. BEHIND and above him are freshly materialized versions of GREEN GOBLIN, RHINO, VULTURE, VENOM and ELECTRO. A sinister six. If there's anyone you want to swap out, let me know! I think the only ones who NEED to be there are Goblin and Venom.

 OTTO: ...and I'm going to POUND it into DUST.

15.2 On PETER, tight-lipped, brow furrowed, in a POSE that's waiting for the FIGHT.

> **PETER:** You and what army?

PAGE SIXTEEN-SEVENTEEN

16-17 A DOUBLE PAGE SPREAD! It's SPIDEY versus OCK, but also the rest of the SIX about to trade blows with what SPIDEY has conjured: FIVE VERSIONS of SPIDEY! Basically one from each issue. Each era we've covered, coming in from the right to take on the bad guys who are coming in from the left.

> I pictured them ABOUT to clash, while our SPIDEY and OCK have already started trading blows in the FG, but maybe it's better to have everyone scuffling? I kind of like the contrast between the SOON-to-be-a-fight in the background and the already-in-progress fight in the FG as our focus.

NO DIALOGUE

PAGE EIGHTEEN

18.1 SPIDEY and OTTO tussling.

> **SPIDEY:** We've done this DANCE before, OTTO.

> **SPIDEY:** A LIFETIME of it.

18.2 On one of the SPIDEYS punching a VILLAIN.

> **SPIDEY CAP:** "And it always ends the same way."

18.3 SPIDEY clocks OTTO.

> **OTTO:** hnF!

> **SPIDEY:** So what makes you think...

18.4 ANOTHER SPIDEY trounces ANOTHER VILLAIN.

> **SPIDEY CAP:** "...this time would be any DIFFERENT?"

18.5 OTTO wipes BLOOD from his MOUTH, looking like he's about to SMILE.

> **OTTO:** BECAUSE ...

> **OTTO:** ...YOU'RE still the same stunted MAN-CHILD you always were. Whereas I've ...

PAGE NINETEEN

19.1 The VILLAINS have all been replaced with a MEGA DOC OCK! A GIANT version of DOC OCK, but maybe possibly infused with the looks/powers of the other SINISTER SIX members? Could look quite cool. When they make it into a toy I'd like it to be called "Chip 'n' Mark's DOC SINISTER." We'll be rich!

Anyway! This DOC SINISTER is HUGE. Our regular OTTO is still there, ready to send DOC SINISTER into battle.

> **OTTO:** ...EVOLVED!

> **OTTO:** So, SPIDER-MAN...

19.2 DOC SINISTER goes to SMASH SPIDEY, who just manages to dodge!

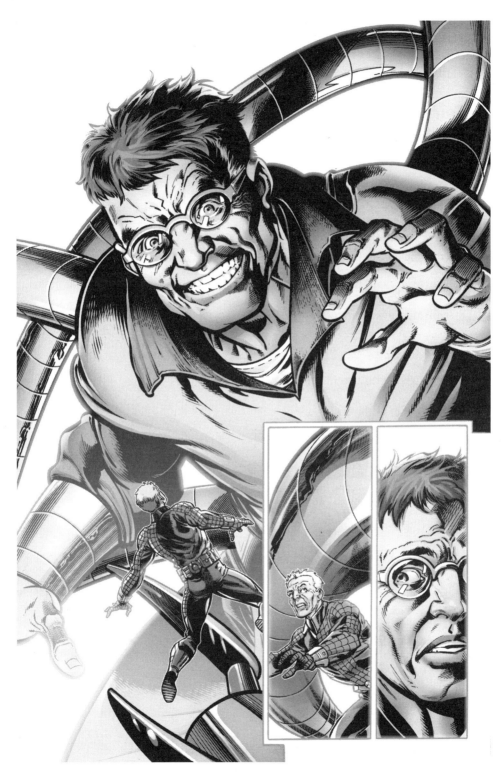

OTTO (OP): ...any MORE tricks up your SLEEVE? Any more WAGGISH remarks?

19.3 On OTTO, looking at something OP, stunned into SILENCE.

OTTO: Or are you READY to ...to ...

PAGE TWENTY

20.1 We see beyond PETER is AUNT MAY. Classic AUNT MAY. Standing there, hands folded in front of her. A little SMALL in the panel, alone, looking right at us/OTTO.

NO DIALOGUE

20.2 PETER stands aside as OTTO meekly approaches MAY.

OTTO: M-May?....

MAY: Otto.

MAY: What have you DONE?

OTTO: I--I just ...

20.3 On MAY. Understanding and sad.

MAY: You were always so ANGRY at the FUTURE. I LOVED you, Otto, but you could never accept the world around you ...

MAY: ...or our LIMITATIONS.

20.4 On OTTO, brow wrinkled with inherent sadness as he looks down, somewhat shamed.

OTTO (quiet): It's not FAIR, May...

OTTO (quiet): It's not FAIR you died, that I'LL...

MAY (OP): No, Otto...

20.5 MAY puts her HAND on OTTO's face, tender.

MAY: ..what's NOT FAIR is taking a young man's LIFE just so you can CORRECT your mistakes.

MAY: You've LIVED your life. I lived MINE. You want to be the HERO now?

MAY: Let Miles go. Let your hatred for PETER go.

MAY: It was never a competition for my LOVE, Otto.

20.6 MAY hugs a crying OTTO.

MAY: There's no LIMIT on love.

OTTO (weak): M-May ...I'm s-so scared, I ...

MAY: It'll be okay, Otto. Trust me...

PAGE TWENTY-ONE

21.1 MAY opens her ARMS AND looks as OTTO leaves her ARMS as DUST blowing away. It's a little AVENGERS: INFINITY WAR (spoilers).

NO DIALOGUE

21.2 PETER smiles a little bit at MAY, who turns to him.

PETER: Fought that guy for DECADES and a MEMORY of you just beat him with a hug...

MAY: Oh, Peter, it's SIMPLE.

MAY: Everybody WANTS something. It's almost never about horrid FISTICUFFS or "world domination."

21.3 PETER smiles. Even the memory of AUNT MAY is smarter than he is.

PETER: Heh. Then what do I want, May?

MAY (OP): Nothing ever really changes...

21.4 On MAY, smiling sweetly.

MAY: You've managed to have a beautiful life. With Mary Jane. Sweet Benjy and Claire. It fills my HEART knowing that.

MAY: That's what you HAVE, though. What you WANT ...

21.5 MAY strokes PETER's face like she did OTTO.

MAY: ...what you want is to save BEN.

MAY: But you can't. So you save EVERYONE ELSE.

MAY: You realized years ago that'll never change, so you embraced it.

MAY: So go, PETER. My sweet boy ...

21.6 PETER and MAY look up and around as CRACKS in the WHITE start to appear behind and above PETER.

SFX: chk CHK CRK

21.7 On MAY, her face resolute, WASHED OUT with WHITE as CRACKS appear all around her. This mind world is falling apart.

SFX: CRK CRACK

MAY: Save everyone.

PAGE TWENTY-TWO

22.1 BACK in the REAL WORLD. The WINDOW of the SHIP has finally given way and PETER and MILES are getting blown out of the HOLE. This is from OUTSIDE so we see merciless SPACE and GLASS flying out and away. MILES is almost unconscious.

PETER CAP: Save everyone.

22.2 PETER, eyes squinting, clearly holding his BREATH, shoots a WEB back toward the STATION, OP, as we see EARTH and the SUN behind him.

> **PETER CAP:** But put your oxygen mask on before helping others...

22.3 PULL back so we see PETER'S WEBLINE attached to the STATION as PETER JUST manages to grab an UNCONSCIOUS MILES before he floats away.

> **PETER CAP:** Damage from the FIGHTING, the WINDOW blown out ...

> **PETER CAP:** ...this STATION isn't going to LAST long enough to deploy Stark's DOOMSDAY PULSE...

22.4 PETER's STICKY FINGERS GRAB onto the INSIDE of the STATION as he PULLS MILES in with him, DEBRIS and PAPERS and KRAVEN'S BONES flying past him out the HOLE.

> **NOTE:** Inside, the STATION is now RED from EMERGENCY LIGHTS.

> **PETER CAP:** All right, PARKER...

22.5 PETER, presumably OPPOSITE the HOLE, one arm reaching out, across MILES, like someone driving a car who instinctively reaches across to protect the passenger. PETER'S FINGERS are touching the WALL behind them, to stop them from flying out. His OTHER HAND is SPRAYING a BUNCH of WEBBING.

> **PETER CAP:** ...need to buy some TIME.

PAGE TWENTY-THREE

23.1 PETER carries MILES down the HALL as we see behind him that PETER COVERED the HOLE with WEBBING. Still SPARKING and CRACKING everywhere. Should feel like it'll all fall apart at any moment. PETER lifts his free HAND up to TALK into his WRIST.

> **PETER:** How much LONGER until the DOOMSDAY PULSE is activated?

> **WRIST (electronic):** Four minutes and twenty-nine seconds.

PETER: Keep me UPDATED.

MILES (weak): Nhhh....

23.2 On PETER, seeing something and being dejected.

PETER CAP: Get Otto and Miles to safety...

PETER CAP: Oh, #$%@.

23.3 We see from behind PETER an ESCAPE POD. It looks like a SLEEK COFFIN, but with an IRON MAN CIRCLE on it and a VIEWING PORT at head level. Standing upright, maybe leaned back a little, so someone doesn't just fall forward while in it.

MILES (OP, weak): P-Parker ...what's ...

PETER CAP: There's only ever one parachute.

PETER: All right, Otto. Here's the DEAL.

23.4 PETER puts MILES in the POD.

MILES (weak): Parker ...what're y-you ...

PETER: Someone's gotta stick around, make sure this WORKS, Otto.

PETER: Go BACK. BE a HERO. GIVE MILES his LIFE BACK.

PETER: PROMISE ME. Promise MAY.

23.5 PETER closes the LID as we see MILES'S face, finally coming to, wanting to get OUT of the POD to help PETER.

MILES: No! Wait! Let me HELP! We can SAVE EVERYONE!

PETER: Sorry, Doc...

23.6 From outside the STATION, we see the POD eject toward EARTH.

PETER CAP: "...can't let you sacrifice a life that's not your own."

PAGE TWENTY-FOUR

24.1 PETER runs down the HALL, shooting WEBBING EVERYWHERE, trying to PATCH up the SHIP.

 WRIST (electronic): Two minutes and thirty seconds.

 PETER CAP: Ship's falling APART!

 PETER CAP: Faster than I can PATCH IT!

SFX: THWIP THWIP THWIP

SFX: crk CRACK

SFX: RmmmbleCRACK!

24.2 Looking up, as PETER FRANTICALLY turns around, firing MORE WEBS to the SIDES as we see above him the HALL about to SPLIT down the LENGTH of it.

 PETER CAP: Going to split in HALF unless I can--

SFX: THWIP! THWIP!

SFX: CRACK! KrCHAK!!

24.3 PETER, CENTRE, holding a BUNCH of WEBS, struggling to KEEP it all together.

WRIST (electronic): One minute and thirty seconds.

PETER CAP: Out of ...out of WEBBING ...just need to HOLD on until ...

SFX: Krrrr--

24.4 The END of the HALLWAY basically FALLS AWAY into SPACE.

PETER CAP: No.

SFX (large):--KRACK!!!!

24.5 On PETER'S FACE, once again exposed to the COLD of SPACE, the OXYGEN whipping PAST him with more DEBRIS. His eyes are closed TIGHTLY.

He is LIT BY THE SUN.

WRIST (electronic, floating): Forty seconds.

PETER CAP: I'm sorry...

PETER CAP: Aunt May, I'm sorry ...I wish I could be STRONGER ...could

24.6 SAME, but PETER'S EYES open. His HAIR is no longer being BLOWN by the OXYGEN.

There are now just a few SPOTS of LIGHT on him, as something is BLOCKING the light.

NO DIALOGUE

PAGE TWENTY-FIVE

25.1 BIG PANEL. We see what's BLOCKING the HOLE. It's the SYMBIOTE, stretched out, filling the GAP. Not COMPLETELY, as some LIGHT comes in through the odd tiny GAP, but he's holding things together.

NO DIALOGUE

25.2 SIMILAR to **24.5**, but there's sadness and happiness in PETER's tired eyes. That's easy to draw, yeah, Mark?

NO DIALOGUE

25.3 SAME, but PETER closes his EYES.

 PETER CAP: "Mary Jane ...I think I did it ..."

PAGE TWENTY-SIX

26.1 We're back in PETER'S MIND, the WHITENESS. He's lying on a bed with MJ. They're both fully dressed in regular clothes. PETER is on his side, looking at MJ as she lies on her back, looking up.

PETER: I think everything's going to be all right.

MJ: Of COURSE it is...

26.2 Back on REAL PETER, eyes closed TIGHTLY.

WRIST (electronic, floating): Doomsday pulse activated.

MJ CAP: "..it's what you DO."

26.3 PETER looks at MJ, smiling.

PETER: Will Otto do the right thing?

MJ: Yeah, I think so.

PETER: Will Benjy and Claire be all right?

MJ: We taught them well.

MJ: And I'm not going anywhere any time soon...

26.4 Back to REALITY, we see the ELECTRIC NET now, SPREAD from the STATION, making its way around the EARTH.

MJ CAP: "...unless I ALSO get bit by a radioactive spider and have to put myself in jeopardy every day...."

PAGE TWENTY-SEVEN

27.1 PETER and MJ, face to face in bed, both smiling.

MJ: But how can you even believe me, tiger? I'm just your BRAIN cooking up an MJ CLONE--

PETER: Shh, we don't use the "c" word anymore.

PETER: Besides, after decades together, I know you better than I know myself. I know everything you're about to say, how you're feeling, your worries, your

dreams...

27.2 SAME, but PETER and MJ are about to KISS.

 PETER: You're my HEART, Mary Jane Watson...

27.3 VERY CLOSE on REAL PETER as he OPENS his ICY EYES, a SMILE in them.

He is lit by the ORANGE and WHITE of the beginning explosions.

 PETER CAP: "...you're my JACKPOT."

27.4 BIG PANEL of the STATION exploding. It's small in the panel, though. It feels small, lonely, soundless in space.

NO DIALOGUE

A BLACK PAGE here might be a nice beat. You know how I love them black pages!

PAGE TWENTY-EIGHT

28.1 We're in a BLACK HALLWAY, looking into a DOORWAY with some weird GREEN LIGHT. We can maybe make out some TECH STUFF and a MAN in a BLACK SUIT.

 MILES: His funeral was today.

28.2 Inside, we see it's MILES. He's dressed for a funeral, but we see him here looking down at a LIFE SUPPORT TUBE, all wires and pipes and cables feeding into it. If it can look similar to the one DOC OCK was in during the whole Superior Spider-Man storyline, great!

 MILES: Everyone was there. It was like the CITY woke up and realized the world had changed, and they needed to witness that.

 MILES: I'm not sure why I'm HERE ...I think I just needed you to KNOW that.

 MILES: To know that a TRUE HERO was gone.

28.3 On OTTO, so very, very old. He's crying, looking up at MILES, sorry for everything he's done.

 OTTO (weak): I'm ...sorry...

 OTTO (weak): I tried to be my BEST...I never meant to ...

28.4 On MILES. Very conflicted about what's happened, and yet he still visits OTTO.

> **OTTO (OP, weak):** ...I never meant to ...

> **MILES:** I wanted to KILL you, Otto. Just reach down and pull the plugs and end everything.

> **MILES:** But ...but PETER wouldn't have done that. And neither will I.

> **MILES:** You can just lie here and think...

28.5 OUTSIDE an APARTMENT BUILDING. It's MJ's apartment. The SILHOUETTE of MILES looking out the WINDOW.

> **MILES CAP:** "...about the STRENGTH that takes."

> **MJ (from window):** Thanks for coming by. I know it's been...

28.6 INSIDE the APARTMENT. MJ approaches MILES, who has turned his HEAD from the WINDOW. MILES is in a T-SHIRT an JACKET. Casual.

> **MJ:** ...well ...

> **MILES:** Yeah.

PAGE TWENTY-NINE

29.1 MJ hugs MILES spontaneously.

NO DIALOGUE

29.2 MJ goes to grab a SEAT on a COUCH. There's the COUCH and a COMFY CHAIR, around a COFFEE TABLE that has TWO CUPS of COFFEE on it and a BOX. MILES walks toward the CHAIR.

MJ: How've you been ...you know ...handling ...

MILES: Having my LIFE taken over by a MONSTER?

MILES: Not well. I mean, besides the OBVIOUS ...

MILES: ...Every time I INTERACT with someone, knowing they'd talked with me when I was DOC OCK ...I just ...

29.3 MILES sits in the CHAIR, dejected.

MILES: ...it brings it all back. I can't even go out in COSTUME anymore, knowing he was swinging around as me, beating people...

MILES: Every part of my life has been TAINTED. Even the part that was supposed to feel like FREEDOM, swinging

around the city in a MASK...

29.4 MJ slides the BOX over to MILES.

 MJ: Miles, I ...me and the kids were talking, and ...maybe there's something we can do to help.

 MJ: Maybe you just need a fresh start. And I'm not saying you should TAKE OVER, just ...you can alter it, make it your OWN, something NEW ...

29.5 MILES OPENS the BOX, a little taken aback by what he sees inside.

 MJ (OP): I mean ...you already have the NAME...

29.6 It's a CLASSIC SPIDEY COSTUME, with the MASK laying on top of it, facing us.

NO DIALOGUE

29.7 Back on MILES, a slight sad smile on his face.

 PETER CAP: "MJ, look, I KNOW dreams are boring..."

PAGE THIRTY

As promised, here is the follow-up to page ONE.

30.1 This is a RE-USE of **1.2**, the BURGLAR about to run past SPIDEY in a distance shot.

 PETER CAP: "...but I KEEP having this one.

 PETER CAP: "It's the day Uncle Ben died.

30.2 This is a RE-USE of **1.3**, closer, as the ROBBER goes past.

 PETER CAP: "The day I let him get away. It's SO REAL, MJ.

 PETER CAP: "It's like I'm there again. And yes, I KNOW what you're going to say...

30.3 This is a RE-USE of **1.4**, closer of just SPIDEY.

 PETER CAP: "But this isn't me beating myself up again. Like always."

 PETER CAP: "It's different this time."

30.4 THIS is a new one. It's **1.4**, but SPIDEY is lifting his ARM, pointing his WEB SHOOTER, about to SHOOT a WEB, presumably to stop the robber.

 PETER CAP: "It's a good dream."

30.5 And THIS is a RE-USE of **1.1**, the SHALLOW PANEL!

NO DIALOGUE

 THE END

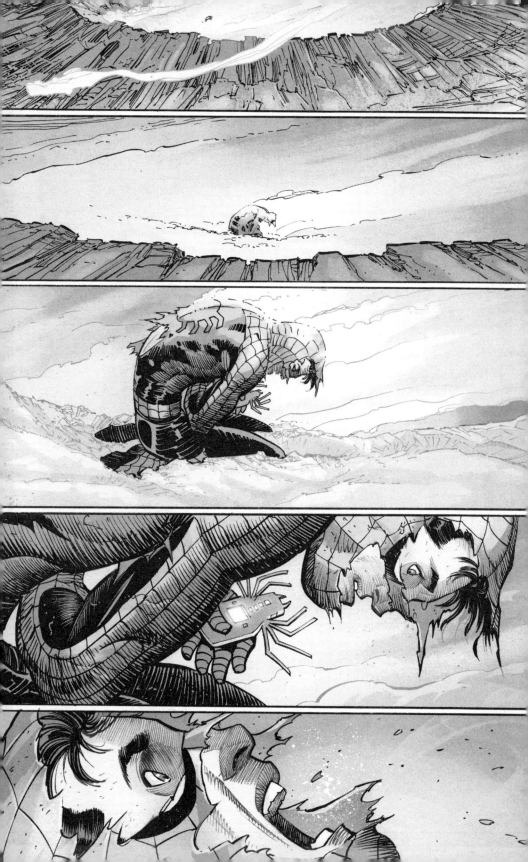

AMAZING SPIDER-MAN (2022) BY ZEB WELLS

AN INTRODUCTION BY **NICK LOWE**
IN CONVERSATION WITH **ANDREW SUMNER**

Get ready for us to beat the crap out of Peter Parker—and then show how he will still get up and save the day as the Amazing Spider-Man!

We launched this latest volume of *Amazing Spider-Man* in 2022, the sixtieth anniversary of Spider-Man. *Amazing Fantasy #15* came out in June 1962 and changed the world, introducing the greatest fictional character ever, created by Steve Ditko and Stan Lee. I mean that. Sorry, Sherlock Holmes and James Bond—you're both second fiddle.

So, we're coming up on the sixtieth anniversary, and I took it upon myself to make the greatest volume of *Amazing Spider-Man* ever to grace this good Earth. And trust me, I know how insane a goal that is. I mean, I've read Steve Ditko and Stan Lee. I've read Stan Lee and John Romita. I've read [classic Spider-Man mini-series] *Kraven's Last Hunt.* I did a lot of thinking leading up to this, trying to boil down what I wanted to do. I knew that I wanted to put together a creative team that could operate on the highest of all possible levels. The things that were in my head leading up to this were that the two previous runs on the book were both pretty historic; we had Dan Slott writing for Humberto Ramos, Giuseppe Camuncoli, Marcos Martín, Stefano Caselli, John Romita Jr., all these amazing artists. Dan's run was historic and amazing—and especially by the end, it went huge. Then we had another terrific run with Nick Spencer writing for Ryan Ottley, Mark Bagley, and Pat Gleason. And Nick went very big the whole time—those are the stories he's into.

One of the things I wanted to make a concerted effort towards was to go small, at least in scope, at the story level. And if that appears to be sort of a contradictory thought, I feel that a lot of times in today's market, especially for these big blockbuster books, creators often go

huge [in terms of scope] as soon as possible. But I knew that I needed a new creative team who, even though the level of the story we were going for might not be huge, it would feel emotionally huge. It would feel huge to Peter Parker himself. I knew I needed a writer who could make a reader feel on a widescreen level. And so, it was a process of wooing one of my favorite Spider-Man writers ever back to comics in a big way. And that's Zeb Wells, who has written two of my favorite Spider-Man stories of all time. There's the Spider-Man/Doctor Octopus *Year One* series that he created with Kaare Andrews (if you haven't read it, run out and get it), and then he worked with artist Chris Bachalo on an arc of *Amazing Spider-Man* which is one of the greatest Lizard stories of all time.

One of the things I love about working with Zeb is that he goes straight to the emotional core—he'll rock you emotionally when you're reading. So I recruited Zeb, and then I had to find the perfect artist to work with him—and I knew I'd be hard-pressed to find a more perfect artist to draw Spider-Man, especially a Spider-Man story that's so emotionally grounded, than one of the greatest Spider-Man artists ever: John Romita Jr. Not only does John have Spider-Man in his genes [he's the son of legendary Marvel art director and classic Spider-Man artist John Romita Sr.], alongside Mark Bagley he's drawn way more issues of *Spider-Man* than anyone else.

John came on board, so I knew that I was in good shape here. When Zeb and I talked with John, it was so much fun—we met close to where I live in Queens, New York, not too far from where Peter Parker grew up (in Forest Hills, Queens). We sat in a park in Queens, and we talked about what we wanted out of the Spider-Man story. We talked about who Peter Parker is and what kind of stories we wanted to tell—Zeb had been researching, reading up on what he wanted to do and, like writer Nick Spencer before him, one of his favorite runs is the *Spectacular Spider-Man* and *Web of Spider-Man* written by [Marvel Comics legend] Gerry Conway—particularly the Tombstone story arc [Conway created Spidey villain Tombstone with Alex Saviuk]. It's amazing how many of our Marvel writers right now grew up reading Gerry's Tombstone stories. So we sat in the park and started dreaming up the direction for *Amazing Spider-Man* #1. We all wanted to do this grounded story, and we also wanted some shots across the bow (as you'll see in the last few pages of this issue). There's a very big Mary Jane moment that I think is gonna knock people on their butts, and there's a very big Doctor Octopus moment that I hope

is going to get people asking questions as well.

That's how this new version of *Amazing Spider-Man* #1 came together, with Zeb and Johnny—I knew Johnny was coming back to Marvel, and so I knew pretty much right away that I wanted them both back on Spider-Man. There are things that are just right, like peanut butter and jelly, like peanut butter and chocolate. They just go together, and Zeb Wells and John Romita Jr. are the peanut butter and jelly of Spider-Man. I think that's what we're getting right here: I'm so happy with this book that we are building, the creative team is gelling so wonderfully. I love this comic.

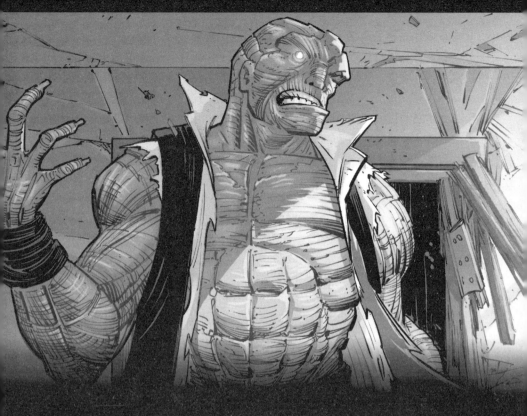

SPIDER-MAN

AMAZING SPIDER-MAN
ISSUE #1
2022

By Zeb Wells

Art by John Romita, Jr.,
Scott Hanna, and Marcio Menyz

PAGE ONE (FIVE PANELS)

1/ In a small crater in the middle of nowhere we can just make out a FIGURE through the smoke.

LOC CAP
Outside York, Pennsylvania.

LOC CAP
Six months ago.

2/ A little closer. We can see the figure is exhausted, on their knees, barely able to hold themselves upright.

FIGURE
(small, barely legible)
guh.

3/ New angle, closer. We can now make out it's SPIDER-MAN. Costume in tatters, clutching something to his chest.

SPIDER-MAN
guh.

4/ Over Spider-Man's shoulder. On the device he holds in his hand. It's shaped like a SPIDER-TRACKER, but it's bigger. Beefier. Green LEDs spot the "abdomen" of the device.

SPIDER-MAN
GUH--

5/ Close on Spider-Man, his mask in tatters. Tears in his eyes as he cocks his head back and SCREAMS.

SPIDER-MAN
(distressed yell, big)
GYAAAAAAAAAAHHHHH--

TITLE PAGE

DOUBLE PAGE TITLE SPREAD. WHITE BLOCK LETTERS ON BLACK:
SIX MONTHS LATER

PAGE TWO AND THREE (TEN-PANEL SPREAD)

1/ Establishing shot of Aunt May's new apartment in Queens. It's modest. She's had to move into a much smaller place to save money.

LOC CAP

Queens.

2/ We're inside now. We can tell it's Aunt May's kitchen by how it's decorated. AUNT MAY sits across from PETER PARKER. There's an awkwardness in the air. May sits up straight, a hot tea in front of her, looking at Peter coolly. Peter is kind of slouched, avoiding her gaze. Depressed and ashamed, he wears a FULL BEARD.

PETER PARKER

(small)

May...

3/ On Peter.

PETER PARKER

May, I--

4/ Facing May, looking at us coolly.

AUNT MAY

Stop, Peter.

5/ May continues.

AUNT MAY

I've stood by you as best I could these past months. It cost me dearly.

(link)

I don't mind being in a smaller place. It suits me, but--

6/ Same angle. Peter looks at us sheepishly.

> ### PETER PARKER
> May, I can--

7/ On PETER, trying to explain.

> ### AUNT MAY
> Shhh shhh.
> (link)
> I can't be lied to again.

8/ On May again. It's hard for her to be this stern with Peter, and it's showing in her eyes.

> ### AUNT MAY
> Something happened to you and you won't tell me what.
> (link)
> Why don't we leave it at that?

9/ Aunt May, heart breaking.

> ### AUNT MAY
> I always knew you kept things from me. But whatever it was seemed to make you happy, so I told myself it was okay.

10/ Aunt May looks away now, emotional.

> ### AUNT MAY
> (small)
> But this...

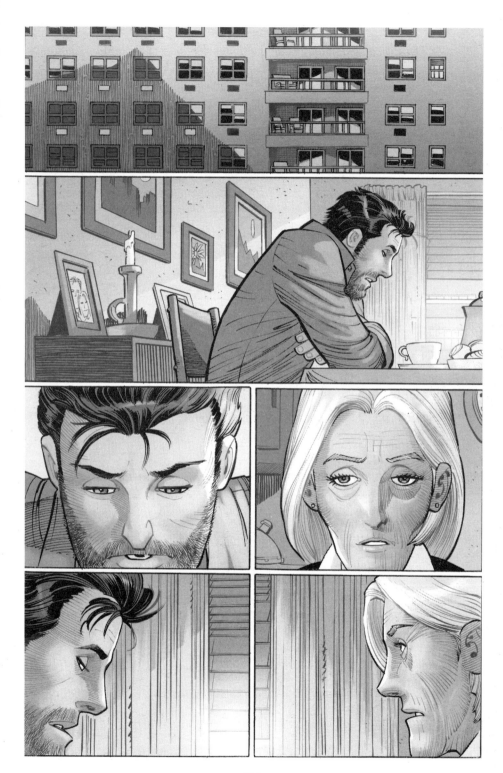

PAGE FOUR (FIVE PANELS)

1/ PETER looks at us, a real sad puppy.

PETER PARKER
May, you have to believe me--

2/ AUNT MAY gets up from the table. She can't do this.

AUNT MAY
I do, Peter.

3/ Facing Peter. May has paused as she walks past him to leave, a hand on his shoulder.

AUNT MAY
That's the problem.

4/ Angled up at May, looking down at Peter sadly.

AUNT MAY
I'll always believe you.

5/ Aunt May is still talking.

AUNT MAY
That's why I can't sit here and listen to you lie.

6/ Peter looks up at Aunt May, who is still talking.

TITLE AND CREDITS

PAGE FIVE

1/ We're in front of a modest (almost dingy) 5-STORY WALK UP off Avenue C in Alphabet City. PETER walks towards us (coming home.) A SLIMY COLLECTIONS AGENT waits for him by the stoop of his building.

LOC CAP
Alphabet City.

GUS
Mr. Parker! Heard you were back in town.

2/ Peter heads past the agent up the stairs. The agent tries to hand him some documentation.

GUS
Wondered if you had a second to go over a statement from McCarthy Medical Center.

(link)

There's still a hefty balance and we'd love to know your plan for paying it off.

PETER PARKER
You the one who called my Aunt?

3/ Facing Peter, not looking happy at all. Behind him the agent smiles like a bastard.

GUS
Mr. Parker, I can't tell you that. But somebody has to take responsibility for the balance.

4/ Peter marches into his apartment.

PETER PARKER
She doesn't have any more money. Don't call her again.

GUS
No idea what you're talking about, Mr. Parker.

5/ Close on the Collections Agent, looking up after Peter. A predator considering its prey.

GUS
Be seein' you.

PAGE SIX (SIX PANELS)

1/ PETER passes through the modest landing of his five-story walk-up, heading towards the stairs. RANDY ROBERTSON leans against a wall, waiting for him.

> **PETER PARKER**
> Oh.

2/ Close on Randy, making a stink face.

> **PETER PARKER**
> (small)
> Hey, Randy.

> **RANDY ROBERTSON**
> "Hey, Randy"?

3/ Facing Peter as he walks up the stairs, depressed. The annoyed Randy trails behind.

> **RANDY ROBERTSON**
> That's what I get? After you drop off the face of the Earth without a word?
> (link)
> Leaving me to pay the rent on an apartment I don't even LIVE IN anymore?

4/ Facing the landing in between floors. Peter heads up another flight. Randy, still following and still annoyed, glares up at him from the landing.

> **RANDY ROBERTSON**
> Leaving me to field calls from everyone you know asking if you're okay.
> (link)
> And May! Do you know what you did to poor Aunt May?

5/ Close on Peter, turning to snap at Randy.

> **PETER PARKER**
> Sorry, should have been more specific.
> (link)
> "Hey, Randy. What do you want?"

6/ Close on Randy, big grin. He needs a favor.

RANDY ROBERTSON
I'm glad you asked!

 (link)

You wouldn't know this since you have
no interest in your friends anymore,
but things are going GREAT with me and
Janice.

 (link)

So good in fact that I'm going to...

PAGE SEVEN (SIX PANELS)

1/ RANDY follows PETER towards the door of his apartment on the 5th floor.

RANDY ROBERTSON
...ask her to marry me.

2/ On Randy. This is exciting for him. Peter looks back at us. He's got a faint smile but we can see he's still sad. Something about Randy's news is hitting him somewhere soft.

PETER PARKER
That's...That's great, Randy. Really.

(link)

Hey man, it was good seeing you.

3/ Peter has turned back towards his door, keys out to unlock it. Behind him Randy is a little taken aback by how quickly Peter is moving on.

RANDY ROBERTSON
That's it? I wasn't really finished.

(link)

See, I'm gonna ask her father for, you know...PERMISSION. Not sure people do that anymore but figured I should.

(link small)

You know, because of all the murders he's done.

4/ On Randy, looking nervous.

RANDY ROBERTSON
Having dinner with him tonight. Think you could call my phone in a couple hours?

(link)

If someone other than me answers ask for proof of life?

5/ We're inside Peter's apartment as Peter enters. Behind him through the door we see Randy peeking in, a little shocked by the mess (would be good if we can suggest it's messy in the apartment. Not like a hoarder lives there, but not well kept up. Clothes and

dishes laying around.

> ### PETER PARKER
> Sure. Again, good seeing you.

> ### RANDY ROBERTSON
> Whoa! When's the last time you cleaned the place? This is why I can't bring Gog over anymore.

> ### PETER PARKER
> Bye, Randy.

6/ Out in the hall with Randy. Door slamming. He looks a little shocked/confused.

> ### SFX
> Slam.

> ### RANDY ROBERTSON
> "Bye, Randy"?
> > (link, small)
> That's it?

PAGE EIGHT (SEVEN PANELS)

1/ PETER stands in his apartment with his back against the door, looking exhausted.

> ### DOOR
> Whatever. Something's not right with you, Peter. Get help, man!
> > (link, yell)
> And the beard isn't working, by the way!

> ### SPID CAP
> Randy, one of my best friends, taking pot shots at me. Thinks I let him down.

2/ He looks down at his SMARTPHONE.

> ### SPID CAP
> The worst part is, he's right. May, Randy, Norman...

> ### SPID CAP
> ...they're all right.

3/ On the smartphone. Peter's thumb hovers over the CALL button of his MARY JANE CONTACT.

SPID CAP

But MJ·...

TEXT

MARY JANE WATSON

CALL

4/ On Peter, thinking better of it.

5/ On the smartphone screen. Peter's thumb has RETREATED.

6/ On Peter again, looking down at his phone, hearing a beep.

SFX

bzzt

7/ On the smartphone screen we see a text from Randy.

TEXT

Yo, Pete! Come on, man. This is ridiculous.

WHERE ARE YOU?

Some guy looking for you. Collections? Where you at?

52 W 136th. 8pm. In case I DISAPPEAR. You remember who my gf's dad is, right?

PAGE NINE (FIVE PANELS)

1/ We're facing the terrifying TOMBSTONE. Ghost-white skin. Trim black suit. He's at a ROUND TABLE with other NYC CRIME BOSSES, but we're just looking at him. He's calm but menacing, holding court. (Johnny, we're saying that Tombstone has been living high on the hog for a while, and as a result has gotten his teeth capped, so they're no longer razor sharp...which lets us save the moment where he regresses and busts the caps off for later, haha.) THE WHITE RABBIT stands behind him, arms crossed. His muscle (it's okay if she's cut off by the top of the panel...I think?)

> **TOMBSTONE**
> No. That's my answer.
>
> (link)
>
> He doesn't have a territory, so I don't deal with him.

2/ Wider shot of Tombstone and some of the crime bosses at the table. We won't get a good look at all of them in this panel, of course, but hopefully we get a good shot of them as we cut around. They are: OWL, HAMMERHEAD, MADAME MASQUE, DIAMONDBACK, BLACK MARIAH, CRIME MASTER and MR. NEGATIVE. Maybe we're at table level and see THE ROSE standing next to one of them. The top half of his body could be cut off by the panel.

> **TOMBSTONE**
> Don't like saying things twice.

> **HAMMERHEAD**
> He's the Kingpin's kid, Tombstone.

> **TOMBSTONE**
> Kingpin's gone.

3/ On THE ROSE, standing there coolly. Unflappable. Watching Tombstone and Hammerhead talk.

> **HAMMERHEAD**
> Still a Fisk. The name will always mean something in this town.

> **TOMBSTONE**
> Not without a territory it doesn't.
> (link)
> It's the way things are. Lions don't deal with hyenas.

4/ The Rose calmly turns to the (off-panel) entrance to the room. Maybe same angle as 3? Do we need this panel?

> **THE ROSE**
> I understand. You doubt my strength.
> (link)
> Very good.
> (link)
> Send him in.

5/ The door is blown off its hinges.

> **SFX**
> crash

PAGE TEN (TWO PANELS)

1/ Digger bursts through the door.

> **OFF SCREEN**
> (huge yell)
> DIGGER?!

2/ DIGGER, the gamma-irradiated monster made out of THIRTEEN DEAD GANGSTERS stands next to THE ROSE. Digger is the Rose's muscle.

> **THE ROSE**
> The gamma-irradiated gangster. Back from the dead.

> **DIGGER**
> There was a green door--

> **THE ROSE**
> (yell)
> Enough with the green door!

PAGE ELEVEN (SIX PANELS)

1/ Close on ROSE.

> **THE ROSE**
> I think we can agree I've got plenty of
> strength.
> (link)
> Or would someone like to disagree?

2/ WHITE RABBIT, totally unfazed, rolls up her sleeves, moving
forward. Ready to fight Digger to the death. TOMBSTONE is waving
her off.

> **WHITE RABBIT**
> #$@%. And I thought I just had to stand
> here and look pretty today.
> (link)
> I got this, Boss.

> **TOMBSTONE**
> Be cool, Rabbit.

3/ On Hammerhead.

> **HAMMERHEAD**
> Where'd YOU get the muscle, Tombstone?

4/ Favoring Tombstone as he turns to explain to the confused CRIME
MASTER.

> **TOMBSTONE**
> Friend of the daughter's. Good kid.
> Insane.

5/ On The Rose.

> **THE ROSE**
> Enough gentlemen. I want the product. And
> I'm offering a fair price.
> (link)
> I won't ask again.

6/ On Tombstone, letting that threat settle. Not intimidated, but
doing the internal calculus. Should I murder this guy?

PAGE TWELVE (FIVE PANELS)

1/ TOMBSTONE leans back, relaxing.

> **TOMBSTONE**
> All right.
> (link)
> Two hours. 143rd and Malcolm.

2/ THE ROSE tenses up. Angry.

> **THE ROSE**
> You want me to come to Harlem? It's
> custom to meet in the middle.

3/ Tombstone stands up, looming over the rest of the table.

> **TOMBSTONE**
> The middle of what? Your territory
> doesn't exist.
> (link)
> You come to me. I have Harlem on lock. I
> guarantee the deal.
> (link)
> Unless someone in here has a reason to
> doubt my word...

4/ SERIES of reverses of the CRIME BOSSES looking anywhere but at
Tombstone. They're not cowed, per se, but this isn't a fight they
feel like having.

5/ Facing Tombstone as he exits, looking dapper in his black suit.
WHITE RABBIT walks behind him, proud to be his muscle.

> **TOMBSTONE**
> That's what I thought.
> (link)
> 143rd and Malcolm. See you around.
> (link)
> Got a dinner to be at.

PAGE THIRTEEN (SIX PANELS)

1/ PETER'S APARTMENT. Over Peter's shoulder (or a POV shot) to his PHONE, and RANDY's TEXT. (We probably don't need to be close enough to read it.)

> **SPID CAP**
> Out the door at 7:15, walk ten minutes to the F, switch to the D. Get to Randy's dinner by eight.

> **SPID CAP**
> Of course I'm going.

2/ Peter puts the phone away, rubbing his FRESHLY SHAVED FACE with his other hand.

> **SPID CAP**
> I'm still a good guy, regardless of what everyone thinks.

> **SPID CAP**
> Though Randy was right about the beard.

3/ Peter stands near his window, his SPIDER-MAN COSTUME laying next to the window. He holds it up in his hand.

> **SPID CAP**
> Putting on the costume feels too much like going on patrol, though.

> **SPID CAP**
> Not up for that yet.

4/ Peter climbs out of his window onto the fire escape.

> **SPID CAP**
> Not even gonna bring it.

5/ Peter wipes his brow. Is it hot all of a sudden?

> **SPID CAP**
> My God, it's hot...

6/ On Peter.

> **JOHNNY (O.P.)**
> Yo, egg head!

PAGE FOURTEEN (FOUR PANELS)

1/ Reveal THE HUMAN TORCH hovering in the sky. He doesn't look super friendly.

> **PETER PARKER**
> (small)
> Oh, God...

2/ Big panel of Human Torch.

> **HUMAN TORCH**
> Got a sec?

3/ PETER shields himself from Torch's heat.

> **PETER PARKER**
> Stay away from me, JOHNNY--
> (link)
> Or at least turn down the heat.

4/ Torch hovers in the air across from Peter.

> **HUMAN TORCH**
> I can't. I told you. It's actually really traumatic for me.
> (link)
> Of course, you'd remember these little things if you weren't completely checked out.

PAGE FIFTEEN (FIVE PANELS)

1/ On PETER, annoyed. On HUMAN TORCH, annoyed at Peter's attitude.

> **PETER PARKER**
> Way I remember it, Reed and Sue don't
> want me coming around anymore.

> **HUMAN TORCH**
> You stole from us, man.

2/ Peter gets a little more heated, pointing at Torch.

> **PETER PARKER**
> I needed your help!

3/ Torch is more angry now.

> **HUMAN TORCH**
> You needed people to look the other way
> while you screwed your life up!
>> (link)
> Were we supposed to let that happen?

4/ Peter leaps off the side of the fire escape, away from the disappointed Human Torch.

> **PETER PARKER**
> Whatever, man. I'm not doing this.
>> (link)
> I've got to check up on a friend.

5/ Close on Torch, his expression turned to sadness.

> **HUMAN TORCH**
>> (small)
> What do you think I'm doing?

PAGE SIXTEEN (SIX PANELS)

1/ Establishing shot of a HARLEM RESTAURANT. There's an alley to camera right of the building, and a window near the alley (for Peter to be peering through later.)

> **RESTAURANT**
> I'd like to thank you for meeting me here
> tonight.

2/ On RANDY, sitting across from the off-panel Tombstone. He's rambling nervously. Terrified.

> ### RANDY ROBERTSON
> I know you're a busy, uh, business man.
> But I actually have some business with
> you, haha.
>> (link, small)
> If you can believe it.

3/ TOMBSTONE sits across from the off-panel Randy, staring at him coldly as he cuts his CHICKEN FRIED STEAK. Tombstone has a NAPKIN tucked in like a BIB to protect his JET BLACK SUIT. He's a successful gangster in his element. Glass of RED WINE next to his plate.

4/ Randy rambles some more, looking away from Tombstone, gathering his courage.

> ### RANDY ROBERTSON
> Right. So...I care about your daughter
> very much. Janice.
>> (link)
> You know her name, of course.
>> (link)
> Yeah. Not sure if you're the traditional
> type, but I wanted to...
>> (link)
> What I'm trying to say is...

5/ Randy looks dead ahead, meeting the off-panel Tombstone's gaze.

> ### RANDY ROBERTSON
> I-I'd like permission to ask your

daughter--for, you know...
> (link)

Her hand in marriage.

6/ Tombstone looks back at him. Coldly. Intense. Is he going to murder this kid?

PAGE SEVENTEEN (FIVE PANELS)

1/ TOMBSTONE looks away, lost in thought.

> **TOMBSTONE**
> When I came up, it didn't matter what you asked for. No one gave you nothin'.

2/ Tombstone looks back at us coldly, meeting Randy's gaze again (Randy off-panel.)

> **TOMBSTONE**
> So you didn't ask.

3/ On RANDY. Petrified.

> **TOMBSTONE (O.P.)**
> You took what you wanted and then you found out if you were strong enough to keep it.

4/ Tombstone leans in a little bit, making his point. He's never looked this cold or dangerous.

> **TOMBSTONE**
> So how 'bout you do what you want, and find out real quick how I feel about it.

> **RANDY ROBERTSON**
> Oh...I...
> (link)
> I don't really--

5/ A small, wry SMILE forms on Tombstone's face.

> **TOMBSTONE**
> Ha. Lighten up, kid.
> (link)
> We both know Janice is gonna do whatever she wants anyway.

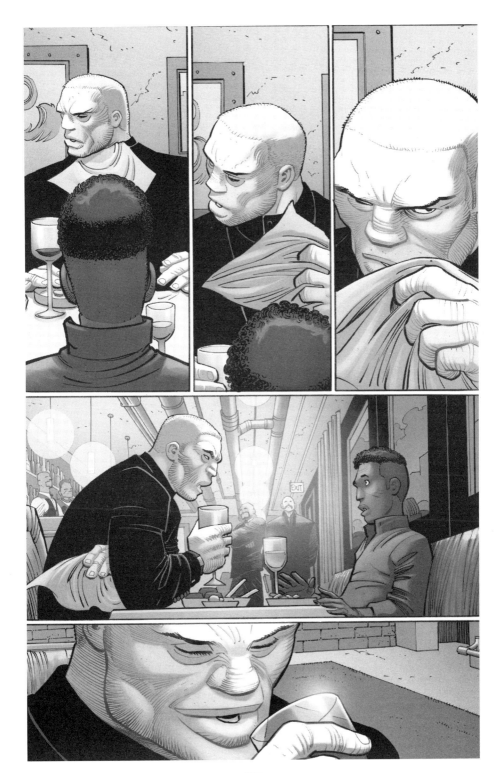

PAGE EIGHTEEN (SIX PANELS)

1/ Randy smiles nervously. Relief and confusion.

RANDY ROBERTSON
Ha.

TOMBSTONE
Was a day I would have broken your back
just for asking, kid. But now...I don't
know.
 (link)
Guess this is what it feels like to have
enough.

2/ We pull out to see TOMBSTONE calling for a bottle of fine
liquor. If it works we're outside the window of the establishment
looking in, with the back of PETER PARKER's head in the foreground
(he's looking in through the window.) Maybe we need two panels for
the pull-out to work? Leave it to you, JOHNNY.

TOMBSTONE
Plus, I don't wanna get on your dad's
bad side. You know he stabbed me with a
pitchfork once?
 (link, yell)
Ricky! Bring us a bottle of cognac. I'm
gonna tell this kid a story.

3/ On Peter, watching.

SPID CAP
Looks like Randy pulled it off.

4/ Peter makes his way down the alley towards the back of the
building.

SPID CAP
Just as well. I've got stuff to do
tonight.

SPID CAP
Bathing in regret, mostly. But still.

5/ Over Peter's shoulder, in the back of the restaurant, we see
WHITE RABBIT getting into the back of a BLACK SUV with some of
Tombstone's HEAVILY ARMED MEN. There's ANOTHER SUV in front of
them.

SPIDER-MAN

Huh?

SPID CAP

White Rabbit and a bunch of goons.

SPID CAP

I knew this would happen if I didn't
bring the costume.

6/ On Peter, looking suspicious.

SPID CAP

And that's why...

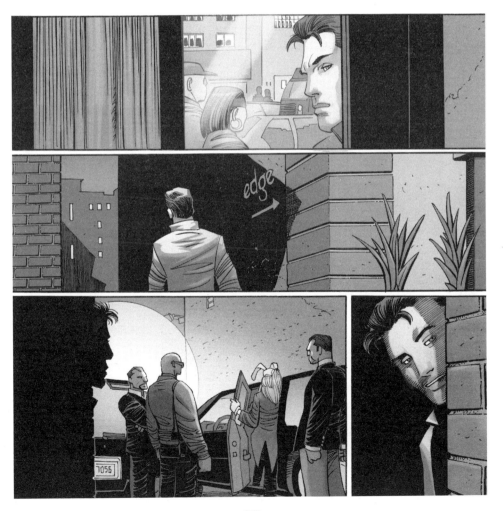

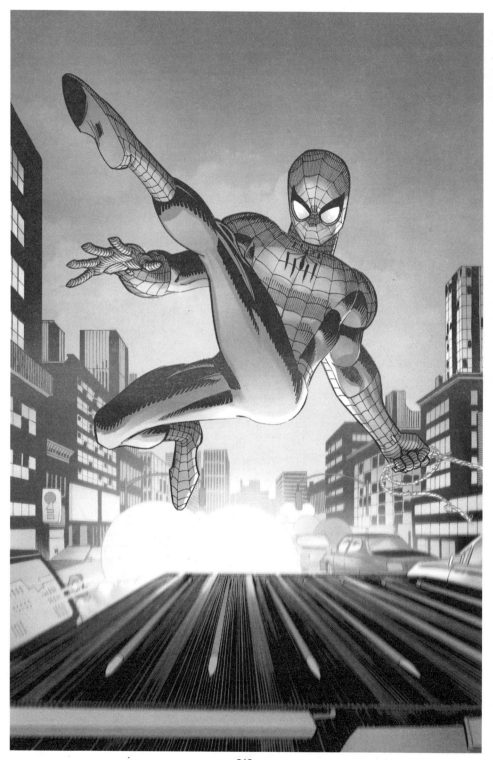

PAGE NINETEEN (SPLASH)

1/ SPIDER-MAN swings through Harlem, trailing the SUV's.

> **SPID CAP**
> ...I totally doubled back for the
> costume.

PAGE TWENTY (FOUR PANELS)

1/ The SUV rolls towards us into the night streets of Harlem.
Behind it in the background, we see SPIDER-MAN swinging after it,
giving chase.

> **SPID CAP**
> Maybe ruining some bad guys' night will
> cheer me up a bit.

> **SPID CAP**
> Tall buildings are a little spotty this
> far uptown, so I'll just land like an
> itsy-bitsy spider...

2/ Spider-Man gingerly lands on top of the SUV.

> **SPID CAP**
> ...and go along for the ride.

3/ Time has passed. Spider-Man lays on his back on top of the SUV,
chilling out.

> **SPID CAP**
> By the time we get to the Hudson I wonder
> if we're just taking in the sights.

4/ The HEADLIGHTS of the SUV illuminate a group of FOUR MEN, part
of The Rose's gang, standing in front of a LARGE MOVING TRUCK.

> **SPID CAP**
> We're not.

PAGE TWENTY-ONE (SIX PANELS)

1/ WHITE RABBIT gets out of her SUV, smiling mischievously. Not a
care in the world.

> **WHITE RABBIT**
> Ah, would a mook working for the Rose by
> any other name...

2/ TOMBSTONE'S CREW meets THE ROSE'S CREW face to face. The SECOND
BLACK SUV has already backed in, so its rear is next to White
Rabbit.

> **WHITE RABBIT**
> ...still smell like a mook working for
> the Rose?

> **ROSE LIEUTENANT**
> You try to smell me I'll shoot you in the
> brain.
>
> (link)
>
> You bring the gear?

> **WHITE RABBIT**
> Of course.

3/ The back door of the second SUV has opened, and we're close on
a GOBLIN GLIDER in the back/storage area. White Rabbit peeks into
frame, presenting it like she's a model on The Price is Right.

> **WHITE RABBIT**
> Hope you brought the money. These things
> are getting harder to find.

> **SPIDER-MAN (O.P.)**
> Ah, a Goblin Glider?

4/ We pull out from the Goblin Glider to see SPIDER-MAN standing
next to it, opposite White Rabbit, like he's just one of the gang.
White Rabbit looks at him in shock.

> **SPIDER-MAN**
> How many miles does it have on it?
>
> (link)
>
> You have to ask. You can get burned on
> these things.

> **ROSE LIEUTENANT**
> Spider-Man?!

5/ On one of TOMBSTONE'S MEN, calling behind him.

ROSE LIEUTENANT
 (yell)
IT'S A BUST!
 (link, big yell)
DIGGER!

6/ Close on Spidey, his spider-sense going off.

SPIDER-MAN
Digger?
 (link)
I know that--

PAGE TWENTY-TWO (FOUR PANELS)

1/ DIGGER BLASTS his way out of the MOVING TRUCK the Rose's men brought, shredding the side of the truck in the process.

> **SPIDER-MAN**
> (small)
> Oh, boy.

> **SPID CAP**
> Yep, got it, spider-sense. I'm in danger.

2/ DIGGER holds SPIDER-MAN in front of him, both hulk-hands wrapped around Spidey's neck. Spider-Man's SPIDER-SENSE is going crazy.

> **SPID CAP**
> Yes, I should have listened to you earlier.

> **SPIDER-MAN**
> Hey, Digger.

3/ Spider-Man grabs one of Digger's fingers, trying to peel it back from his neck.

> **DIGGER**
> Been waiting for this a long time!

> **SPIDER-MAN**
> (weak)
> --kaf

4/ Push in a bit as Spider-Man, in sheer desperation, peels back one of Digger's finger's with great effort, using both hands.

> **SPID CAP**
> Got about five seconds before I pass out.

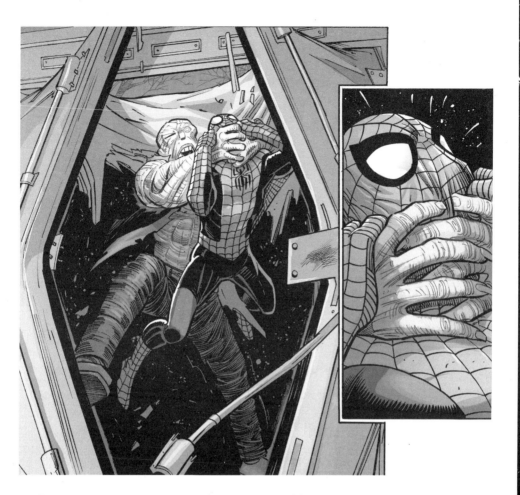

PAGE TWENTY-THREE (FOUR PANELS)

1/ Spider-Man breaks the finger backwards. Digger SCREAMS.

<div align="center">

SPID CAP

</div>

No time to be cute.

<div align="center">

SFX

</div>

(little)

snap snap snap snap

<div align="center">

DIGGER

</div>

AAAARGGGHHH!!!!

2/ Digger has dropped Spider-Man, who crouches in front of Digger, collecting himself.

DIGGER

Our fingers!

SPIDER-MAN

You were choking me!

DIGGER

So?! The Rose says you killed us last
time!

SPIDER-MAN

No, no.

(link)

I wore you out and you melted. There's a
distinction.

3/ On DIGGER, furious. Around him THE ROSE'S MEN have gathered. A
few look at Digger oddly, while the Lieutenant barks orders.

DIGGER

I DID NOT GET WORN DOWN AND MELT!

SPIDER-MAN

Whatever you say.

ROSE LIEUTENANT

Grab the glider! We're out of here!

4/ WHITE RABBIT and TWO TOMBSTONE GRUNTS stand right behind Spider-
Man. They all hold BIG GUNS and are ready to use them. Spider-Man
looks alarmed at their presence.

WHITE RABBIT

They're trying to stiff us. Light 'em up!

SPIDER-MAN

Hold on--

PAGE TWENTY-FOUR (FIVE PANELS)

1/ THE ROSE'S MEN scatter from the gunfire.

> **SPIDER-MAN**
> (big yell)
> Everyone calm down!

> **SFX**
> budda budda budda

2/ Digger nonchalantly turns to the MOVING TRUCK.

> **ROSE LIEUTENANT**
> @!#$!

> **DIGGER**
> Relax...

3/ Digger hoists the truck over his head. The Lieutenant screams at him.

> **DIGGER**
> ...I got this.

4/ Digger tosses the truck.

> **DIGGER**
> (big effort)
> Yeearghh!

> **ROSE LIEUTENANT (O.P.)**
> (big yell)
> Digger, the cash--!

5/ SPIDER-MAN leaps, tackling WHITE RABBIT and a TOMBSTONE GRUNT out of the way as the MOVING TRUCK crashes into the SUV holding the GOBLIN GLIDER (the other SUV needs to survive.) Explosion. BURNING CASH flies out of the truck.

> **SPIDER-MAN**
> (big yell)
> Down!

> **SFX**
> KA BLAM

PAGE TWENTY-FIVE (SIX PANELS)

1/ SPIDER-MAN lays on the ground with WHITE RABBIT, looking back at the off-panel carnage.

> **WHITE RABBIT**
> Yikes.

2/ On Spider-Man and White Rabbit.

> **WHITE RABBIT**
> Tough day to be Kareem.

> **SPIDER-MAN**
> Who's Kareem?

3/ One of TOMBSTONE'S MEN is caught in the flaming SUV, pounding on the window, eyes wide with fear.

> **KAREEM**
> AAAAHHHHHH!!! Rabbit, help me!

4/ Spider-Man leaps into action, leaving White Rabbit behind.

> **SPIDER-MAN**
> I'll get KAREEM. Wait here.

> **WHITE RABBIT**
> You think I was gonna follow you?

5/ DIGGER walks away from the wreckage. ROSE'S LIEUTENANT barks at him, standing with Rose's OTHER MEN.

> **DIGGER**
> Let's go.

> **ROSE LIEUTENANT**
> WHY?! You've got 'em on the ropes!

6/ DIGGER pulls ROSE'S LIEUTENANT up by the collar, hissing in his face.

> **DIGGER**
> Because maybe I don't wanna wear myself
> out and melt! OKAY?!

> **ROSE LIEUTENANT**
> (small)
> Yeah, yeah. Sure, Digger. Let's go.

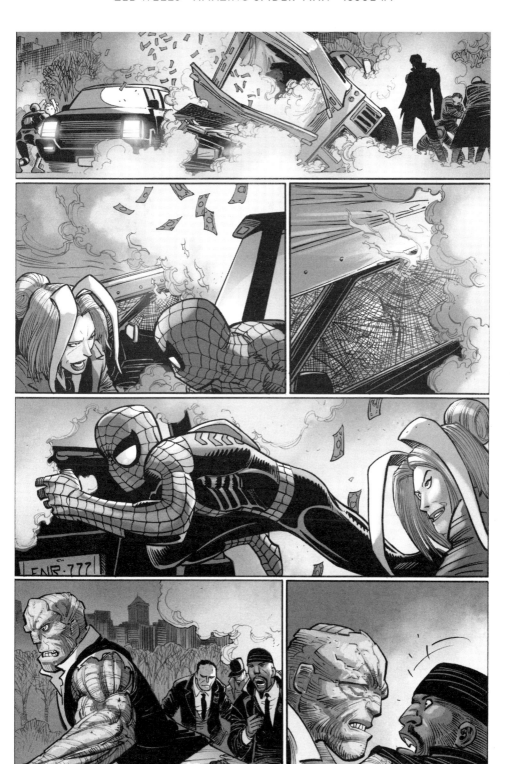

PAGE TWENTY-SIX (SIX PANELS)

1/ SPIDER-MAN pulls TOMBSTONE'S MAN from the burning wreckage.

> **SPIDER-MAN**
>
> Hnnngh! Stay with me, KAREEM!

> **KAREEM**
>
> (weak)
>
> You know my name?

2/ Spider-Man is doubled over, recovering. KAREEM sits next to WHITE RABBIT, who's now standing, looking at her nails. They're near the SECOND SUV. Maybe in the distance we can see the lights of police sirens? If not I'll handle in dialogue!

> **SPIDER-MAN**
>
> (weak)
>
> Don't...don't go anywhere. I'm not done with you.

> **WHITE RABBIT**
>
> Don't think so. You hear those cops? After that mess with Bullseye they're just as liable to arrest you as me.

> **SPIDER-MAN**
>
> Y-you're right. I've gotta go. Can I offer you some thwip thwip before I leave?

> **WHITE RABBIT**
>
> What?

3/ Spider-Man webs the shocked White Rabbit to the SECOND SUV.

> **SFX**
>
> Thwip thwip

> **WHITE RABBIT**
>
> Hey! You piece of @#$!

4/ Kareem's back is to Spidey as he tries to free White Rabbit. Spidey uses the chaos to SHOOT A SPIDEY TRACER at the SECOND SUV (in the wheel well or something, and hopefully we can sell that White Rabbit and KAREEM wouldn't see it? I know, I'm asking a lot of these panels!) Maybe a small inset showing the Tracer land?

> **KAREEM**
>
> I got you!

> **WHITE RABBIT**
>
> Hurry, KAREEM!

> **SPIDER-MAN**
>
> Any chance you wanna tell me where

Digger's going?

WHITE RABBIT

#@$% you!

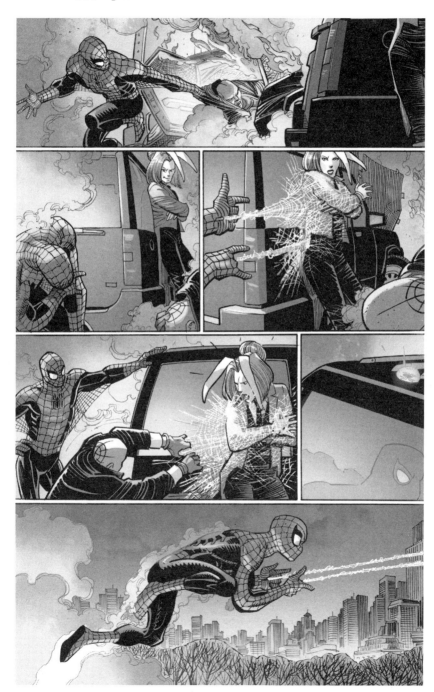

<div align="center">

SFX
</div>

tek

5/ On the Spider-tracer.

<div align="center">

SPIDER-MAN (O.P.)
</div>

Fine...

6/ Spidey swings off.

<div align="center">

SPIDER-MAN
</div>

I'll find him myself!

PAGE TWENTY-SEVEN (SIX PANELS)

1/ Inside Peter's apartment. It's dark, moonlight shining through the window onto his CLUTTERED COUCH.

<div align="center">

LOC CAP
</div>

Four hours later.

<div align="center">

SPID CAP
</div>

I did not find him myself.

2/ On the window, SPIDER-MAN coming through it, taking his mask off.

<div align="center">

SPID CAP
</div>

Though I was a bit like the dog chasing a car. I don't know what I'd have done if I'd caught him.

3/ Spider-Man plops on the couch, exhausted. Mask off. He's pulled his phone out.

<div align="center">

SPID CAP
</div>

He's almost as strong as the Hulk. I only stopped him last time because he didn't know when to stop.

<div align="center">

SFX
</div>

THUMP

4/ Peter's POV of his phone, thumb hovering over the CALL button, MARY JANE's name above that.

<div align="center">

SPID CAP
</div>

Wonder what that feels like.

5/ His thumb presses the button.

<div align="center">

330
</div>

SFX

 tk

6/ On Peter, looking hopeful and scared, phone to his ear.

SPID CAP

 Here we go.

PAGE TWENTY-EIGHT (SIX PANELS)

1/ PETER'S eyes widen. She picked up.

PHONE
Peter.

PETER PARKER
MJ! Hi, I--

2/ On MARY JANE, she's ducked into a dark room out of the hall in her home, taking the call in secret.

MARY JANE
You've got to stop this.

3/ Back on Peter, looking desperate.

PETER PARKER
MJ, please. I'm not trying to--

4/ On MARY JANE, in shadow. Sad with a cold expression.

MARY JANE
Don't call me again.

5/ MARY JANE has hung up. The phone is at her side.

6/ On Peter, phone at his side. Eyes wide in stunned sadness.

PAGE TWENTY-NINE (SIX PANELS)

1/ NIGHTTIME exterior shot of Tombstone's HARLEM MANSION (there's a famous one from The Royal Tenenbaums and some other cool ones on google. OR WE JUST PRETEND!)

<div align="center">

LOC CAP
</div>
> Harlem.

2/ TOMBSTONE stands on his upper balcony in a swank SMOKING JACKET. It's late. He's comfortable and ready for bed. He's holding a BRANDY in one hand and his SMART PHONE in the other. His SCRAGGLY CAT stands on the railing to his side.

<div align="center">

TOMBSTONE
</div>
> I don't care how much he lost. The
> product was destroyed. Cost of doing
> business.
>
> (link)
>
> Spider-Man is considered force majeure.

3/ Close on Tombstone, sipping his drink.

<div align="center">

PHONE
</div>
> You guaranteed the deal, Tombstone. The
> Rose is in everyone's ear saying you
> can't run a territory.

4/ On the cat, getting a nice petting from TOMBSTONE.

<div align="center">

TOMBSTONE
</div>
> He's lookin' for an excuse to make a
> move.

5/ Tombstone turns to go back inside, finishing up his call.

<div align="center">

PHONE
</div>
> No, he's got an excuse. The bosses are in
> agreement, if something happens we can't
> get involved.

<div align="center">

TOMBSTONE
</div>
> Somebody ask you to? It's late,
> Hammerhead. Get some sleep.

6/ Tombstone heads inside.

<div align="center">

PHONE
</div>
> Wait--

<div align="center">

SFX
</div>
> tk

PAGE THIRTY (FIVE PANELS)

1/ TOMBSTONE struts inside, the cat at his feet. He's in his FANCY
BEDROOM.

2/ He stands at a BAR CART against the wall. A PAINTING of a LION
fighting HYENAS is hung above it. He regards it thoughtfully.

3/ Tombstone pours himself another drink.

4/ Close on Tombstone, sniffing the air. He smells something.

SFX
> snff snff

5/ Tombstone grimaces in annoyance.

TOMBSTONE
> #@$%--

PAGE THIRTY-ONE (TWO PANELS)

1/ Tombstone's mansion EXPLODES.

<div align="center">SFX</div>

 BADOOM

2/ Rose's thugs watch the building come down.

<div align="center">SFX</div>

 FWOOSH

PAGE THIRTY-TWO (SIX PANELS)

1/ On DIGGER, ROSE'S LIEUTENANT, and a few other GRUNTS watching the mansion burn from the lawn, their VEHICLES behind them. Rose's Lieutenant is trying to hurry Digger away. The Lieutenant has a ROSE tucked in his shirt pocket.

> **ROSE LIEUTENANT**
> (small)
> I think we used too much fuel...
> (link, big)
> WE GOTTA GO!

2/ Digger plucks the rose out of the scared lieutenant's shirt.

> **DIGGER**
> Relax, will ya?

3/ Digger eats the rose.

> **DIGGER**
> The Rose wanted it loud.

4/ Digger tosses the stem.

> **ROSE LIEUTENANT**
> I was supposed to leave that behind...

5/ Digger spits out the flower.

> **DIGGER**
> Oop. Sorry.

> **SFX**
> P-TOO!

> **DIGGER**
> There ya go.
> (link)
> See ya at the office.

6/ The vehicles race away from the burning mansion.

> **ROSE LIEUTENANT**
> (small)
> Anyone got an extra rose?

> **SFX**
> Screee!

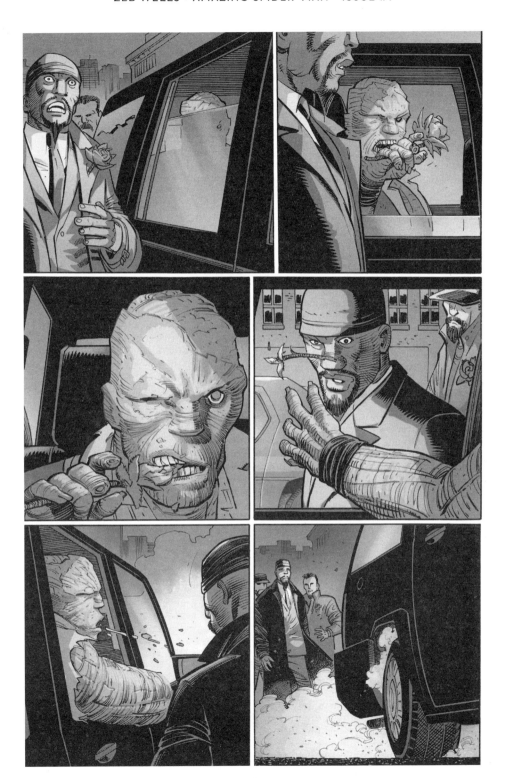

PAGE THIRTY-THREE (FIVE PANELS)

1/ We see the burning entrance to the mansion.

2/ In the burning wreckage, we see a shape.

3/ TOMBSTONE stumbles out of the burning mansion, clutching his stomach.

4/ He releases his stomach, and the SCRAGGLY CAT leaps out of his arms onto the lawn. Tombstone's eyes stare forward, an icy glare.

 SFX
 meowrrr

5/ Close on Tombstone. Grim determination on his face. It's on.

PAGE THIRTY-FOUR (SIX PANELS)

1/ PETER PARKER has just woken up, looking groggy.

 SPID CAP
 10:30 AM.

 SPID CAP
 Wake up.

 SPID CAP
 Get out there.

 SPID CAP
 Fight some crime.

 SPID CAP
 Or look for a job.

2/ Peter rushes past the COLLECTIONS AGENT.

 SPID CAP
 12:00 PM.

 SPID CAP
 Dodge creepy collections guy.

 SPID CAP
 Keep moving.

 SPID CAP
 Interview in half an hour.

3/ Peter walks past a HELP WANTED sign.

 SPID CAP
12:45 PM.

 SPID CAP
Missed the interview.

 SPID CAP
Okay.

 SPID CAP
Will fight crime.

 SPID CAP
After I eat.

4/ Peter has a BIG BREAKFAST in a DINER.

> **SPID CAP**
> 1:30 PM.

> **SPID CAP**
> I eat.

> **SPID CAP**
> Breakfast for lunch.

> **SPID CAP**
> Power move.

5/ Peter walks through the city.

> **SPID CAP**
> 3:30 PM.

> **SPID CAP**
> Walking off pancakes.

> **SPID CAP**
> Then will fight crime.

> **SPID CAP**
> Or look for job.

> **SPID CAP**
> How long has it been raining?

PAGE THIRTY-FIVE (FIVE PANELS)

1/ Close on Peter in the rain.

> **SPID CAP**
> 5:30 PM.

> **SPID CAP**
> Look up.

> **SPID CAP**
> Realize I'm here again.

2/ Bigger panel, behind PETER PARKER, looking past him up to the NICE BROWNSTONE TOWNHOUSE he's stopped in front of. Rain pours down.

> **SPID CAP**
> MJ's.

3/ Facing Peter, standing with sad eyes in the rain, looking up at the house. Behind him, a LIMOUSINE has pulled up in the rain.

> **SPID CAP**
> Praying I had a good reason to be here.

4/ On Peter as he turns to face the off-panel limousine, hearing a voice.

> **TOMBSTONE (O.P.)**
> You walk a lot, Parker.

5/ On TOMBSTONE, looking out of the half-rolled down window. Some cuts and scrapes on his face.

> **TOMBSTONE**
> It's raining. Get in.

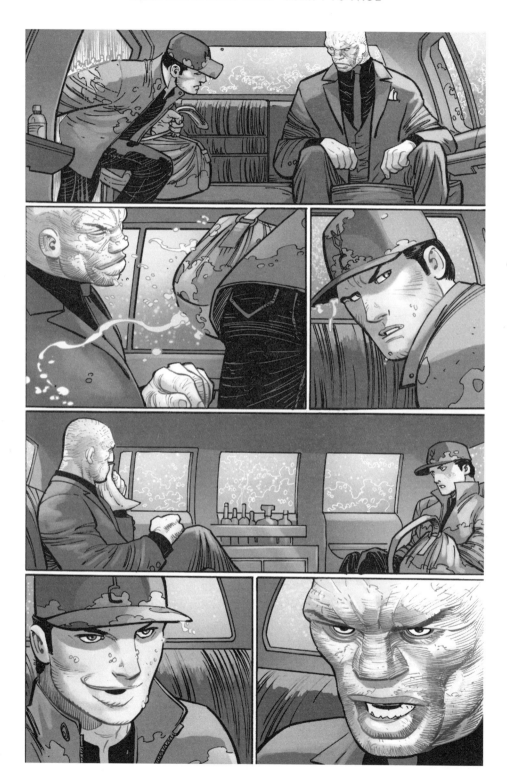

PAGE THIRTY-SIX (SIX PANELS)

1/ PETER gets into the limo, sitting opposite Tombstone.

> **PETER PARKER**
> If you're planning on threatening my
> life, you picked the wrong night.

> **TOMBSTONE (O.P.)**
> Shut up. You know Spider-Man, right?

> **PETER PARKER**
> We've met. Pretty cool guy. Super funny.
> Ass with the ladies though.

2/ On TOMBSTONE. Cold. Matter of fact.

> **TOMBSTONE**
> The Rose blew up my house last night. Cat
> barely made it. We're going to war.
> (link)
> Need you to get Spider-Man a message.

3/ On Peter, wet and annoyed to be having this conversation.

> **PETER PARKER**
> I'm positive Spider-Man has zero interest
> in teaming up with you.

4/ Tombstone looks out the window, watching the rain.

> **TOMBSTONE**
> I'll deal with The Rose. That's my world.
> But I want Spider-Man to know, this war
> that's about to happen?
> (link)
> It's all his fault.

> **PETER PARKER**
> I'll tell him to pack his bags...

5/ Peter being a wiseacre.

> **PETER PARKER**
> ...sounds like he's going on a GUILT
> TRIP.

6/ Tombstone looks back to us, looking more menacing now. Anger
shining through.

TOMBSTONE

You tell him I'm gonna teach him how stupid all his do-gooder bull#@$% is.

(link)

You tell him he's my project now.

PAGE THIRTY-SEVEN (six panels)

1/ On TOMBSTONE, not amused. Looking more dangerous.

TOMBSTONE CAP

"I'm gonna show him how the world really works.

TOMBSTONE CAP

"And when I'm done he ain't gonna have nothing left.

TOMBSTONE CAP

"You got that?"

2/ On PETER PARKER. He's grinning evilly, looking out the window himself.

PETER PARKER

Heh. Heh heh.

TOMBSTONE

Something funny?

3/ Peter turns back to us, smiling.

PETER PARKER

It's just that Spider-Man was telling me the other day how he doesn't have a lot going on.

(link)

How he's been dying for something to do.

(link)

So yeah, I'll tell him you're coming.

4/ Peter leans forward, meeting Tombstone's off-panel gaze confidently.

PETER PARKER

And he's gonna LOVE IT.

5/ Tombstone stares back at us. Cold. What's he gonna do.

6/ Same angle, same expression.

<div align="center">TOMBSTONE</div>

You're a weird dude, Parker.

 (link)

Get out of my car.

PAGE THIRTY-EIGHT (FOUR PANELS)

1/ PETER gets out of Tombstone's car into the rain.

TOMBSTONE
See you around.

2/ Facing his back as he looks up at MJ's apartment again. If it works for the angle we see the LIMO drive off.

SPID CAP
6:00 PM.

SPID CAP
Look at that.

3/ Profile of Peter.

SPID CAP
I got a job after all.

4/ Facing Peter, looking at the apartment again, but this time with a bit of optimism on his face.

5/ On the apartment.

6/ Peter tips his hat.

7/ Peter marches off, his body language changed. He's got a mission now and feels better. In the background we hang on MJ's apartment, looking at the second-story window.

PAGE THIRTY-NINE (SIX PANELS)

1/ Peter walks away.

2/ We're up at the second-story window. Behind the curtains we see MARY JANE looking down from the window sadly. Standing in the dark.

3/ Facing her through the window.

4/ Close on her face. Her lip trembling. Sad and longing.

<div align="center">

HALLWAY (O.P)
</div>

MJ? You okay?

5/ MARY JANE turns, putting on a happy face.

<div align="center">

MJ
</div>

Y-yes! I'm good, Paul.

6/ PAUL comes into the room with a smile. He's conservative and friendly. Warm. We like him.

<div align="center">

PAUL
</div>

You're gonna need to be better than good.
I can't hold them off any longer...

PAGE FORTY (FOUR PANELS)

1/ TWO CHILDREN, a little BOY and a little girl run into the room cheerfully. The boy has dark hair and the girl has red.

<div align="center">

CHILDREN
</div>

> (big yell)
>
> MOMMY!!

2/ Reverse on MJ as the kids run up to her.

<div align="center">

MJ
</div>

> My KIDDOS!

3/ BIG PANEL, the kids wrap themselves around MARY JANE. She looks at them lovingly as NUC approaches warmly.

<div align="center">

MJ
</div>

> Come here.

<div align="center">

PAUL (O.P.)
</div>

> I'm sorry. If you need a minute I can toss them the StarkPad...

<div align="center">

MARY JANE
</div>

> No, this is great.

4/ Push in on MJ's and NUC. They look at each other lovingly. A happy family.

<div align="center">

MARY JANE
</div>

> Everything is great.

POST-CREDITS/LETTERS PAGE

PAGE FORTY-ONE (SIX PANELS)

1/ Wide screen panel, extreme close-up on DOCTOR OCTOPUS. So close we only see his GOGGLED EYES and NOSE. If we could see his mouth, he'd be grinning evilly.

> **DOCTOR OCTOPUS**
> He's already broken. As such, a diagram
> of his destruction is beneath me.

2/ Square panel of Doc Ock's outstretched HAND.

> **DOCTOR OCTOPUS**
> I can't wrest his happiness from him if
> it's already gone.

3/ Twin panel to 2. Facing the "palm" of one of Doc Ock's MECHANICAL ARMS. Its claws are outstretched as well.

> **DOCTOR OCTOPUS**
> So I'll leave him be, until one day, when
> he's full of life...

4/ Square panel of Dock's hand making a fist.

> **DOCTOR OCTOPUS**
> ...I'll grab him by the throat...

5/ Twin panel to 4. Facing the palm of Doc Ock's mechanical arm again. The claws have closed.

> **DOCTOR OCTOPUS**
> ...and squeeze.

6/ We've pulled out on Doc Ock's face from panel one. His hair is sticking straight up (we'll learn it's from gravity in the next page. In the foreground we see a FIGURE standing in front of him, but the figure appears to be UPSIDE DOWN. It's disorienting. Doctor Octopus looks annoyed.

> **AVATAR**
> Vague. Florid. Useless.
>
> (link)
>
> Do not toy with me. I will have the
> schemes by which you plan to destroy him.

> **DOCTOR OCTOPUS**
> My thoughts are radiant, glorious things.
> Your brain could not hope to contain
> them.

PAGE FORTY-TWO (SPLASH)

1/ SPLASH: We've pulled out to see DOCTOR OCTOPUS in FULL FIGURE. We've corrected the perspective from the previous page to show that he is in fact hanging UPSIDE DOWN in a HIGH-TECH APPARATUS that keeps him a prisoner. In front of him stands a FIGURE, sleek and in a suit. This is the AVATAR of the HYPER-EVOLVED LIVING BRAIN. We don't need to make out that the figure is mechanical. It looks like an alarmingly smooth man regarding his prisoner in a tight-fitting suit. All eight of Doc Ock's limbs are spread out, making him look like a sort of VITRUVIAN MAN.

> **AVATAR**
> My mind is alight and alive, Doctor
> Octavius.
> (link)
> And hungry.
> (link)
> Oh, so hungry.

TO BE CONTINUED!